decoding design

decoding design

understanding and using symbols in visual communication

discover the hidden meanings inside common corporate logos and designs

MAGGIE MACNAB

BOOKS

Cincinnati, Ohio
www.howdesign.com

Edited by
Amy Schell

Designed by
Grace Ring

Production
coordinated by
Greg Nock

For more fine books from F+W Publications, visit www.fwpublications.com.

12 11 10 09 08 5 4 3 2 1

Distributed in Canada by Fraser Direct, 100 Armstrong Avenue, Georgetown, Ontario, Canada L7G 5S4, Tel: (905) 877-4411. Distributed in the U.K. and Europe by David & Charles, Brunel House, Newton Abbot, Devon, TQ12 4PU, England, Tel: (+44) 1626 323200, Fax: (+44) 1626 323319, E-mail: postmaster@davidandcharles.co.uk. Distributed in Australia by Capricorn Link, P.O. Box 704, Windsor, NSW 2756 Australia, Tel: (02) 4577-3555.

Library of Congress Cataloging-in-Publication Data

Macnab, Maggie.
 Decoding design : understanding and using symbols in visual communication / Maggie Macnab.
 p. cm.
 Includes index.
 ISBN-13: 978-1-58180-969-5 (pbk. : alk. paper)
 1. Logos (Symbols)--Design. 2. Signs and symbols. 3. Commercial art.
I. Title.
 NC1002.L63M33 2008
 741.6--dc22
 2007039619

F+W PUBLICATIONS, INC.

About the Author

Maggie Macnab has been recognized for her logos and graphic design for more than twenty-five years. She has taught logo design and symbols as visual literacy at the University of New Mexico for more than ten years and is past president of the Communication Artists of New Mexico. Her work has been published in national and international design magazines and books, along with her writing on critical thinking in design. She speaks at conferences and guest lectures at art and design schools internationally.

Dedication

For the ones who came before, Arden and Sandy.
And for the ones who come after, Evan and Sommer.

Table of Contents

Foreword

Connecting by Design

The desire for the spiritual is deeply embedded in our DNA—and represented in the meaning of numbers, colors, symbols and fables created by our ancestors and ourselves, all providing clues to the perennial question "Why?"

Designers incorporate the elements of the mystical in their designs, often oblivious to the significance of their actions and unaware that there is a mathematical relationship that results in harmony. Historically, enlightened designers created a dynamic system tied to some very specific proportions—specifically those based on the Golden Mean, a ratio which appears in nature in innumerable ways as well as in the monumental designs of the Pantheon, the Pentagon and Stonehenge. Designers who are aware of the significance of the Golden Mean have historically honored the relationship and meanings of iconography as well and for the same reason—because it connects us with the universe.

But in the late 1900s trends in design started to gravitate toward meaninglessness: Designers started to mix up a garbled stew, creating chaos that entertains and shock for the sake of awe.

Designers embraced their newfound tools: the computer, the Internet, millions of typefaces. Their tools were now limitless. And, as a result,

there was a rebellion against the old guard philosophy in design that required rigidly applied grids and rules. New design was about throwing out the recipe.

But the ingredients of symbolism are eternal and indestructible: The harmony of the trinity; the union of two; the balance of the yin and yang; the magic of the ether. These concepts cross over cultural barriers; they are part of our common language. We are so painfully aware of disharmony in the world; we need to get back to harnessing the power of symbolism to get back to clear communication.

I visited northern India in 2002 and was thunderstruck by the power and prevalence of primal symbols embedded in every culture of that ancient land: I felt I had come home. By contrast, the modern West was a jaded, sterile and joyless world.

The principle of reductionism (typical in modern Western cultures where science often trumps spirituality) distills the world to zeros and ones and, in the process, destroys the indefinable—the God—of nature. Whereas Eastern holism accepts that there is something more in the whole, as Aristotle observed, than the sum of the parts.

New Mexico, where Maggie Macnab lives, is a unique balance of holism and reductionism. The yang—Los Alamos National Laboratory, where the first nuclear weapons were born—is nestled right alongside the yin—the Sangre de Cristo mountains, which is home to some of the most ancient, most holy land on earth including Chimayó, considered the Lourdes of America. Maggie's longtime immersion in symbolism is a way for designers to demystify the universal language that is theirs to use—to decode design and embed clear and universal meaning in their work.

DK Holland
New York City, New York

Introduction

"You cannot understand the universe without learning first to understand the language in which it is written. It is written in the language of mathematics, and its letters are triangles, circles and other geometric forms. Without this language humans cannot understand a single word of the universe. Without it we wander in a dark labyrinth."

—Galileo Galilei

Qualities Count More than Quantities

Our culture has lost touch with the archetypal principles that underlie simple numbers and shapes. We tend to see numbers as quantities and use them almost exclusively as a counting system. But numerical principles lie deep within the unconscious and have a psychological and spiritual impact on us. It is important for designers to reconnect with the wellspring of this symbolism. Visual communication that taps into the dynamic energy of the collective psyche makes a powerful and direct connection that is expansive on many levels.

It's easy to see why numbers are regarded primarily—often *only*—as a counting tool: They provide a systematic language by which we can measure space and time, allowing us to "count" on future events. Numbers

underscore the technological advances that have precipitated the explosion in human population. As our earth becomes more compressed, it is crucial to be aware of the quality to quantity ratio. Mainstream culture is only just beginning to acknowledge the price that quantity extracts from nature when not reciprocated. Ultimately, and not long from now, this will impact us in significant ways. Quantity alone does not sustain itself.

This holds true for designed communications as well. There are far more compelling ways to create a message besides saturation. As designers, it is our responsibility to create conscious and lucid communications. We can't afford to contribute to information junk any more than the world's landfills can continue to be inundated with trash. Only a few clients have budgets big enough to rely on the quantitative aspect of overwhelming the market, the success of which is based on continual feeding. Using common sense—connecting to the experience of living we all have—has more value than big budgets because it creates an immediately understood relationship. A message that invites participation out of choice takes much less energy—on both sides—than one used as a battering ram.

Interpreting the qualitative aspects of number and shape is an alternate approach to the literal, assembly-line communication so prevalent with today's technology. Employing the principles of symbolic design are actually quite practical because they are familiar to us regardless of language or culture. And the added aspect of intuitive connection inspires a simultaneously universal but intimate meaning—quite attractive to a thinking species.

The most effective messages start with a good idea fueled by connection to a subtler and more significant relationship. By using our ingenuity to expand on what already exists—what has always existed, in fact—we communicate with a clarity we know in our essential selves to be true.

Maggie Macnab
Sandia Park, New Mexico

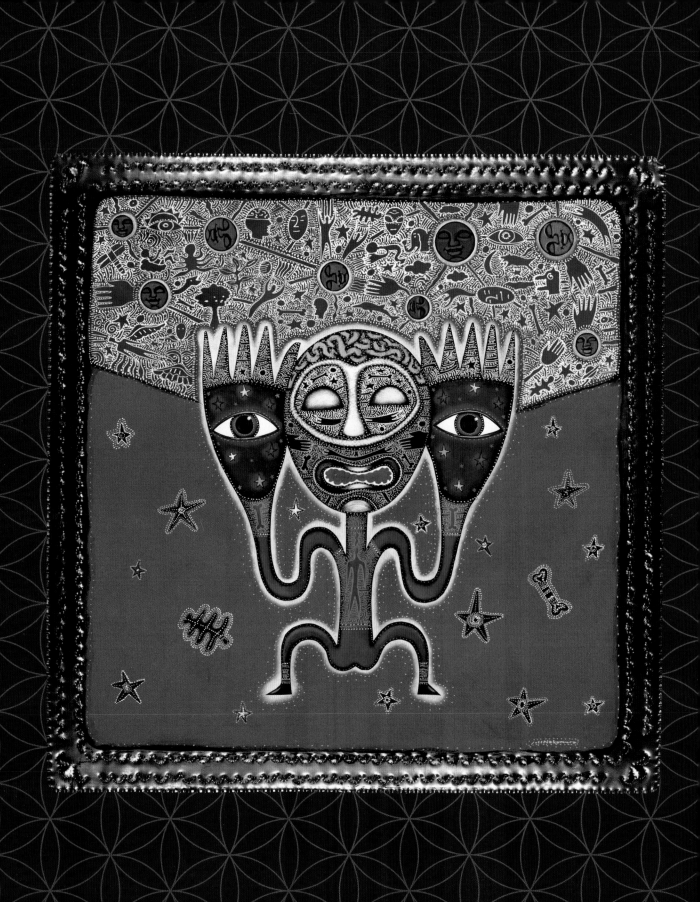

Pattern: Laying the Groundwork for Design

Figure 0.1
Sensing the Universe by Joel Nakamura

Many tribes transitioned from being hunter-gatherers to cultivating land and domesticating animals for food and labor only about ten thousand years ago, a fraction of our evolutionary history. For millennia, before civilization was a possibility, we watched the patterns between the sky and seasons, the migratory relationships of the animals we tracked, and the growth cycles of the vegetation we gathered. We had to interpret relationships to survive. This is where our extraordinary ability to make meaning took hold, carrying us far beyond any other mammal. We have been able to understand how basic patterns connect, allowing us to alter our experience. We survived over enough generations to inherently understand the relationships of natural cycles. The pattern of intuitive experience was brought into consciousness when we began to mark off and recreate a manageable human-sized model of seasonal and celestial relationships.

In other words, we learned to symbolize.

Our ability to symbolize allows us to conceptually manipulate objects in two-dimensional space, or conjecture an experience we haven't yet had. We can model and visualize things in 2-D that do not yet exist, and conceptualize scenarios that allow us to anticipate and

plan future events. Everything we envision and create—everything we are—comes from the ability to symbolize. This is what is meant by "creating our reality."

Safeguarding our own manipulation resides in our experience and knowledge of nature so that we may grasp the essence of how things work. This is the basis of thinking for oneself and a threat to those whose interests reside in the ability to manipulate. It is the ability to see beyond the obvious, the quantified, the literal, that is our saving grace. And it *is* literally a grace: It is direct communion with the greater whole.

The appreciation and understanding of nature underlies both cultural and personal evolution. Any ideology or product can be formatted through a symbolic template to bring credibility, urgency and need—whether it is real or invented doesn't matter. As designers, it is our job to understand the deepest aspects of symbolism—not only for effective design, but ethical design as well. Knowledge is our tool for communication and independence.

Why Should Designers Understand Natural Patterns?

In the same way breathing is an unconscious action, patterns are so pervasive we don't notice most of them. Likewise, we cannot exist without them and we use them subliminally and constantly. The cracking of thunder signals the transformation that lightning and rain bring to earth, just as any auditory alarm alerts us to a new and urgent action—whether in the whoops of our ancestors as they pursued prey, or in the beeping of our clock radio that forces us up in the morning. The sun transits the heavens cyclically, just as an analog clock follows the quartered hours in a circle. Time is intimately tied to space and we track it through pattern to grasp our sense of being.

We have always used the pattern of nature to know when to hunt, when to plant, when to stay and when to move on. Patterns are arrays that unfold in predictable ways to reveal distinct interrelationships that can be grasped through our senses. We learn how to exist in the world by reading them. As we develop ever more sophisticated technology, we become more disconnected from nature and less able to understand and appreciate its patterns. We forget that the human form itself is a

construct of natural pattern—embedded in our DNA as the double helix of evolving life—and it is essential to everything related to our existence. We cannot disconnect from our source. By being the clever creatures we are, we have imposed our own desired order of pattern onto nature, often to our own detriment.

Still, natural patterns are fundamental to us getting along in the world. By appreciating natural patterns, we better understand the basic patterns we intuitively recognize, thus we better learn how to communicate. Design is the ability to communicate through an intuitive sense of pattern. It is the difference between lucid communication and meaningless noise.

Recognizing pattern is one of humanity's greatest abilities. It is the basis of conscious awareness that brings cohesion to a chaotic world by allowing us to see contrast as well as similarity. Most creatures have intuitive intelligence that allows them to recognize symbols: Bees can find honey down a diverging maze by navigating colorized directional symbols after a few tries. Chimps use symbols not only to identify objects but also to describe conceptual impressions of the world around them, and can even use rudimentary language to say "yes" and "no" in response to someone talking to them over the phone. Human beings have upped the ante with an intelligence that allows us to sort the pieces of pattern at the surface of consciousness. Recognition of how things

Figure 0.2
Until the summer of 2006, archeologists widely thought that human ritualistic behavior was only about forty thousand years old, based on artifacts found to date. Things of a certain age simply disintegrate over time and so it is difficult to determine just how long humans have been using their brains symbolically. This six-meter long python, discovered in Africa in 2006, is embellished with more than three hundred man-made indentations representing scales, showing that *Homo sapiens* performed advanced rituals in Africa as long as seventy thousand years ago.

0.2 Image courtesy of Associate Professor Sheila Coulson, University of Oslo, Norway

connect allows us to rearrange pattern into versions that can benefit us. Pattern recognition anticipates consequences so we can ingeniously plan our future—the hallmark of our species. This is a great thing. But intelligence does not always equate to awareness; this is where an intuitively savvy designer has an edge over one who is not. The purpose of this book is to connect us back into the language of nature, to revive our understanding of source, and to create communications that flow unobstructed by an intelligence that has lost its way in the world. This book is about creating conscious design that is naturally aesthetic, efficient and enduring by its very nature of being nature.

Pattern establishes a dynamic relationship that connects seemingly opposed, unrelated or even invisible forces. A designer's understanding of this can be carried into planning the "genetic material" that makes up cohesive and effective visual communication. Just as DNA holds the blueprint that unfolds into an entire species in a bit of collapsed information, the "genetic material" of a successful communications program begins with a conscious grasp of how long-term consequences relate. The designer's job is to appropriately code bits of information that expand over the lifetime of the communication. Pattern awareness allows us as designers to choose the most appropriate relationships that specifically describe a client's unique attributes, while simultaneously embedding universal cultural concepts. If you can penetrate beyond the initial glance, there is an opportunity to get into the details of the communication.

Pattern lays essential groundwork for its use on every level. It cues the designer to make meaningful relationships, which in turn lead the viewer effortlessly toward comprehension. This is visual communication at its most effective: using a pattern that is recognized intuitively and immediately, and engaging the viewer by using design that is elegant and clear. Intuitive pattern encrypts information about the subject in a way that supports interest, recognition and remembrance in a very deep way. The initial transference to your viewer doesn't come in words, but with images that connect deeply and meaningfully because they contain universal knowledge. The viewer may not know immediately what is so compelling about the design, but they notice and they remember.

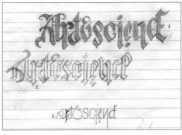

0.3

0.4

Figures 0.3, 0.4
Philosophy: Art & Science
by John Langdon
Turn the book upside down: An ambig-ram reads the same when it is rotated 180°. Opposites are deeply connected and reliant on one another. John Langdon says, "Philosophy is really the foundation of my work. Specifically, orienting my life around the idea that there's more than one way to understand any situation has made it more comprehensible, manage-able, interesting, fun and rewarding. The best nonverbal representation of the phi-losophy is the yin-yang symbol, which is expressed in the ambigram."

There are relatively few patterns that make up existence, considering the breadth of diversity this universe supports. There are only a handful of basic shapes that combine in ways stable and efficient enough to be practical in three-dimensional space. These patterns are mirrored from micro- to macro-scale, and come into play in every scale between. And yet, with the application as varied as the diversity of form, it only takes a few basic patterns constructed from a few basic shapes to underlie processes that are found in all places and all time. We will be looking at how to distill information to its essence and how to appropriately match symbol to client, just as pattern is matched to task.

While patterns are beautifully and oftentimes clearly articulated in nature, how they translate as universal principles is not something we notice at the conscious level. This inherent knowledge is accessible to all of us but is simply not acknowledged or developed in mainstream cul-ture. During periods of significant cultural enlightenment such as the Renaissance, classical education included learning about the language of nature through practices such as sacred geometry, cosmology and intercultural philosophies applied to art, architecture and relationships between man-made structures and the universe—all based on natural common sense. The times of revolutionary creative development have historically been in direct correlation to times of inquiry into the fun-damental workings and mysteries of nature. The desire to know over-rides cultural perspectives, which are based on knowledge that is often

in flux. When the journey of exploration and discovery become the priority, humans are at their very best.

PATTERN IN ARCHITECTURE

The Renaissance is an excellent example of how far we can go with knowledge when the focus is cooperation rather than competition. From the ninth to the fourteenth centuries, the Muslims led the world in the pursuit of research and experimentation. The Islamic world was the most scientifically advanced and made significant contributions by refining and synthesizing ideas from several diverse cultures. They laid foundations in philosophy, medicine, astronomy and mathematics still in use today. As human culture spread and interacted, many Muslim ideas were transmitted to medieval Europe, transforming Western culture. By the thirteenth century, many European students studied at Islamic universities, primarily in Muslim-controlled Spain. European knowledge did not surpass that of the Islamic world until the Renaissance, when this education was improved even further through continued cultural exchange and cooperation. Through the enlightenment of knowledge, Muslim thought was a major influence that dispelled the ignorance of the dark ages.

The Alhambra mosque, built in Moorish Spain between the mid-thirteenth and fourteenth centuries, is an exquisite example of higher knowledge integrated into art and architectural design. It carries tessellated patterns that identically follow molecular crystalline structure. Tessellating patterns are shapes that completely and symmetrically fill space on a plane without any gaps or overlaps: Tessellate is from the Latin *tessella*, meaning "tile." To mathematicians, symmetries are defined as transformations that leave an object unchanged; that is, the movement is completely equalized, and specific rotations will not alter the whole. This is a visual illumination of the intricate balance of energy in the universe, and is the first step toward following nature's lead in our own efforts to balance human activity with natural law. Expressed as art or design, it becomes the subtle and beautiful patterns of energy at work.

Survival of the fittest applies to quality in graphic design just as it does in nature (after all, they are the same). Visual association can be far richer in information than words because it interacts intuitively and immediately. We sense what is already known through the genetic translation of those that came before. A design that "makes sense" in a visually direct way eliminates having to process the word, make it into a picture, and factor in the cultural associations that give meaning to its context. Our minds make intuitive connections with subliminal information to form the design. Sensing uses imprints far

Figures 0.5, 0.6, 0.7, 0.8
In apple blossoms and squash alike, five petals signal energy-conversion compatibility with our digestive system.

Petals of flowering plants that number five or multiples of five bear fruit edible for human beings. Flowers of love, such as the rose, passion flower or plumeria used in tropical wedding leis, are based in the pentagonal symmetry of the spiral (more about how the number five and the spiral are related in Chapter Five).

Poisonous plants—alternatively medicinal, depending on ingested dose—have flowers with petals numbering six or nine. Not surprisingly, five is broadly the number of organic life, and specifically relates to human physical structure, both in quantity and quality—five appendages that extend from the torso including the head; five fingers and toes per appendage; five senses in the head region.

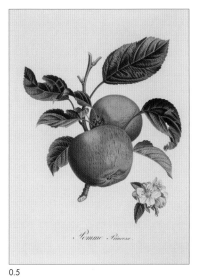

0.5

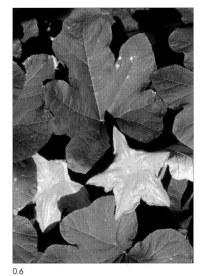

0.6

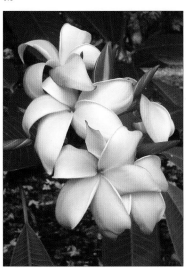

0.7

0.8

Figures 0.9, 0.10, 0.11
Music is audible pattern in time. Musical notation is rhythmic pattern in space. The SwanSongs logo was created for a musician who started a nonprofit collective to bring music to terminal patients. I knew instinctively the essence resided visually in the notes. A swan song is one's last legacy, and a perfect name to represent this organization's purpose. It connected deeply with the graceful idea that our essence continues through the living once we are not: The spirit of who we are lives on through how we are loved, a direct extension of how we loved. Discerning the musical properties of the spiral shape and embedding them as a comprehensive relationship between the name, visual and intent creates a powerful logo that conveys the principles of growth, evolution and appreciation of change as forward movement, demonstrated by the spiral continuity of the curl as it moves outward. This design speaks intuitively and immediately in support of the client by applying accurate symbolic principles.

older than civilization, and therefore is initially free of cultural association, or even the encumbrance of language. It is a direct route to establishing connection.

I suggest that we look to nature as teacher—strategically doing what we have already been doing unconsciously. Good design is inherently a fusion of intellect and inspired intuition. We gain access to inventive design by trusting our intuitive intelligence and allowing sensed bits to flow into a relative and conscious form. In the following chapters we will look at shapes and their association to universal principles. This will lay the groundwork for you to appropriately choose visual background and foreground information that communicates in an immediately accessible way.

We will expand beyond the typical design brief—which includes interviewing the client, researching their field and learning about their competition—by taking it a step further with the shapes, colors or images that come up when you begin the creative process. If you look carefully and thoughtfully at these images, you can begin to break them down into potential visual contenders that will do the work of symbolic communication. We will ask questions of subtlety and depth. For instance,

0.9

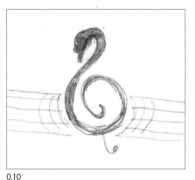

0.10

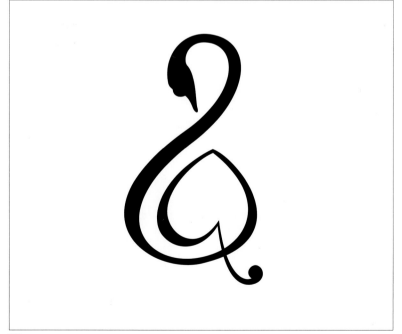

0.11

how does that shape or principle connect with the client? Does it have other associations in human application, regardless of when in history it occurred? What is a common myth or symbolic association most of us relate to? How can this quality be integrated to support the design visually? What specific visual information can be woven back into that quality to make it relevant to its audience?

All at once, it appears before you: that "aha!" of illumination following a period of delving (sometimes lightly, sometimes intensely). It is making the leap to the potential residing in the spaces between the broken down bits of information: the alchemy generated out of interaction between inspiration, intuition and creativity. If this sounds a bit like magic, it is because there is a part of the process that is inexplicable. The creative leap occurs by bringing subliminal information to the forefront. Much of the process is logical, but the leap into inspiration is not a linear one.

How Do Patterns Reveal Relationships?

Energy organizes itself in multi-dimensional relationships, explored in more depth in the later chapters. Connectivity is of essential importance to how energy works. In our universe the complementary partner of energy is form (or matter); and that form is consistent with the principle energetically performed. The ancient Taoists say "form is the envelope of vibration," or put into more accessible language: Form visually expresses its energetic principle. Rather than form following function, or vice versa, each needs the other to exist. They are differently represented aspects of the same principle.

Branching

Specific patterns relate to specific universal principles. The branching pattern in all circumstances—whether tree branches or roots, water tributaries, human veins or intestinal structure—each are examples of micro to macro patterns of energetic transference. Our blood carries nutrients to organs from the outside in and back out again; leaf veins transport converted sunlight energy into food throughout the plant; waterways meander and branch into the contours of the earth

Figure 0.12
The Chicken Is the Egg
by Maggie Macnab
"Which came first?" is the eternal question of form and function. It's the same sort of problem theoretical physicists struggle with trying to distinguish the nature of particle and wave. The more sophisticated the technology, the more elusive the terminology. I finally answered this question (in my own mind, at least) in a satisfying way, but it took raising my own chickens and this logo to get there.

Figure 0.13
"Tree Branching," © 2000 Gary Braasch

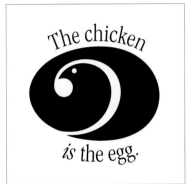

0.12

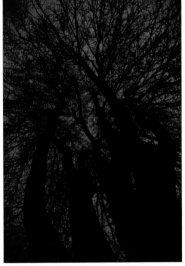

0.13

Figure 0.14

In Jungian psychology the tree portrays an inner process of development independent of consciousness. The cross section of tree rings resemble a mandala—a symbol of the self—while the tree in a branching profile is a metaphor for the growth process. Like many archetypal symbols, it contains a symbolic paradox. With branches reaching up to the sky and roots gripping deeply into the earth, trees are symbolic of levels of growth as well as cycles of regeneration. Having been climbed for its fruit and as lookout observatories, they are analogous with aspiration, connectedness, development and growth—the axis around which all existence revolves.

Figure 0.15

Human Circulatory System, Visual Language, Art of Anatomy

Figure 0.16

"Eiffel Tower as Conductor," photo c. 1902

Figure 0.17

Satellite image of the Mississippi River delta

to provide the lifeblood of plants and animals; and lightning transforms carbon and nitrogen into compounds that plants can assimilate. Form is synonymous with function and gives clues to the work the pattern describes.

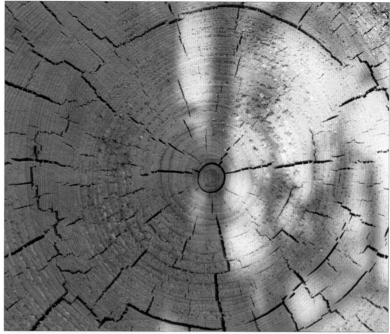

0.14

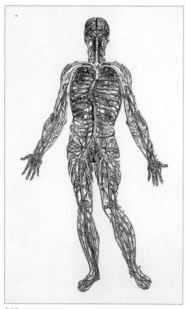

0.15

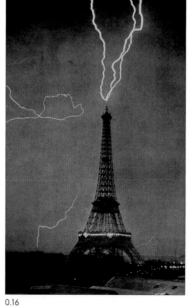

0.16

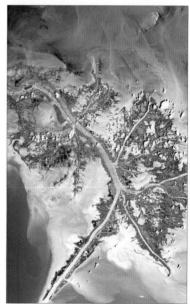

0.17

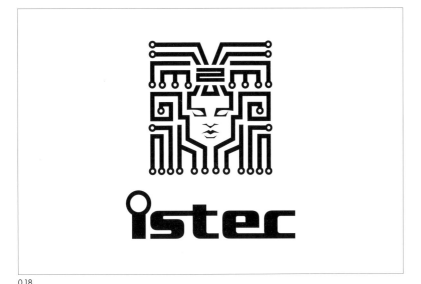

0.18

The Spiral

The spiral visually contains a high degree of movement and nonlinear expansion potential that is highly engaging to us. Its appeal is no surprise: This is the shape of growth over time—evolution, essentially—found in a wide variety of organic life and systems of momentum, such as tendrils that creep or hurricanes that spin. The visual pattern of the spiral (the spiral is also a symbol) shows the catalytic process of life as movement and contains the underlying mathematics of what most humans experience as beautiful proportion. This is one of the most powerful patterns to human perception because it is so directly related to our own existence.

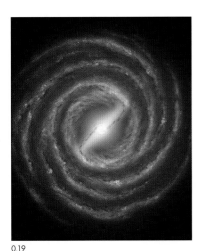

0.19

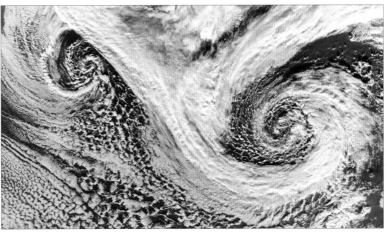

0.20

Figure 0.21
The proportion of the spiral is considered beautiful to humans and underlies much of what we see as aesthetic, from art to facial proportions that are considered beautiful cross-culturally.

Figure 0.22
Arabian Horse by Maggie Macnab
The generative principle also exists in the Tao symbol of the reflecting universe; the yin and the yang. This principle is embedded in a logo for an Arabian horse breeding farm.

Embedded into a logo as shape or with its mathematical characteristics of proportion, the spiral engages our aesthetic sense and innate attraction to our own evolution and movement through time and space.

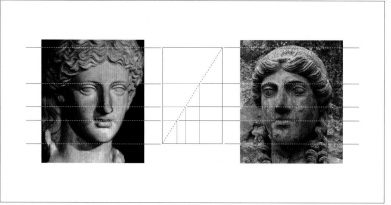

0.21

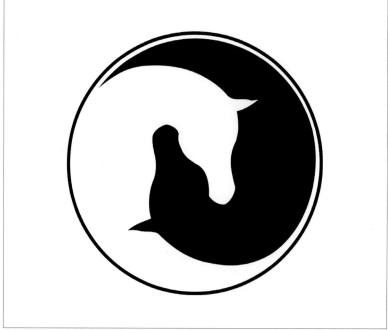

0.22

Weaving and Helices

Weaving is indeed one of the oldest arts. The back and forth, twisted relationship signifies the interactive movement of energy and matter. When opposing processes are woven together, they form the warp and

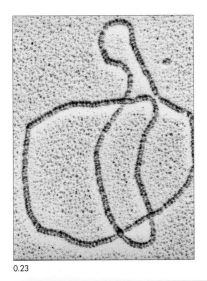

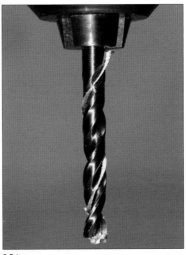

0.23

0.24

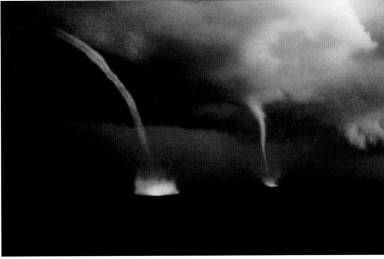

0.25

Figure 0.23
Weaving the fabric of the universe: This is the knotted nature of DNA before separating and recombining in mitosis during cell division. These knotted string patterns contain the genetic information that must reconfigure to make us, or any other form of life. It resides with another close relative to the spiral pattern, the double helix: a focused and penetrating structure designed especially for critical tasks, such as funneling the blueprint of life into the next generation.

Figure 0.24
Movement-associated principles are contained in both helices and meanders. But like a drill bit, helices rotate around an axis in space, while meanders display a more random pattern and have no asymmetrical mate. The focused movement of the helix serves the specific immediacy of next-generation creation, while the meander's job of maintenance moves in a diverted, broad manner. The visual signatures of each are compatible to the energy required.

Figure 0.25
Even though not a life form, the waterspout (a sea-going tornado) utilizes the same organized energy pattern that builds the momentum necessary to sustain survival. Over the space of ocean surface, or over the time of generations, the spiral unwinds in a slow dance. This energetic pattern knows where it's going because it knows where it's been.

weft of our universe's fabric that binds three-dimensional space. From a common sense perspective, united opposites provide the strongest bond, because opposing forces are working together. This principle underlies durable fabric, cultures that survive over time, and genetic material that builds future generations.

Weaving is intrinsic to the basis of our existence, in the form of the DNA double helix. Helices are rare in inorganic life, and inside DNA's twisting motion are specific instructions on how to build an organism. When DNA replicates itself during the genetic dance of mitosis (from the Greek *mitos*, thread), the helices unthread and rethread themselves.

DNA's woven and knotty structure has proven enlightening for other fields, such as string theory in physics—a way for scientists to visualize multiple universes knotted together in space.

Figure 0.26
Just discovered in March 2006, the Double Helix nebula is very close to the black hole at the center of our Milky Way galaxy—just 300 light-years away. As a comparison, Earth is more than 25,000 light-years away from our galaxy's center. The nebula has the energetic equivalent of 1,000 supernovae.

Figure 0.27
Entwined Serpents, Aztec, pre-Columbian
According to the anthropologist James Narby in his book *The Cosmic Serpent*, shamans from many cultures have been visualizing the graphical patterning of genetic structures such as the double helix and chromosomal division for millennia. Instead of using high-powered technology to capture micrographs at subatomic levels, they use trance, deprivation of sensual experience, and, on occasion, psychoactive drugs to understand patterns through which to grasp universal mystery and truth.

Figure 0.28
Oriental Medicine Consultants
by Maggie Macnab
The caduceus, long associated to the medical profession, addresses the elemental nature of the helix pattern. As in all archetypes, it contains the opposites found in deeply related symmetry: In this case, "heal or harm" in the caduceus contains the visual metaphor of a poisonous creature's relationship to well being. This logo subliminally weaves the Western caduceus and the Eastern life force of "qi"—what Westerners more commonly call *chi*, or energy—into a visual that represents the Eastern and Western modalities of this medical practice.

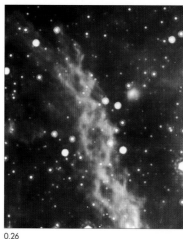

0.26

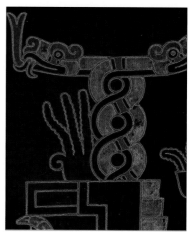

0.27

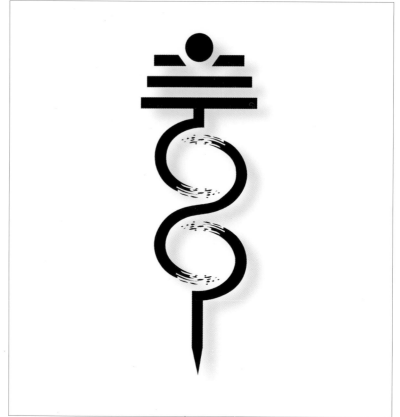

0.28

Meandering

Associated with "lazy," the meander is in truth a very effective way to level peaks of work by distributing them almost equally. Meandering, seen typically in river flow, is the most effective way for water to do its energetic work by rolling and turning in a downward movement. This is another reason for the lumpy convolutions of our brain: It gives us the spatial ability we need to spread information over a larger surface area for more sensual processing, as well as to stockpile the vast quantity of it.

Figure 0.29
Fertile Estuary, Prince William Sound, Alaska

Figure 0.30
The meander is anything but lackadaisical. The roll and turn of this brain coral from the Caribbean evenly distributes the energy of work across space.

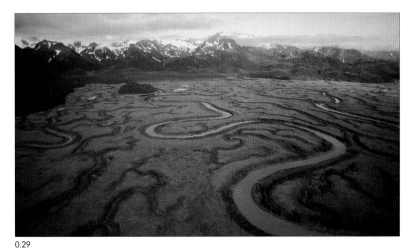

0.29

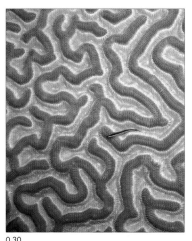

0.30

Breaking Patterns and Symmetrical Stacking

Patterns move, store and connect energy to function in the most efficient way. Drying mud, bubbles and cracking rock, all products of elastic processes of nature, tend to break or connect at 120° angles. These shapes and angles are forced by balancing pressure and size to relieve stress. Nature contains an abundance of spherical objects such as viruses, cells or molecules, and when packing with their own kind they achieve the tightest fit: a hexagon with approximate 120° angles. The most classic example is the wax chambers built by bees which are perfectly formed for extraordinary strength and economy of space, a design adapted by Buckminster Fuller for the strongest, lightest and cheapest structure known for human-scale building, the geodesic dome. This is a classic shape for financial or other security-conscious organizations wishing to convey strength, stringency, conservatism, and a quiet, pervasive power.

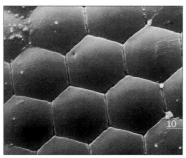

0.31

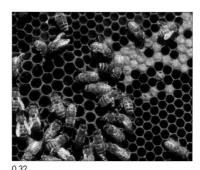

0.32

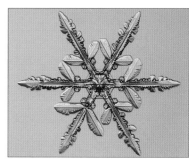

0.33

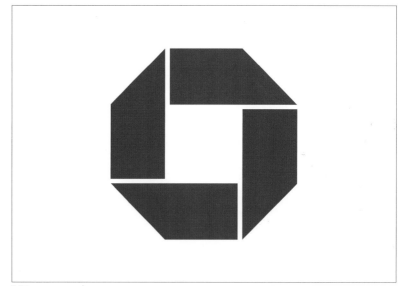

0.34

Figure 0.31
This micrograph of a fly's eye shows the superior engineering of vision contained in a compound eye: Multiple lenses fit together in a hexagonal pattern without any wasted space on a wide-angle, concave surface. Part of fly physiology for 390 million years, this design gives highly precise vision for lightning fast reactions. The compound eye design in trilobites of the Cambrian period goes back some 530 million years. We have used this design in eyeglasses for a few hundred years.

Figure 0.32
The hexagonal structure of a beehive has been determined over time by physical forces that make the best use of energy in space.

Figure 0.33
Most—but not all—snowflakes display the prowess of structural six.

Figure 0.34
Chase Manhattan logo
by Chermayeff & Geismar, 1960
This logo displays a variation of the multi-angled symmetry which was so prevalent in the 1960s, 1970s and 1980s. It imparts absolute, hard-edged strength, efficiency, reliability and conservative economy.

Symbols in Relationship to Pattern

How do symbols perform this amazing task of being so comprehensive in one simplistic visual bit? How are concepts such as "now" and "always" contained in one thing? Symbols are the essential connectors that create a consistent link between the diverse patterns that exist all around us. A clock tells time but does not cause it. In the same way, a symbol expresses an unfolding universal rhythm in a way we can comprehend it. The symbol is not the rhythm; it is the manifestation of the energy that creates the rhythm. Ever present, but usually unnoticed, symbols provide a momentary pause in dynamic patterns that are in constant movement.

A symbol, when you catch it, has made it from intuitive sensing to conscious awareness. You have just made the eternal connection from

your deepest experience to "right now" reality and caught a glimpse of a timeless, universal truth. As the mythological scholar Joseph Campbell pointed out, "The ticking of the clock shuts out eternity." Symbols are visual metaphors that intimately link to the energy they express—but they are not that energy. They are a door opening into far more expansive powers. Taken literally, or mistaken for the power themselves, they are mutable and can be warped into literal significance. This has brought down entire civilizations. Symbols contain profound meaning as metaphor, expression or illusion: They lead to a greater truth when experienced for what they are.

How Patterns Relate to One Another

Disruptions in pattern indicate one energetic expression transitioning into another. For example, concentric circles at the end of a chaotic, cascading stream signal something different is about to happen. This outwardly moving circular motion gives the rushing molecules of water an opportunity to reorganize and change their speed and direction, eventually converging into a calmer flow. Where deviation occurs—the place of inconsistency such as the concentric circles between the chaos of freefall and the more organized flow of parallel movement—dynamic processes are connecting with one another and their polarities are briefly reunited. In this case, ripples provide a temporary connection between turbulence and flow. These connector "nodes" give valuable information about how different realities interact.

The circle, as a symbolic "node," is a perfected form of movement. As a curved line, it makes sense as an intermediate between the spirals of turbulence and the more linear roll and turn of calm water. Originating shapes, such as the expanding circles of water ripples or the hexagon of the perfectly structured honeycomb, are symbolic representations captured in a momentary glimpse.

Symbolic visual communication can be viewed as the node of connection that links sender with receiver. These two purposes become relevant to one another in the meaning provided by communication. When the designed communication is authentically organized around the pattern, a connection is made and relationship is possible.

THE RECURSIVE NATURE OF NATURE

On the miniscule scale, cellular, viral and molecular structures are all spherical: the "whole" shape of unity. It is out of the totality of the circle that the parts come. Every cell of our bodies contains the complete genetic imprint to replicate any part of the organism, but the ultimate outcome is determined by external influence. The immense versatility of a basic cell can create a lung, blood or bone function, depending on what is triggered by necessity. As a symbolic shape, the circle also performs the task of mother. In the following chapters you will experience how every shape related to the first ten numbers is birthed through the circle. Wholeness is the essential start of everything else.

DNA has the ability to compress information that can stretch out up to six feet long when unwound from a single cell into three-dimensional space. This ability to fold or unfold into similar patterns through economy of scale is called self-similarity (see more about fractals on page 127). Just as a flat sheet retains its relatively rectangular shape after being folded down over and over again, the cell has the capability to recreate countless refined duplications of itself over generations—all the while coordinating with trillions of other cells in this lifetime to make up the whole organism. Astoundingly simple efficiency: This is the power of what we call the symbol, whether regarded as the natural essence of the universe, or a human method of communication.

As designers, we can learn from a boundless and imminently accessible source: nature. Design that embeds the power of the symbol is a human variation no less relevant than a cell's unfolding into the infinite mystery, a power revered and feared and always subliminally noted by human cultures. As professional creatives, being able to read and understand pattern creates better design. As people living in a world that demands better choices for survival, responding thoughtfully provides an option of choice. A knee-jerk reaction is not a choice. Conscious understanding gives us a platform where we can decide for ourselves what we should or shouldn't do.

Being able to read pattern engages all manner of historical advances that match tool to task—language, for instance. This facility allows the

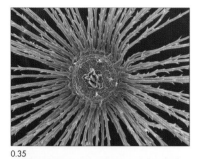

0.35

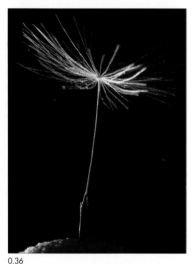

0.36

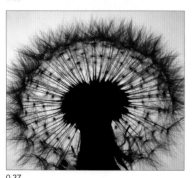

0.37

creation of designed communications that are highly effective in the distraction of the information age. The ability to read pattern underlies our success as a civilized animal.

0.38

In an efficient, compacted bit, a symbol can be unfolded to tell an entire story of relationship. It is indeed the DNA of pattern. It harmonizes information directly related to the pattern in a way that is immediately accessible in a seamless and natural way. An integrated logo containing appropriate symbolism makes a direct connection by being true to what it represents. Designers should take the time to consider pattern and symbol design within a philosophy guided by nature. Only then are they able to refine complexities into an elegant and economical symbol that represents a client's identity by transferring authentic characteristics.

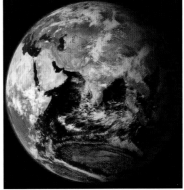
0.39

Figures 0.38, 0.39
Spherical objects in space

As you might imagine, this has ethical implications as well, which are explored in future chapters that look at corporate symbol use. Each symbol's appropriateness is examined, and the company's commitment to sustainable interaction in the world is analyzed. Symbolic design often has traces of intent embedded at subtle levels.

Explore patterns personally. Spend time with them and notice the ones that most appeal to you. What are the natural processes they convey? Are you frequently noticing spirals in different situations and are you yourself in a growth cycle? Or are squares of particular attraction and stability the most important thing in your life right now? What is it in your own personality that connects with that process and makes it so appealing to you? Go to the source: Spend time in nature and start looking for patterns. What does the visual say to you? Let the shape of pattern tell you what it is. This simple exercise of spending time with nature and thinking about pattern will allow you to better recognize your own intuitive intellect and to apply it to design. Reading pattern is not difficult. It is, in fact, very natural.

Now that you have a perspective on how patterns form the world, we will move on to exploring how symbols inform design.

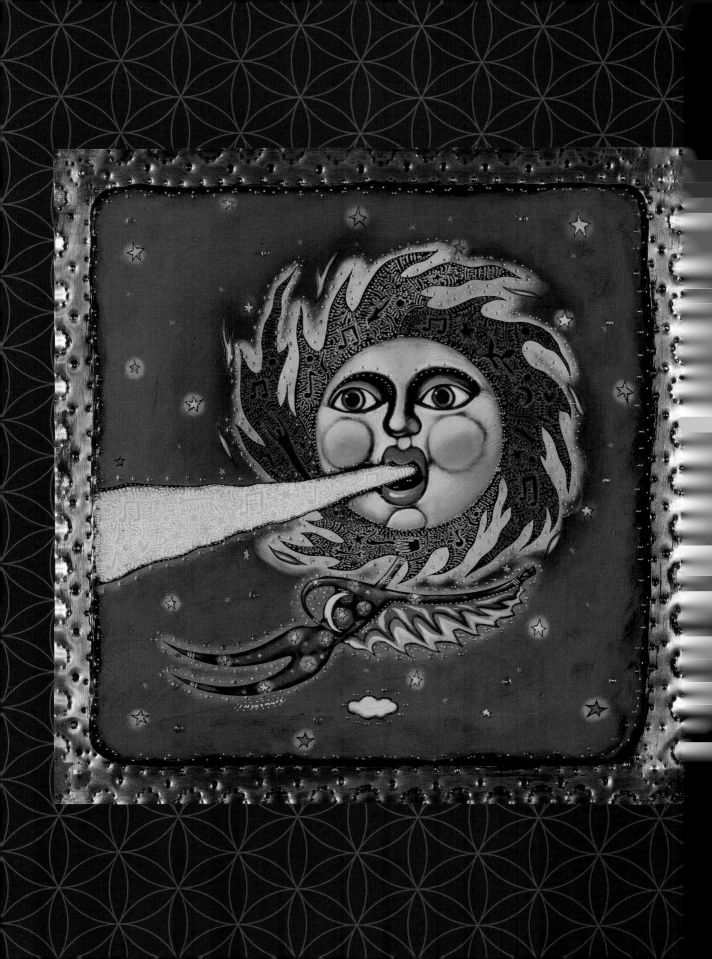

Wholeness

1

The symbolic quality of one is wholeness and completion. Its shape is the circle. But in order to perceive "one," a field of "nothing" is necessary. In many cultures, the circle also represents the concept of "nothing" by its nature of emptiness. And so it is—as with most archetypes—that the symbol of the circle embodies the paradox of both everything and nothing. Though modern culture elevates absolutes to the status of "truth"—such as good and evil, right and wrong, heaven and hell—paradox is the reality of this human life. We must constantly compare and balance opposites to steadily move forward: Light illuminates darkness, autonomy underlies strong connection, life is followed by death. We understand through relationship, which anchors opposites in a common bond. This is why it is so important to us to make meaning—to make sense—in a sometimes senseless world. It brings us back to the ultimate reality of the intimate connection between all things, regardless of how disconnected they may appear on the surface.

In the coming pages, we will begin to experience this inclusive—and yet distinct—quality of symbol and practice its use in a variety of contexts. How fitting that our numbering system begins with the inclusive all, represented by the numeral I. Note that without the contrast of emptiness, "wholeness" has no meaning.

Figure 1.1
Breathing Light Into the Universe
by Joel Nakamura

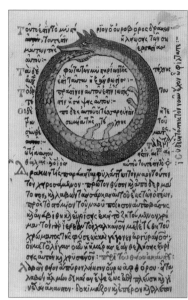

1.2

Figure 1.2
Ouroboros

Humanity has always recognized the whole as a cyclical process, and this symbol is used as the core representation of spiritual manifestation across time and culture. The archetype of a snake eating its tail, called the ouroboros, is a metaphor for the eternal cycles of the self-sustaining nature of organic existence on earth. The German chemist Kekulé dreamt of the symbolic ouroboros when he discovered the basic circular structure of the carbon atom underlying organic nature. This symbol addresses the concept in quite a literal manner: the cyclic process of "life eats life to live." Symbols structurally match their energetic purpose and are repeatedly received by our sensual perception in similar ways. We never tire of them because of their endlessly evolving nature that simultaneously connects us back to our origins while propelling us into the future.

The numbers one and zero are mathematical and shape equivalents that describe the beginning's return to the end in the shape of a circle as the all-inclusive representation of one. The circle also relates emptiness, and is the shape we use to describe zero as the opposite of all. Our world is comprised of opposed qualities that allow us to compare and gauge. Study of the contradictory brings us ever closer to understanding the connections between apparently unrelated aspects, and allows us to facilitate understanding through the use of meaningful associations.

Nothingness provides the ground on which somethingness can occur, and through the distinction of all from nothing, the phenomena of the physical world is defined. This is also the principle upon which the symbolic shape of all is visualized: The circle begins as a point of potential, which has no basis as a real thing, but that expands into endless possibilities. Our circle tool, the compass, demonstrates this expansion of infinity from a defined point. Much in the same way it expands from a zero-dimension point to an infinite amount of points that define the mother circle by surrounding her, our recognition of the inherent existence of the integrated "one with none" opens the opportunity to create infinitely. As the exercise of drawing a perfect circle illustrates, the seed—or starting point—is the source within, while simultaneously being all-encompassing. The energy of "all" can make unlimited transformations, but it is always of the same essential nature, described by the variety of shapes that are contained within it. We will explore its potential to divide and morph into other shape qualities in the coming chapters.

THE PRINCIPLES OF MATH APPLY TO THE PRINCIPLES OF SOUND LOGO DESIGN

Mathematical language is the basis of scientific, computational and geometrical figuring of what we know and experience through our senses. But some mathematical disciplines are philosophical by nature and address what we experience outside of direct relationship. One is topology, used by many current-day physicists to study the connectedness, continuity and compactness of shapes, rather than the linear nature of

their measurement. Topology is used in visualizing universes that we can't experience, as we can't begin to perceive the imperceptible with logic alone. Some geometric problems rely more on the subtleties of connection than on factual measurement. In a similar way, how elements of an identity are related can be as important as the literal "what" of connection. I have altered the three main principles in topology, so they can be used as a model on which to base sound design. Every design should be:

- *Connected*: Convey fundamental aspects of the client in an intuitive and immediate way through the associated principles of a related pattern or symbol.

- *Continuous*: The logo should have enough flexibility to be used successfully in various media and applications. It should read equally well in still or animated applications, and carry seamlessly into different materials. It should retain its integrity in both large and small scales of space. And it should be timeless by being based in substantial rather than stylistic considerations.

- *Economical*: The logo should contain simple symbols that expand their meaning from the core when combined with visual information specific to the client. Simple shouldn't be confused with simplistic, or symbols that are so broad they do not convey meaning.

The decision to commit—to purchase a product or to go out on a second date—is made first at an unconscious level. These three principles set communication apart by transferring a deep level of relatedness that

Figure 1.3
A torus is the product of two circles that intersect from perpendicular angles.

Figure 1.4
Most containers have an inside and an outside. A Klein bottle is a closed surface with no interior and only one surface. It can only be realized in three dimensions with intersecting surfaces, as this wire frame model demonstrates.

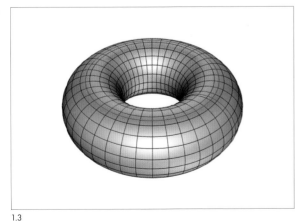

1.3

1.4

Figure 1.5
Moundville, Alabama, Native American
1200–1600 C.E.
In his book *The Mythic Image*, Joseph
Campbell says of this work: "... the
framing pair of rattlesnakes, like those of
the Aztec Calendar Stone ... symbolize
the power binding us to the vortex of
rebirths, and the opposed knots would
stand for the two doors, east and west,
of the ascent and descent, appearances
and disappearances, of all things in the
endless round. Furthermore, the fact that
the eye is at the center of the composi-
tion, would suggest that compassion
is the ultimate sustaining and moving
power of the universe, transcending and
overcoming its pain." He further states
that as we are seeing the hand from
both front and back (note that the artist
deliberately shows the crease line below
the palm, and also the fingernails on the
opposite side of the hand into one com-
posite view), it suggests that this power
of compassion unites opposites.

makes them highly effective to the unconscious. By using these three
principles to describe the client's product or service, you can immediately
communicate who and what the client is. Cleaner and clearer communi-
cation adds value by cutting out distraction. This reserves more energy
for action, which could be the direct action of purchase, or the action of
remembering the message when the need arises later. These strategies
maximize the efficiency of the dollars spent in the same way nature maxi-
mizes energy by being structurally economical. Conservation of either
money or energy creates potential.

There are ethical consequences as well. A communication that is
soundly based in its symbolic conveyance works because it is "true." It fits
like a puzzle piece that imparts valuable information by making reliable,
usable connections.

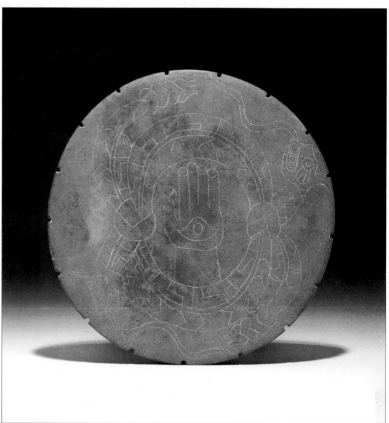

1.5

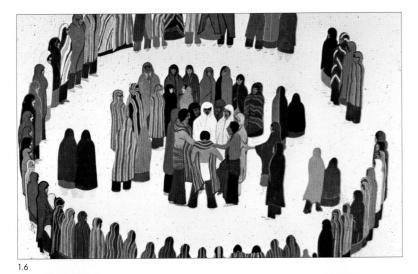

1.6

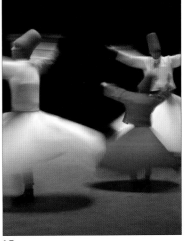

1.7

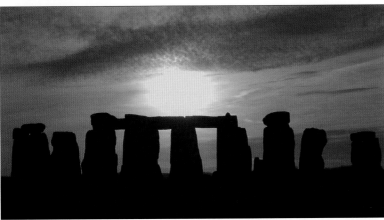

1.8

1.9

Figures 1.6, 1.7
Dance also emulates the cyclical process seen here in the community Taos Pueblo Round Dance (also called the friendship dance), and the Whirling Dervishes, a Sufi sect begun by Rumi in the thirteenth century. The spinning reunites the follower with Allah by abandoning ego and turning toward truth and love, the individual experience of dance as circle.

Figure 1.8
One of the most famous prehistoric sites, Stonehenge was begun in the Neolithic age as a circular ditch with the setting of large stones and other phases added over several millennia. It is disputed as to whether it has a religious or astronomical purpose. Perhaps the ancient people who built this place didn't see much distinction between the two.

Figure 1.9
Aztec Sun Stone, Tenochtitlan, Mexico, c. 1479 C.E.

Figure 1.10
The Buddhist dharma wheel at the Jokhang Temple in Lhasa, Tibet, represents the perfection of the teachings of the Noble Eightfold Path. (See more on the Noble Eightfold Path in Chapter Eight.)

Figure 1.11
Hindus associate the lotus blossom with creation mythology, and Buddhists with releasing desire (beauty floating above the muddy waters of attachment).

Figures 1.12, 1.13
Grandiosity combined with the symbolic meaning of the circle make a powerful impression, used here in both a domed cathedral and a modern shopping mall in Paris.

Figure 1.14
The concentric rings of Saturn. Oscillation is the energy of movement in organic life and otherwise: The whole is circular at every scale.

1.10

1.11

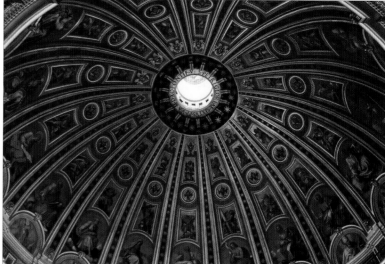
1.12

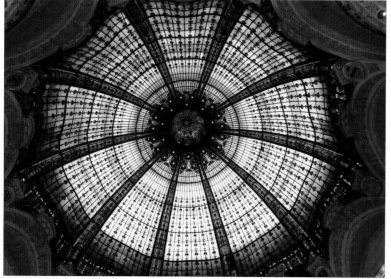
1.13

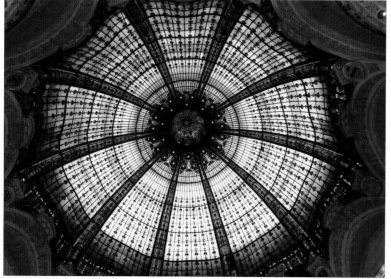
1.14

The First Visible Pattern of Energy

Many cultures have represented the number one as a single line. This addresses its fundamental quantity: a single mark to symbolize a single unit. The circle, on the other hand, is all-inclusive, and precedes the act of separation; this is the originating shape of "all as one." As the beginning number, one needs a symbolic ground on which to exist; one needs emptiness. The circle begins at a point of potential. Using the compass, the center point defines the point of origin for the circle's evolution, just as a pebble tossed into a pond is the origination of the concentric vibrations of energy that move outward from the point of contact. This is a visual pattern of energy. The point has zero dimension, again demonstrating the containment of opposites, or "the empty" inextricably embedded within "the all." As the compass expands beyond itself to complete the circle, you are drawing an infinite amount of points that manifest as a visual curve of "all."

To understand 0 and 1 as symbol, you must let go of thinking of numbers as a simple counting device and explore the universal and symbolic meaning of the numbers themselves. To better comprehend this concept, you need to know something about archetypal symbols—a phrase meaning "original pattern" and coined by Carl Jung, the Swiss psychiatrist and founder of analytical psychology. Most symbols are generally recognized with cultural overlays of human reasoning—such as in religion, philosophy or even folktales—that superimpose a filter of that culture's beliefs over a basic symbol or pattern of universal

Figure 1.15
The Whole (The Circle: One)
The whole is created easily with a compass on paper. This process emulates infinity expanding from a single point of energy, just as we imagine the universe did according to the Big Bang Theory. As is visually obvious, you have just created "all" from an expanding point of emptiness, or zero dimension.

Figure 1.16
The Connection of Points (The Line: Two)
Put your compass point (without changing diameter) on any edge of the mother circle and draw another circle. This creates a clone of the first circle and separates infinity into two pieces. The separation is necessary for a new dimension: that of the line, or one dimension.

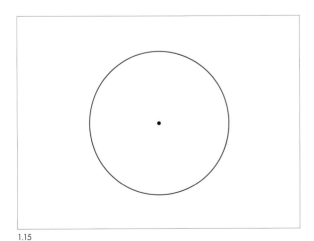

1.15

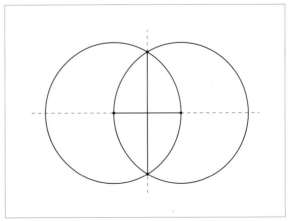

1.16

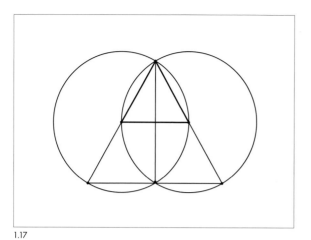

1.17

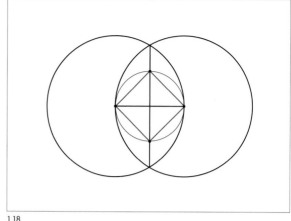

1.18

Figure 1.17
**The Surface of Transformation
(The Triangle: Three)**
A third point creates an opportunity for
closure, and just as the triangular shape
suggests, the beginning of life is funneled
through a broader, less organized dimension
into a point of transformation of refinement
in the next. Now a plane exists in which
an entirely new reality can play out. This is
two-dimensional space, and it provides the
spatial opportunity for form to manifest.

Figure 1.18
Depth (The Square: Four)
The addition of a fourth point brings
depth to the picture: Three-dimensional
space creates the stage for boundless
diversity to play out its existence. Though
difficult to visualize by its nature, time is
the fourth dimension. The shape associ-
ated with time is the spiral, a shape com-
mon to movement in both organic and
inorganic life. It is also the visual construct
of both Einstein's and the Mayan idea of
how time operates. The spiral time system
is by far more precise than our linear
Gregorian calendar (the Mayan calendar
is accurate within seconds every 10,000
years, with the next 10,000 year cycle
beginning December 21, 2012), because
the spiral is the inherent shape of organic
growth in three-dimensional space. A line
comprises the spiral but is just a segment,
merely giving a glimpse of the overview.

nature. Beliefs are opinions or thoughts that help us to organize and
understand what we cannot. They provide agreement within a culture.
If everyone has essentially the same story, it makes moving in one direc-
tion much easier.

In and of itself, there is nothing inherently good or bad about a
symbol. A symbol is a neutral expression of how the universe's energy
exists. However, as sensing beings who feel pleasure and pain, we have an
inborn propensity to assign meanings to align with our cultural beliefs.
For instance, the terms "good" and "bad" are based on an individual
perspective. A circle is neither good nor bad; it simply is. In the same way
we are intelligent enough to break apart and reassemble patterns to indi-
vidualize our reality, we re-slant symbols to create cultural distinctions,
to wreak havoc for political gain, or to enhance corporate profits.

REINVENTING THE WHEEL

Subtle alterations can be used to influence belief and reconstitute the
common meaning of a symbol. The swastika is an example of how
manipulation can radically distort the meaning of a symbol. Traditionally
the swastika had positive associations as a representation of sun-power
on which all life is reliant (see Figures 1.19–1.24). The Third Reich used a
brilliant propaganda scheme to devastate and overwhelm another belief
system through manipulation of the symbol.

The Nazi version of the swastika has intensified the symbol's momentum with a notable 45° rotation, further enhanced with the secondary design elements of shape and color. The shape is surrounded by a circle (the shape that implies containment within the whole), giving an intuitive impression of being complete, acceptable, and having inherent integrity. The right angles of the symbol present a front of indestructible permanence. The color scheme of black, red and white speak to color power: Black, the "non-color," applied to the symbol, masks the intent in darkness and mystery, and is placed on a ground of literally "untouchable" white supremacy. (Ironically, the purity of white breaks down into—and is reconstructed by—all colors of the rainbow.) The red ground echoes the sacrifice of blood. The full impact of the symbolic distortion becomes evident when you deconstruct the logo in light of historical events. It's often easy to see in retrospect, but with a basic understanding of symbols and cultural conditions, the distortion can be seen even while in the eye of the hurricane.

Figure 1.19
A 10,000-armed Buddha holding multiple aspects of reality including the swastika, whose original meaning from Sanskrit approximates "well being."

Figures 1.20, 1.21
Interior and exterior views of the still working Shaffer Hotel, built in the early 1920s in Mountainair, New Mexico. New Mexico was also home to a small coal mining community in the early 1900s called Swastika, renamed Brilliant when the symbol fell out of favor.

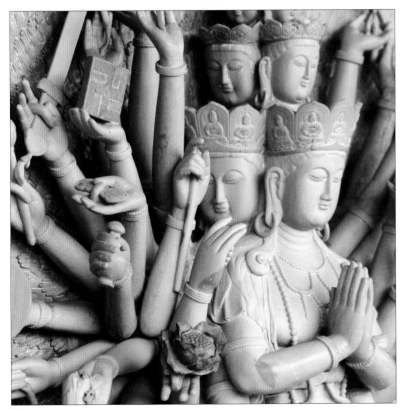

1.19

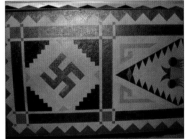

1.20

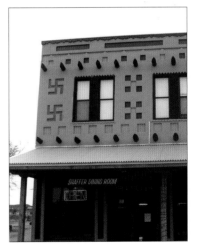

1.21

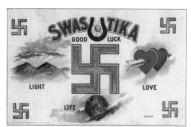
1.22

Figure 1.22
"The Four L's" Postcard, United States,
c. 1907
From the backside of this postcard:
"Good Luck Emblem—The swastika is the
oldest cross and emblem in the world. It
forms a combination of four L's which
stand for Luck, Light, Love and Life. It has
been found in ancient Rome, in excava-
tions of Grecian cities, on Buddhist Idols,
on Chinese coins dated 315 B.C., and
our own Southwest Indians use it as an
amulet. It is claimed that the Mound Build-
ers and Cliff Dwellers of Mexico, Central
America, consider the swastika a charm
to drive away evil and bring good luck,
long life and prosperity to the possessor."

Figure 1.23
This is a yearbook from New Mexico
A&M (now New Mexico State University,
Las Cruces, New Mexico), c. 1936,
from my own collection. My grandfather,
Alexander Jesse MacNab, taught ROTC,
math, physics, track, swimming, and was
the football coach there in the mid-1930s.

Figure 1.24
An Islamic tiled wall incorporating the
swastika with vegetal ornamentation.

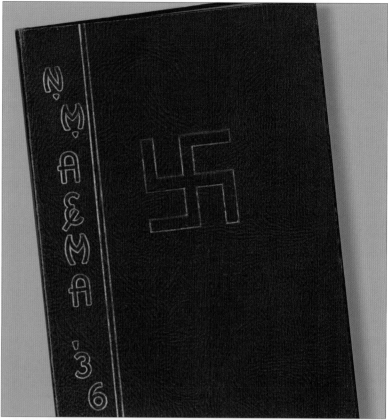
1.23

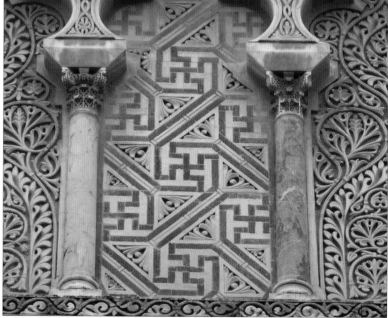
1.24

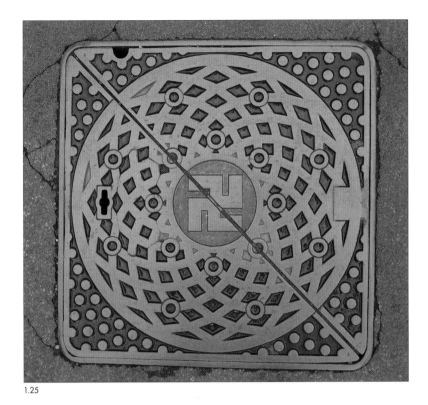

1.25

1.26

Figure 1.25
Manhole cover from Hirosaki, Japan

Figure 1.26
The sunwheel, the genesis of the swastika, has been honored throughout history in monuments: for instance, the circular configuration of Stonehenge or the spiral Sun Dagger at Chaco Canyon, New Mexico. The oldest sunwheels discovered to date are Paleolithic, from around 25,000 years ago.

The four breaks in the circle that create the swastika distinguish the different processes that make up the whole: winter, spring, summer, fall; north, east, south, west; storing, planting, cultivating, harvesting. These could also symbolically "break" night and day. The relatively recent square swastika, now more typical than the circular one, could be indicative of the transformative process of "squaring the circle," or bringing the heavens down to earth for human use. This was literal "geo-metry"—geo (earth); metry (measure)—in context with the cosmos.

The power of a symbol is to illuminate processes that are universal and provide a roadmap for human use. Symbols are tools of understanding, the basis of alchemy. Neither good nor bad, they speak to the essence of energy. How we implement that knowledge resides in free will.

The Sun Symbol

Many ancient cultures were not as unsophisticated as newer generations often like to believe. It was essential to survival to find, follow and note patterns. One of the most crucial patterns to our survival was that made by the sun. Special celestial events, such as the solstice and equinox, were noted as benchmarks of an annual cycle and signaled planting or following herd migrations. Though the sun appears to arc and stop, many cultures had the natural intelligence to know the sun did indeed make a full cycle to the opposite horizon the next morning, and tracked it very accurately throughout the year.

From Expectation Into Experience

To explore the essence of symbol we need to move beyond the expectation of what a number is and experience the shape and meaning of the

form. The circle is representative of both zero and all encompassing, or the whole. Archetypal symbols are ancient enough to contain the integrated opposites of the primordial goulash—a point in time prior to what we currently call the Big Bang—when matter and energy were one. Throughout scales of time and space—the cell prior to division, the Earth floating in the ether of space, cyclical seasons in the container of time—all embody the experience of circular unity as visualized in a cyclical or circular pattern.

An archetypal symbol shares the same meaning for everyone, regardless of the time you live in, your culture, your educational background, your age or the environment you come from. In other words, an eight-year-old Bushman who lived in an African village five hundred years ago and the current leader of a highly developed country will—on a psychological level—relate to an archetypal symbol in the same way, because symbols describe the essence of the human condition. According to Jung, archetypes predate time, and are embedded in our psyche. The energy of an archetype has a profound effect on us, regardless of our conscious recognition of it. They influence our relationship with the world. The circle is the primal archetype and has a symbolic meaning that transcends its role as a zero-digit. It's this sort of symbolic meaning we want to explore and understand as designers: the meanings that we all understand universally, immediately and intuitively.

That which reflects wholeness—or the material world that allows us to see the parts of the whole—can be altered by virtue of its smallest pieces, making it manageable and changeable. As a part of wholeness, our actions affect the whole—or so mystics, and now many physicists, say. Although western logic dislikes contradictions and has no tolerance for mystery, the barefaced truth of simplicity is that wholeness—the simple circle—is a mystery. The English language doesn't have a word for this kind of paradox, but many other cultures do. An ancient Dinka creation myth asks, "What is the what?" The circle is both extraordinarily simple and mysterious. From it all other geometric constructions are born, and it is the symbol we use to represent wholeness, which we have always, throughout time and culture, regarded as holy or sacred.

DECONSTRUCTION OF THE TARGET LOGO

The original Target logo was represented as a literal target design containing a bull's-eye within concentric rings. Bull's-eye is a term for success and implies hitting the mark. It is the purpose of eye/hand games that display coordination skill, and whose roots lie in the ability to bring down prey by throwing a rock, hurling a spear or shooting an arrow. Later associations include a "marked" person—someone who is the aim of an attack, especially a victim of ridicule, exploitation, capture or killing by an adversary (i.e., the target of a manhunt). Psychologically, Target's first logo could be viewed as hostile because of these associations. Although it could indicate a success-driven company, it doesn't represent a value-driven company.

The new Target logo was designed at the peak of flower power culture in the United States. The changes are minimal to the previous design, but the purpose is clear: to be closely aligned to the archetypal symbol of the strength of all for one and one for all, in the encompassing circle around a point. Target had either option available, but made a

Figure 1.27
Original Target logo, 1962

Figure 1.28
The revised, "friendlier" Target logo, 1968

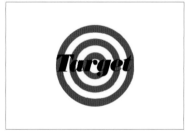

1.27

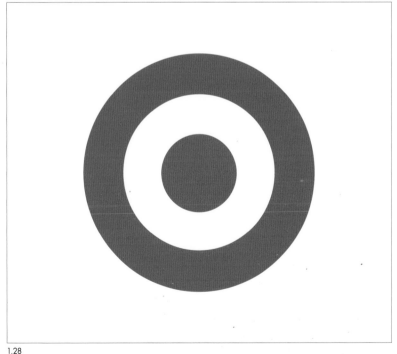

1.28

conscious decision to identify itself as a community supporter rather than a distant corporation.

The revised design speaks directly to our deepest being as a reflection of our oneness with a divine nature and timelessness. This symbol directly reflects Target's philosophical shift to address a cultural concern by embedding values such as contributing to environmental issues, diversity in the workplace with opportunity to advance and commitment to community. Understanding our interdependence on each other and the environment is a reflection that comes out of knowing and honoring the connection we have to everything. The direct association of "separation contained within unity" is visually and simply demonstrated in this design.

The first logo is a literal "target" tied to a visual clip-art-type of reference, making it a externalized, sign-rather-than-symbol logo; the second is a statement that ties the universal principle of unity—a point at the center of a circle—directly to a visual variation of the client's name. The difference between the two is symbolic integration. Target also values inspired individualism as is evidenced in the innovative advertising the company creates.

One for All (And All for One)

Ancient philosophers knew that "one" or "all" is the parent of everything else, an obvious but subtle implication that allows us to see the world with an altered perspective. All numbers contain different qualities of their genesis. Just as Figures 1.15–1.18 show various shapes evolving through the mother circle, a mathematical equation can demonstrate the principle of all single digits evolving from the number one. This is illustrated in a simple but compelling metaphorical equation:

$$(9) \text{ I's} \times (9) \text{ I's} = 12345678987654321$$

or

$$\text{IIIIIIIII} \times \text{IIIIIIIII} = 1\,2\,3\,4\,5\,6\,7\,8\,9\,8\,7\,6\,5\,4\,3\,2\,1$$

Note the numerical sequence of scaling in order from lowest to highest and back down again. All comes from and returns to one, the basis of most religious philosophies.

Any number multiplied or divided by unity also retains its identity. This is because one is the basic component of everything: Wholeness doesn't alter itself or components of itself. The number six, for instance, can be broken down by 2 or 3 (6÷3=2 or 6÷2=3), but 6÷I=6, and 6÷6=I, because it retains its inherent quality when divided by what it is made of—its permeating character.

If absolute oneness exists, how can separation also exist? The monad (from the Greek root word *menein*, "to be stable" and *monas*, "Oneness") generates the "other"—other principles, other shapes, other numbers—by reflection. "The circle replicates a mate for itself by contemplating itself, reflecting its light, and casting its own shadow," says Michael Schneider in *A Beginner's Guide to Constructing the Universe*. A number of origination stories contain this same idea.

"In the beginning there was only Tokpella, endless space." So begins the Hopi myth of emergence. Dawa, or Tawa, a solar deity, puts light into the void and combines it with the elements of that place. With this act, he begins the evolutionary process of creating successively complex worlds through which the people pass on their way to becoming true humans.

1.29

Figure 1.29
Tawa, Hopi Sun God

Symbolic Greek Letterforms

The cap symbol for the Greek letter phi (Ø) is comprised of the intersection of the circle by the line. We use these symbols in Western culture to represent zero and one. The Greek meaning of phi is love and aesthetic. Philosophy is composed of "philo," the Greek word for love, and "sophie," or wisdom … philosophy is the love of wisdom. Phi is also the name given to the golden ratio, or the ratio considered to have the overall most pleasing proportions to us, and is known as the "human" number (see Chapter Five). This Greek letterform shows the interrelatedness of symbol, beginning with encompassing "all" (also known as "love" or "god") and intersected by consciousness symbolized by a logical, penetrating line.

The Beginning and the End

Much as zero and one describe all and nothing, the first and last letters of the Greek alphabet represent the beginning and the end; it is also

where much of Western philosophy is derived. The shape etymology of the alpha, or beginning, of the Greek alphabet is derived from the Phoenician aleph: ⪦ which is clearly pointed and penetrating. The omega: Ω, the last letter of the Greek alphabet, is round and full, literally, "the big O," or "mega circle." This suggests a connection opportunity: The aleph fits snugly inside the omega and creates a cyclic circle out of the interaction between beginning and end.

Separating to Relate

All communication requires the basic use of none and something. There must be nothingness to register something-ness. Using code, the language of technology, based on the binary system of ones and zeros, is the most immediate way to process complex information. Like the universe, it implements the system of off/on, all/none … reciprocal oscillation. It is the most elemental system there is to translate nothing-ness into something-ness.

Like code, language is embedded in human terms. Language is common to all cultures, with some more illustrious than others, such as Egyptian hieroglyphics or Chinese ideograms. Picture-words engage our senses visually. In Western culture, written language must be processed through an abstract string of letters that form words to conjure an image, a more linear-oriented, left-sided operation of our brain. This process engages logical thinking. Either hemisphere—in the brain or on the earth—has distinct perspectives that rely on one another to exist.

THE I CHING

The *I Ching* has underlying implications: It is pronounced *yi* (as an adjective, this word means "simple" or "easy," and as a verb, "to change") *jing* (meaning "enduring," and derived from "regularity" or "persistence"). The main idea is that the fundamental law of form is that the universe is straightforward and simple, the value of form is in continual flux; and even while form is in continual flux, the underlying essence of it is persistent.

The *I Ching* represents a profound observation of the relationship between the behavior of humans and the constantly changing structure of the universe. It is based on the same philosophical system as higher mathematics and quantum physics. There are sixty-four hexagrams (six-line structures) that are made up of two types of lines: yang (strong, unbroken, masculine lines), and yin (broken, yielding, feminine lines). The sixty-four hexagrams present every possible combination of these lines when thrown as coins with corresponding head/tail combinations, six at a time ($2^6 = 64$). Each of the sixty-four hexagrams is accompanied by ancient texts and commentaries. The text refers to sixty-four archetypal human situations along with thousands of variations caused by the changing lines. It is said that the *I Ching* triggers an intuitive, remarkably accurate awareness of the way things actually are at any moment in time, with perspectives on potential options of transformation.

1.30

Figure 1.30
I Ching by Tim Girvin

Models from various methods of communication demonstrate how paradox can be effectively used to discover unanticipated connections. Significant advances have been made in math, philosophy, science and the creative arts by recognizing a paradox that resolves itself in a deeper truth. This also translates in visual communication. To understand the relevance of this, it is important to understand the difference between contradiction and paradox. A contradiction asserts its opposite, whereas a paradox allows for resolution between those opposites. In other words, paradox contains possibility—a very attractive factor to our species—while contradiction does not.

An archetypal symbol—a symbol that unites, separates and reunites again—contains the paradox of our experience that is the basis of a good joke, a sound theology or an effective logo design. This method applied to design encourages the viewer to consciously participate in the design by the simple act of enjoying resolution to a quandary. It's instructive. Logos that are based in archetypal imagery tell a piece of our human story, and engage us in a deep way.

Figure 1.31
An Aesop's Fable: *Androcles and the Lion*

Figure 1.32
Veterinarian logo

THE CIRCULAR PRINCIPLE IN PRACTICAL APPLICATION

I created this veterinarian's logo shortly after going into business for myself in 1981. After some conceptual struggle, a childhood fable came to mind. Here is the basic fable and how I used it to resolve a conceptual problem, and create an iconic logo with a powerful, symbolic message.

One day the slave Androcles escaped from his master and fled to the forest. As he was wandering about, he came upon a lion lying down moaning and groaning. He turned to flee, but noticed that instead of pursuing him, the lion put out his paw, which was swollen and bleeding. A huge thorn was lodged in his foot. He pulled the thorn out and bandaged the paw. In gratitude the lion rose and licked Androcles' hand. In time both Androcles and the lion were captured. The Emperor sentenced the runaway slave to be fed to hungry lions as a spectacle in the coliseum. After several days of starving the wild animals, the day of spectacle came and the lion was released from his cage, ready to feast. But the lion recognized Androcles instantly upon catching his scent and knelt at his feet, licking his hands like a friendly dog. The Emperor, astonished by this, set Androcles and the lion free.

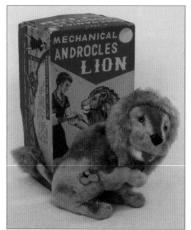

1.31

1.32

This story became the point of departure for the visual integration of paw print and bandage that instantly conveys the fusion of animal, human compassion and medical care. It bridges distinctly different concepts into a common relationship. The use of this fable—which is archetypal—is directly responsible to the success of this design. I drew on what Carl Jung termed "collective unconscious," that is, the ocean of understanding that is fundamental to us at any age, in any culture and without processing. It is a concept so ancient and so evident, it's as automatic as breathing. Compassion unites and heals.

The circle didn't have to be literally incorporated into this design to get the inclusive idea across (though in the pencil roughs, this was used as a template), and is embedded in the circular concept of "what goes around, comes around."

I began working with a concept that I had no intention of showing the client, but the associative process has to start somewhere and there's nothing wrong with starting with a cliché. The magic is in moving beyond the mundane and into inspiration.

This vet specialized exclusively in cats and dogs, so I distilled the underlying message into a fundamental commonality between them. Alone, the paw print is much too generalized and doesn't address the caretaking aspect of veterinary services, but it was intrinsic to the simplicity that makes this design a success.

Seamless integration of these two simple messages created a specific relatedness within the symbol and between the symbol and the viewer. In almost any culture and nearly any era, this symbol would connect humans in the care of animals.

The ultimate moral of this story is that anyone can access personal experience and incorporate it effectively in a way common to us all. Nearly twenty-five years later, the logo is still in active use. It was awarded the National ADDY from the American Advertising Federation in 1983 for logo design and was honored in many design annuals.

1.33

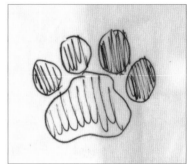
1.34

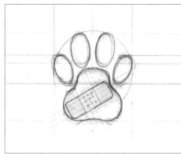
1.35

Figures 1.33, 1.34, 1.35
Veterinarian logo development

Case Studies Based on

Designers:
Michael Bierut and Esther Bridavsky

Art Director:
Paula Scher

Design Firm:
Pentagram U.S.

Location:
New York City, New York

Fashion Center

"The Fashion Center comprises 175,000 designers, manufacturers, stylists, models, wholesalers and retailers who are located in midtown Manhattan. The Garment District had no real geographic or architectural center, and Pentagram extended the design into a structure identified by a huge polyester resin button held in place on its roof by a giant stainless steel needle. The kiosk puts fashion industry information out on the street instead of hidden inside a building, and gives the visitor a sense of having arrived at the center of the fashion universe."

—Pentagram

Chronotime

Chronotime is a product line of Cellini, a major retailer of Swiss watches and jewelry in Romania. Wanting to imply the use of the sun as a time-tracking device, Frison incorporated this visual of the circle being divided by the intersection of the horizon. Time intersected by space is the basis of conscious understanding.

Designer:
Simon Frison

Design Firm:
Gavrila & Asociatii

Location:
Bucharest, Romania

"Chronotime" logo, property of Chronotime International

Collaborative Conservation Network

This logo shows three primary elements: human, animal and plant. But the idea of integrated harmony is forefront with wholeness and balance. We often don't see what is right in front of us; it's a matter of shifting perspective. You can see Ford was on track from the beginning with his conceptual sketches. The trick is to integrate several smaller concepts into the larger whole.

Designer:
Ryan Ford

Location:
Huntington Beach, California

© Collaborative Conservation Network

Designer:
Mark Fox

Design Firm:
BlackDog

Location:
San Francisco, California

Wild Brain

Vision comes from sensual reception, and vision is the primary sense from which we receive information. Mark's correlation between the client's name and how this sense impacts our mind is a delightful visual pun. There's absolutely no reason to not have fun with your work.

GoFlex Tupperware

Retaining the wholesomeness of food is simply and clearly defined in this identity. The circle is reinvented as the integral element for print, web and the utilitarian product.

Designer:
Joseph Foo
Design Firm:
3nity Design
Location:
Petaling Jaya, Malaysia

Designer:
Woody Pirtle

Design Firm:
Pirtle Design

Location:
New Paltz, New York

Dallas Opera

"The symbol for The Dallas Opera Company is an attempt to visually suggest the properties that one associates with opera—refinement, elegance, beauty, precision, harmony, robustness and a whole string of other words that help define the medium. Before I left the first briefing meeting, I had decided that whatever I was going to do would be in some form of Spenserian script. The extreme contrast of thick and thin, the fluid lines, sensuous curves and refined quality, would be an immediate visual link to the sensibilities of the opera experience. As I began to work with the initials, it occurred to me that a seamless connection of the D and O would further allude to the medium, reflecting the blending of complementary voices. Through hours of trial and error to refine the relationship between the letters—and redrawing the combination countless times to perfect it—the highly refined Dallas Opera monogram emerged."

—Woody Pirtle

The Gardens Shop

"The Gardens Shop was a brand that went onto all products sold at the main gate shop of the Royal Botanical Gardens Melbourne, one of only six Royal Gardens in the world," says David Lancashire. Complexity contained within the simplicity of the whole is beautifully illustrated in this design.

Designer:
David Lancashire

Design Firm:
David Lancashire Design

Location:
Victoria, Australia

The Universe of Reflection

2

Just as the number one suggests unity by its shape, the number two suggests separation and the compelling desire to return to wholeness. Duality is about opposites: individual/community, assertive/passive, intense/bland, logical/intuitive, creative/practical, energy/form. Duality creates conflict and conflict seeks resolution. A story has to have opposition between characters to shape the action of the plot. In the same way, a design that integrates duality creates something dynamic; a relationship that can only be distinguished by the tension or edge between two opposing forces.

Energy is continuous and without form, and must separate from the infinite in order to manifest. Indeed, the fundamental characteristic of life is the ability to distinguish itself from the whole as "other." Life contains separation at its most fundamental level of physical existence, as a dividing cell, and carries this principle of duality throughout the living process. Life also naturally gravitates toward return and resolution. Independence, or moving away from the whole; and intimacy, the return to it, are alternating experiences of life.

The reproductive process follows this pattern. The feminine principles of darkness, chaos and mystery are made tangible by the infusion

Figure 2.1
Juxtaposed Vibrations by Joel Nakamura

Figure 2.2

Cell division. The process of being
begins with dividing, just as energy must
separate from matter to enter into exis-
tence. But dividing is only half of the story.
We must reintegrate to fully become.

of masculine light, order and knowledge. Male/female polarities unite to
fertilize an egg that subsequently divides; those cells multiply into bil-
lions more to create a newly integrated physical force; separation occurs
again from the mother at birth; and the family unit is bound together
until the young go out on their own, find a mate and continue the cycle.
Coming into being emulates this process in many life forms, from the
human spirit actualized as embryo, to the universe as a point of energy
in our current theory of the Big Bang.

Dividing is Only Half the Story

We begin life as a single cell infused with new genetic information
that splits and expands into independence and possibility. Separa-
tion provides the distance necessary for reflection. And as difficult as
separation can be at times, the tension of duality is necessary to assess
where we are in relation to the rest of the universe. Carl Jung believed
that a human being is whole, but that most of us have lost touch with
important parts of our core. Declaring ourselves independent is only
part of the journey. Jung took the idea of disintegration one step
further by bringing it full circle as "individuation," a concept that
addresses the separation and reintegration of the individual in a cycli-
cal metamorphosis that continues throughout life. It does this by con-
tinually integrating what we learn as individuals back into the whole
experience of our lives.

2.2

Individuation cannot occur without the ability to reflect and rein-
tegrate. If we realize, accept and express our uniqueness, we can con-
nect to our true self. Each human being has an individual calling, what
Jung's friend and peer Joseph Campbell referred to as "following one's
bliss." If the union between consciousness and unconsciousness is unful-
filled, the individual—or culture—becomes dysfunctional and sick. It
is our great love to share ourselves with others. When we cannot, the
whole of our experience becomes a negative feedback loop that doesn't
have (or give) the benefit of expression. Design is this expression of shar-
ing a part to connect into a greater whole.

Jungian Individuation as Creative Process

From the moment we are separated from our mother at birth—and throughout the life cycle—priorities are continually reassessed as we encounter milestones of personal development. The journey of the individuation process is a common human yearning, but not all of us commit to getting there. Becoming fully ourselves—integrating our experiences into who we are at our core—is the goal of individuation. This process allows us to contribute our unique perspective to the collective.

Figure 2.3
Yin Yang Jung by Maggie Macnab

2.3

The world is rich with fragments of symbolic information that connect us to the heart of its truth. This is the beauty of acknowledging the symbolism of nature. Both design and life are creative pursuits. We are continuously given opportunities to understand our world by experiencing its nuance through the language of symbols. Uncovering subtle connections just below the surface makes for better design—and the ability to understand is an important influence for a better world.

2.4

Figure 2.4
Yin Yang Boy, drawn by my son Evan at about 2½ years of age—the same time he was separating his identity from mine. From the inside out, continuing to define ourselves as distinct from "other" is natural. This is a necessary part of evolution and growth, but we cannot completely disconnect from our source—nature—without severing the lifeline.

A newborn infant is whole without cultural or family conditioning—and comes into the world complete. He exists in the world without ego, simply as "Self." As a child becomes integrated into the world, consciousness develops. Awareness of another makes him aware of self—and of the separation between the two. Children begin to draw shapes at about the same time they develop this consciousness. No longer in a state of wholeness because they have recognized separation, they can objectify and describe wholeness as a visual symbol. The initial shape they draw is usually a circle, the symbol of primal oneness. Symbolizing requires an objectified perspective to initiate the process of understanding and altering reality. It allows us to break apart concepts and reconstitute them at will. The human ability to conceptualize and re-form through conscious thought has shaped our species by creating everything we use, from pencils to language. All human inventions are derived from thinking them into existence with symbolic dexterity.

In life we must have the courage to be who we are, often without knowing who that is or how others will respond. Design, as an art form, follows life. Tossing the template takes courage, but there is the potential to produce work that communicates far more effectively across time and culture. (Though, with global immediacy an increasingly important consideration in all forms of communication, it is essential that we understand how a design will play in other cultures, as well as how it connects with the larger picture.) Symbolic design engages its audience by fitting known concepts in unexpected ways. A perspective that ties the new to old, and the individual to the universal, addresses the substance of existence. It never goes out of style. A new perspective on a timeless theme is what enduring and effective design is all about. Individuation is, in a sense, a new way to experience old information: as a conscious individual who is having a "new" experience via the ageless theme of the human condition. Simplicity coupled with depth communicates on many levels.

JUNGIAN TERMS REVISITED
FROM A DESIGN PERSPECTIVE

Personal and Collective Unconscious

Personal and *collective* are two levels of the unconscious. The personal unconscious consists of everything we experience throughout our life and is what makes us who we are. This is much like specific information about the client: who, what, where, their distinctions and similarities. Most of this may be superficially obvious, but some may be uncovered in the discovery process.

The collective unconscious consists of humanity's universal and archetypically shared experiences. Embedding a symbolically relevant principle into a client's identity creates a background framework into which specifics can be woven.

Integrating the personal unconscious into the broader collective unconscious in symbolic form creates a bridge of commonality that is relevant to the viewer. When you incorporate both specific and universal information into a visual communication, you anchor the visual of who the client is and how they fit into the whole. This separates your communication from advertising noise by providing an immediate story in a symbol—and it influences the viewer to participate actively with a purchase, or passively by recalling who the client is. In short, they "get it" by matching it to information they already know through experience. This allows consciousness to grasp and hold the design and the communication effectively and efficiently. This economical approach of nature can be applied to design.

The Persona

The persona is what we present to the outside world—something like a mask. The equivalent is the projected image of a company. A company's image should be consistent with their identity. Find, tell and adhere to the truth of your client in order to project that image.

The Ego

The ego is the most overt part, the focus. This can be a company's hook of an identity—a slogan or visual—that catches your attention. It's not the substance, but a stylistic addition that should complement, accentuate and extend the core principles.

The Shadow

Underneath the superficial shell of the persona is what lives below it, hidden in the shadows. Each of us has a shadow; so do clients and professions. In order to do a good job on the design, it is important to know all aspects of your client, even their weaknesses. Acknowledge or resolve what is considered less desirable and move forward with integrity.

Anima and Animus

Anima and animus refer to the gender leanings of a personality and likewise to an organization's dominant presence of being soft or hard. There are outward, masculine-oriented companies—for example, those within the technology industry—that convey an animus presence, just as there are lower-key, more anima-principled organizations, such as many of the nonprofits. And there are androgynously balanced organizations. But just as soft doesn't necessarily mean effeminate, neither does hard necessarily mean aggressive. The balance of these two aspects (with a dominant approach when appropriate) captures the essential presentation of an identity. Access to the intuitive message should always be seamless, even if the target market has a definite gender preference in the identity.

The Self

This is the center and totality around which all other aspects orbit ... the gravity that holds it all together, the symbolic form that conveys the essence of your client. Initiate the core in the spirit of wholeness, and you will have created an identity that can expand and contract as needed. A logo designed in this way breathes life into the organization by implementing principles we all experience by having the flexibility to address change in a company's evolution. The logo is the seed from

Decoding Design

which the brand grows by channeling appropriately integrated symbolism that cleanly and clearly communicates essential qualities. These qualities provide a sound basis from which more extensive and compatible communications can be developed.

An Archetype of Two

The yin yang symbol demonstrates opposed balance within the mold of the original archetype, the circular "one." By its inherent nature, positive and negative space give a solid case to what appears to be impossible to reconcile; what we call opposites. These opposites are held in balanced stasis, along with traces of the opposing mate. Within each space, the seed of the other is contained in the center of its opposite: The white "yang" contains the black seed of the feminine-principled "yin," and vice versa. Opposites are more alike than they appear. In fact, they wrestle over the same boundary—the edge of separation.

The essence of the yin yang symbol is the other being carried over in seed form from the opposite, just as *two* is contained within the originating mother circle of the *one*. This is the oscillation of nature and the nature of oscillation: First you look at the negative, then the positive, then the negative, back to the positive; you see the two; you see the one. It forces you to shift your eyes, and therefore your brain, in a dance that reflects this rhythmic principle of the universe. The principle of separation is the first act of becoming, the first venture into the illusion of "separate."

Create a Vesica Piscis

In logo design, symbolic connections provide simple but meaningful associations. Let's look at how this works in the geometric construction of the vesica piscis, common in Western culture as art, architecture, religion and design.

Draw a mother circle, either by hand with a compass, or with a computer drawing program using the shift+option commands to draw from the center out (either way, the center point will reference the point of

Figure 2.5
The construction of the vesica piscis.

2.5

origin). Now on any edge of that circle, place the point of your compass without changing dimension and draw another circle. On a computer, copy (command+option+shift) and drag so that the edge of the second circle is on the center point of the mother circle. The almond shape in the center created by the overlap is called the mandorla and is associated with halos and auras, or the energetic perfection that emanates from a holy/whole being. It is seen commonly in religious icons, such as surrounding the Virgin de Guadalupe.

Now draw vertical and horizontal lines that join the circles' intersections and center points. You have just created multiplication from division—again, the inherent nature of the archetype to reconcile opposites. The cross is the symbol of Western spirituality and it is derived here, at the origin of separating matter from energy to create endless possibility through duplication.

DECONSTRUCTION OF THE MASTERCARD LOGO

The MasterCard logo is an example of the symbolic use of the number two. The genesis of credit cards began in the late 1940s when banks started to issue special papers that could be used as cash in local stores. Over the next decade, several franchises evolved from this concept, one of which was the Interbank Card Association in 1966, which became Master Charge, and later MasterCard. The first Japanese partners joined in 1968, and in 1969 a new logo was introduced consisting of two overlapped circles. The two circles represent the overlap of commerce between international powers, in particular, the East and West. Associations that could be made with this symbolism are the Japanese flag carrying the red circle, and the golden circle as the power of the "sun" of the "golden" West—the land of opportunity and highest attainment in current history. By using two overlapping circles to indicate the two opposite spheres of the world—East and West—the logo indicates that these opposites come together and find resolution through the spending power of MasterCard. By using the vesica piscis, a visual statement is made that shows the power of duality in the seeking of unity. Two overlapped circles indicate the interaction between customer and credit card to generate the third objective: the outcome of dollar numbers, demonstrated by the mandorla shape in the center.

Figure 2.6
Current MasterCard logo

Figure 2.7
Original Interbank logo, 1966

Figure 2.8
MasterCard Worldwide logo, 2002

2.6

2.7

2.8

Recently, MasterCard designed a separate logo to represent the "MasterCard Worldwide" market. According to MasterCard public relations, "international" is now considered an antiquated term, while "worldwide" conveys a more global model because of its World Wide Web association. The three circles of the new corporate logo build on the familiar interlocking red and yellow circles of the MasterCard consumer brand to "reflect the company's unique, three-tiered business model as a franchisor, processor and advisor," says the MasterCard marketing division. However, what stands out by far is the off-center emphasis on the golden circle, which could be interpreted to indicate the power is not equally distributed but resides with the golden origination in the western hemisphere. The primary shareholders, JPMorgan, Chase, Citigroup and Bank of America, are of Western origin. Clues like this give emphasis (in this case about energy or power) often as a strategic move, but are not always intentional.

This particular identity is no dramatic feat of design aesthetic, but it demonstrates what can be discerned in logo deconstruction. Hints at power play, or where the energy is focused, can be found within the symbolically related messages.

The Extension of Two Into Western Thought

A circle initiates all other shapes through its own duplication. The point, from which the circle is derived, has zero dimension. There can be no manifestation without separation. Polarity is the principle of the next digit: two. The line, or connection of two points, is one dimension. The poles, while repulsed in their division, are attracted back to one another—the paradox of this principle. Within the archetype of two lives the visual expression of this paradox: A line both joins and separates. Archetypes often contain opposites because they address the original wholeness of energy and form being bound together.

Wholeness recreates itself by reflecting itself as "other." As described earlier, two overlapped circles symbolize the vesica piscis. The intersection of these two circles creates an almond shape called the mandorla. This shape has fascinated artists, architects, mystics and mythmakers for

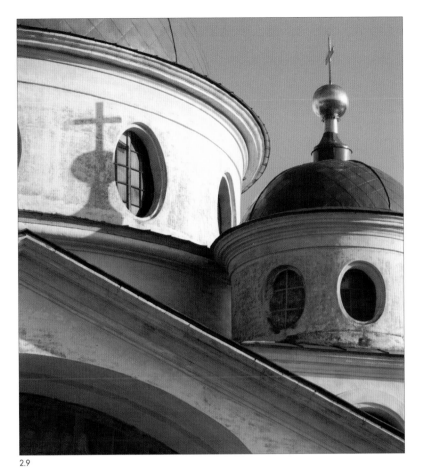

2.9

2.10

2.11

centuries. The shape is reminiscent of the female generative organs and therefore symbolic of creation, which is in fact what the overlap of two does by creating a third separate entity. It expresses the principle of duality from a Western perspective, which has a very different approach from the Eastern symbolic representation.

Western thought tends to perceive existence as a sequential and linear process: One thing is clearly linked to the next thing. We qualify life as a noun and this approach dominates the way we have interpreted the universe. The philosophy of this idea dates back to the Indians and Greeks in the fifth and sixth centuries B.C.E., who recognized atoms conceptually (from the Greek *atomos*, or uncuttable), and was lost until the Renaissance rekindled interest in exploring natural source. Classical mechanics, the theoretical basis of science for the last several hundred years, is based on this logical order to the universe that began and

Figure 2.9
The Rostov Kremlin, located in one of the oldest Russian townships, displays a Christian cross.

Figure 2.10
Yin yang: The seed of polarity is contained within each.

Figure 2.11
The ancient Celtic cross (this one from the Scottish highlands) shows a hybrid symbol that includes the inclusive and separate nature of circle and line.

Ancient origins are ambiguous, but this symbol expresses early Christianity combining with pagan beliefs as a symbolic transitioning strategy.

ended at the atom as the basic building block. But in the 1930s, the discovery of the neutron and fission made it necessary to acknowledge an entirely new universe. For the last four hundred years or so, westerners have perceived the world through a lens of logical sequence. It follows that we see the process of reflection as the linear movement of a literal object: The circle is changed in position by being moved laterally one half the width of the mother circle. Connecting the points of intersection and center create the intersecting lines of the cross, the common symbol for Western spirituality.

Eastern philosophy approaches the same principle from a very different perspective: from one of scale. Two half-sized circles are contained as a perfect fit within the mother circle. It's also a perfect fit philosophically as paradox is accepted as a necessary part of worldly experience in Eastern culture. Two half circles coexist peaceably within the whole to create an undulating duality—an oscillation. This agrees with the Eastern philosophical approach of life as movement and change; or as a verb.

As Western thought defaults to linear and logical progressions, is it any wonder our thought pattern chose the intersection of lines to illustrate the same principle? Western culture has traditionally been far less tolerant of inconclusiveness and mystery. We have created scientific, religious and philosophical attitudes that demand absolutes: empirical evidence, heaven and hell, and individuals as separate from the whole, the basis of our business and political structures. It is a natural symbolic fit that the linear cross became the dominant religious symbol in Western culture and the weaving yin yang became symbolic of Eastern philosophy and spirituality.

Eastern philosophy duplicates the mother circle within itself by half its *size*, whereas Western philosophy duplicates the mother circle outside of itself by a half-slide linear *position*. These implications directly address the Western propensity of an externalized and literal 1:1 thought pattern, while Eastern philosophy leans toward a more internalized, inclusive and scaling philosophy that flexes to accommodate what we do not or cannot know. These nuances are almost invisible, but when you understand the visual associations, this is vital information for creating design that speaks at the intuitive level of cultural preference.

THE FISH AS A RELIGIOUS ICON

This fish-formed center of Christian art symbolizes Christ as the fish—the joiner of heaven and earth. This was a dominant geometric design of religious art and architecture during this period. The Christ is being "birthed" through the mother mandorla, the overlap between the two circles and a shape very much like the female sex, typical for this period in art and architecture. As patriarchal religion supplanted the ancient goddess religions, this image makes perfect sense. Belief structuring can become visible through reading its symbolism. How we think is predicated on what we know: Our experience of life is born of one plus other, and all beliefs contain symbolic representations of opposition that generate dynamic movement. Movement is a prerequisite of life and opposition gets it moving.

This period of time implemented the "fish" graphic extensively as a religious icon. In cosmic-evolutionary terms, this was also the Piscean Age. The era was characterized as the formal embodiment of spiritual manifestation: The word becomes flesh. Not coincidentally, the astrological symbol for Pisces is a section of the vesica piscis in the process of division:)(.

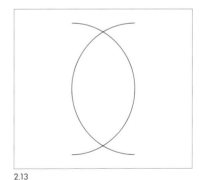

2.13

2.12

Figure 2.14
Codex from the Badische Landesbiblio-
thek, Karlsruhe, Germany, c. 1220

A common universal principle often permeates human history as a
symbolic shape. It must manifest before it can be transformed, creating an
intimate link to human evolution. Taking the time to consciously integrate
what we intuitively sense gives great depth to understanding our experi-
ence of life, as well as to designed communications that engage the most
fundamental aspects of our humanity.

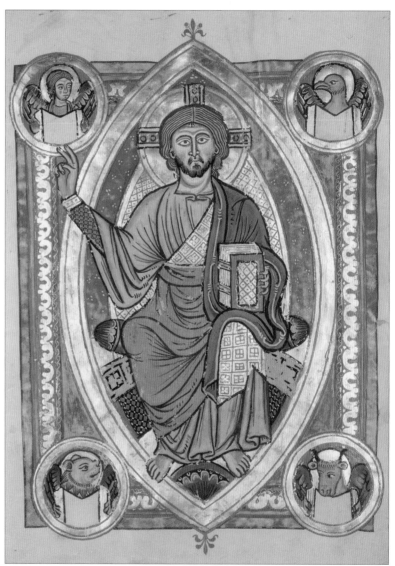

2.14

Construction of the Yin Yang

The construction of the yin yang symbol is sometimes done as a meditation on the nature of reality from an Eastern point of view.

The half sized circles' diameters are equivalent to the circumference of the whole when added together, regardless of how many times it is halved. This dividing and multiplying process continues on, ad infinitum,

Figures 2.15, 2.16, 2.17, 2.18
Redrawn from *Sacred Geometry: Philosophy & Practice* by Robert Lawlor

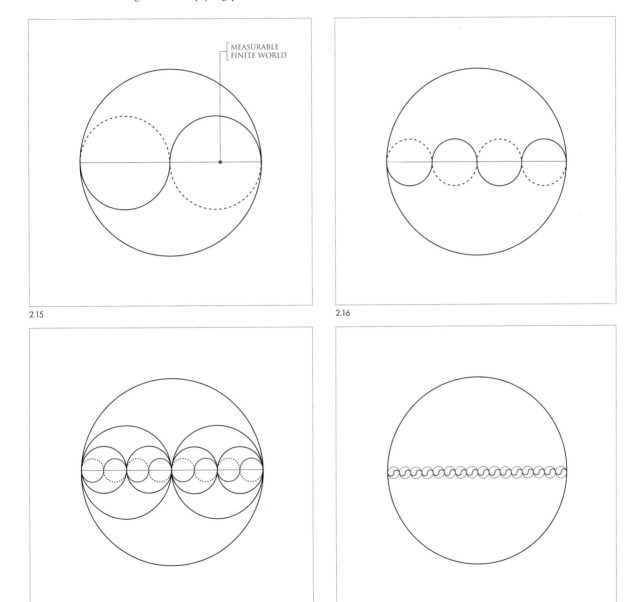

MEASURABLE FINITE WORLD

2.15

2.16

2.17

2.18

2.19

until the daughter circles begin to visibly flatten as the wave approaches the line of the diameter. Paraphrasing Robert Lawlor in *Sacred Geometry: Philosophy & Practice*, the paradox of the diameter becoming equal to the circumference of the same circle illustrates that at the origin and end, all differentiation merges toward unity. Alternation is the visible pattern of growth extending itself into dimensional space, while at the same time being bound into the loop of infinity of all as one.

The Duality Principle in Practical Application

The Arabian horse logo is a variation on the ancient yin yang symbol that represents the intrinsic role of inclusiveness in the universe. This related the farm's involvement with breeding mares and stallions. The shape also visually supports the signature arch of the breed's neck and dish face, creating a multi-metaphoric, yet very simple symbol. This is an example of integrating client-specific information to a universal symbol that lets intuition fill in the blanks.

Figure 2.19
Sacred Sexuality
A god and a goddess embrace in a moment of intimacy expressing the ultimate of the Absolute. Beyond the act of recreation, the sacred marriage serves as a symbol of the soul's longing to be reunited with the divine, or to become whole again. Sacred sexuality is part of many archaic cultures. As with anything, the sacred becomes profane when separated from the "all," or any culture's version of "god." The word profane, from the Latin, literally means *pro*: "separate from," and *fane*, from fanum, meaning "temple." To be profane is to separate from the holy, or whole, place of god.

Figure 2.20
Using the intuitive principles of "all/none" of the yin yang symbol, I created this logo, which has been recognized internationally in publication and with awards.

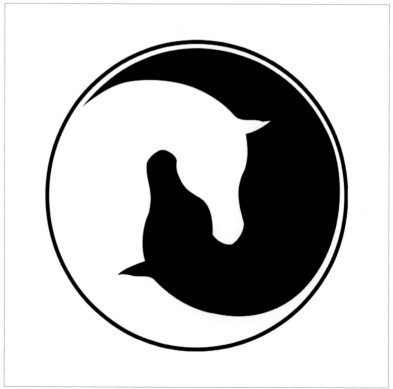

2.20

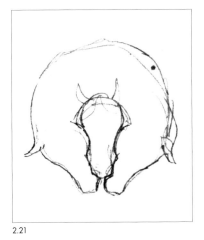

2.21

2.22

2.23

2.24

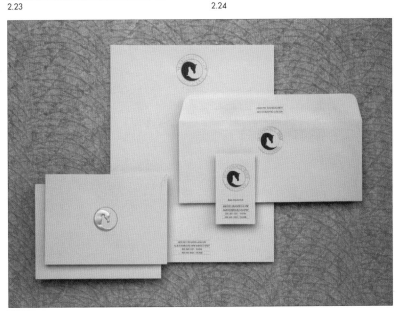

2.25

Figure 2.21

I began by working with the general shape of an Arabian horse. I focused on the most distinguishing characteristics of the breed: the elegantly arched neck and dished face.

But there was something else that was crucial to express. We have a long-standing relationship with horses for a reason: They played a key role in human development. Much of monumental civilization was built on horsepower, and nomadic horseback riders accelerated the spread of ideologies. (My own life-long love of horses certainly was a part of it as well.) I concentrated on how to visually convey a deep respect and relatedness with this animal.

Figure 2.22

Play is very important in discovery: You have to experiment without an expected result. The interaction with the visual led me into the negative/positive area, which in turn led to the final design.

Figure 2.23, 2.24

I discover the fit and it's a short jump to the yin-yang circle of perfection.

Figure 2.25

Here is the final stationery package for the client. The stationery has a foil emboss and a flatstamp and uses one Pantone ink.

Case Studies Based on

Designer:
Fredrik Lewander

Design Firm:
Redmanwalking

Location:
Stockholm, Sweden

Broman Odell

"Tackle business owners Johan Broman and Mikael Odell wanted to combine their lifelong knowledge of fishing and tackle design into one brand. I wanted to make a connection between the letters B and O. It's practical to have a hint of the name in the company's symbol … and the shape of the half circle kept coming up."

—Fredrik Lewander

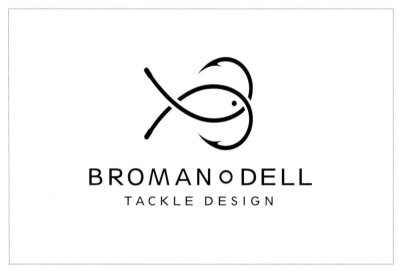

Experimenting further with the circles, the overlap was the next step that created the mandorla—the center of the vesica piscis. Fredrik developed the obvious dual hook/fish in the half circles. The visual story in the form of a symbol fell into place. In the lower right of his conceptual development, he even experimented with a yantra, the visual equivalent of a mantra. This repeating geometric design creates a visual pattern from the center outward that is used in the meditation on the connectedness of everything.

Human Worldwide

Designer:
Paul Driver

Managing Director:
Steven Lucker

Design Firm:
Social UK

Location:
London, England

"The bulk of the time spent on this international music and sound design collaborative was in the creation of a name. Human was selected based on the individuals who would be making up the company, but also as a comment that so much music is created using computers—yet human talent and passion remain the key to its success. Once the name was approved, we looked at interesting ways of manipulating fonts to suggest something 'human.' A clever typographic tweak lent itself perfectly to the creation of the sperm shape. We wanted a clean and minimal—almost clinical—finish to offset the name."

—Steven Lucker

The simplicity of the black and white color scheme, the sperm shape entering the center of the lowercase "a," and the tension set up between name and image all instill the visually economical impact of duality in this design—not to mention the literal association of the sperm entering the egg to begin the first stage of life development.

Designer:
Luba Lukova

Location:
Long Island City, New York

Three Posters

These posters, designed and illustrated by Luba Lukova, demonstrate the separation of duality and the yearning for a return to wholeness.

Romeo & Juliet

"This is a poster for a production of the classical play at the Ahmanson Theatre in Los Angeles. I was told that the director would be Sir Peter Hall, the founder of the Royal Shakespeare Company in London. I had worked with Sir Peter Hall in the past, designing a poster for another of his Shakespeare productions. His depth of knowledge and understanding of visual art was impressive, so I was expecting a lengthy process of approval. I started working on the sketches and I did many. I always enjoy that process of immersing in the play and finding that hidden symbol which carries the essence of the complex text. After doing some forty drawings, I came up with the idea of two hands separated by a sword. I thought the image might work and decided to show only this one to the company. This was a risky approach because the client could have denied the idea without seeing anything else to compare with. But I took the chance, feeling that the image had an expressive power that would speak for itself. It was approved right away."

—Luba Lukova

Peace

"The image for the poster *Peace* was first published on the cover of *Boston Review* in an issue devoted to the contradiction of war and peace. A year later the United States became involved in the Balkan conflict and the image was reproduced as a black/white illustration for an Op-Ed article in *The New York Times*. After the publication in the newspaper, an antiwar organization approached me and asked me to design a poster with the same image. For the poster design I replaced the black background with an innocent blue color to emphasize the irony and added the handwritten 'peace.' I sketched several drawings of doves and chose a simple silhouette that would allow me to fill it with smaller shapes. I thought that this was an appropriate idea after

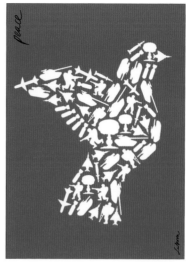

reading the articles in *Boston Review*. There was a quote of the Roman proverb: 'If you want peace, prepare for war.' I wanted the image to carry that controversy, to ask a disturbing question, and yet still be hopeful. U.S. Senator Dianne Feinstein saw the poster and wrote to me commending the work on behalf of the Unites States Senate 'for sharing a positive message.'"

<div align="right">

—Luba Lukova

</div>

Eco Crime

"This image was first published in *Nozone* (an underground comic book) in a group of four full-page illustrations that I called the Crime series. In a symbolic way each image represents a different crime. Later on the illustrations were enlarged and utilized as posters. The *Eco Crime* poster speaks on how, by destroying nature, we actually destroy ourselves. I had the idea for this image years ago back when I was still an art student in Bulgaria. When I was asked by *Nozone* to create the series I redrew the picture from memory. The poster was done entirely by hand with brush and tempera paint. I was looking for a warm, human look so I painted on a board with a rough texture. When the poster was printed, the silk screen was about four times larger than the original art. The natural blemishes of the painting become even more pronounced, a desired effect to emphasize with a dramatic impact."

—Luba Lukova

Designer:
John Langdon

Location:
Philadelphia, Pennsylvania

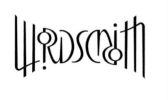

Ambigrams

Letterform can also show the principle of reflection, as seen in these ambigram designs by John Langdon. Ambigrams read the same when rotated 180°.

Wordsmith

"The Wordsmith ambigram was done for a client, Wordsmith.org, who puts out a daily e-mail to subscribers called 'A Word A Day.'"

—John Langdon

Aerosmith

"Dan Brown had been an Aerosmith fan for years when he met Steven Tyler in the [New England] Patriot's owners box at an AFC Championship game a few years ago. Tyler told Dan how much he enjoyed *Angels & Demons*, mentioning my ambigrams specifically. Dan then commissioned me to create an Aerosmith ambigram, which he gave to Tyler as a gift in the form of a beautiful piece of etched glass. Seldom is it possible to superimpose a desired style on an ambigram, but in this case I was able to mimic Aerosmith's original logo design."

—John Langdon

Nippon, for Tenyo

"I was commissioned to create ambigrams that would interest a Japanese audience on Tenyo's cell phone site. They are strictly for entertainment, no further purpose. I stuck to ambigrams that require rotation (as opposed to reflection) because that works best on a cell phone—it is easy to turn the screen around in your hand. 'Nippon' means 'Japan' in Japanese and the colors were inspired by the red and white of the Japanese flag."

—Scott Kim

Designer:
Scott Kim

Location:
Half Moon Bay, California

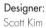

Designer:
Woody Pirtle

Design Firm:
Pirtle Design

Location:
New Paltz, New York

Crossroads Film

Demonstrating the geometrically linear symbol for duality of a cross as described in this chapter, this logo by Woody Pirtle fuses the client's name with visuals and embeds a literal sign into the symbol for double impact. Signs collapse information while symbols expand it. When you have both, you've covered all the bases.

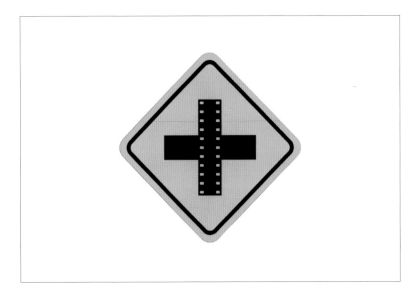

Designer:
Maggie Macnab

Design Firm:
Macnab Design

Location:
Sandia Park, New Mexico

Balance is the Key

This is one of a series of logos developed for a new-age music client that was not accepted. It was then reinvented for product application by adding a slogan that makes a subtle pun on the visual.

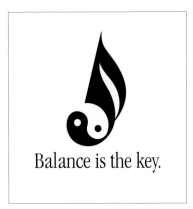

Citic Pacific

"When conglomerate Citic Pacific became an autonomous company, they sought a visual identity distinct from their Beijing parent, yet still expressing their Chinese heritage. A traditional lantern forms the word CITIC, echoing the shape of the character for 'China.' The lantern's welcoming, vibrant red has positive connotations in Asia."

—Henry Steiner

Designer:
Henry Steiner
Design Firm:
Steiner and Company
Location:
Hong Kong, China

This logo has integrated an informational overlay of cultural and word associations with great success: The name ingeniously doubles as a visual lantern form, and aesthetic cultural integrations of pattern and color support the collateral. Underlying this well thought-out and executed design, the symbolism clearly indicates the autonomy this company was seeking to achieve. The line dividing the circle communicates this conceptual genesis. This is a good example of how to "intuitively see" the principles of shape.

Designer:
David Lancashire

Design Firm:
David Lancashire Design

Location:
Victoria, Australia

The Restaurant (Stefano de Piers)

The Restaurant uses a juxtaposition of beef and codfish from the nearby Minney River, showing an inclusive duality between earth and water with sky between. The feet contribute to the nighttime starry sky—and in the case of the codfish, perhaps recall the evolutionary roots of subsequent terrestrial travelers.

Associação Cultura Franciscana

"The Franciscan Cultural Association, owned by the Franciscan Nuns of Ingolstadt, Germany, promotes missionary and educational projects in Brazil. St. Francis himself chose *Táu*, the nineteenth letter of the Greek alphabet, to represent the cross and the redemption. This symbol is still in use today by Franciscan Orders. The design solution embedded this symbol—*T*, the Táu—with the figure of St. Francis in a way that visually describes a welcoming unity. Franciscans are impassioned by all of creation, and with that in mind, we developed a visual that interacts with nature."

—José Carlos

Designer:
José Carlos
Design Firm:
Kriando
Location:
São Paulo, Brazil

ASSOCIAÇÃO CULTURA FRANCISCANA

 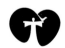 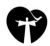 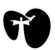 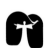 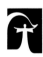

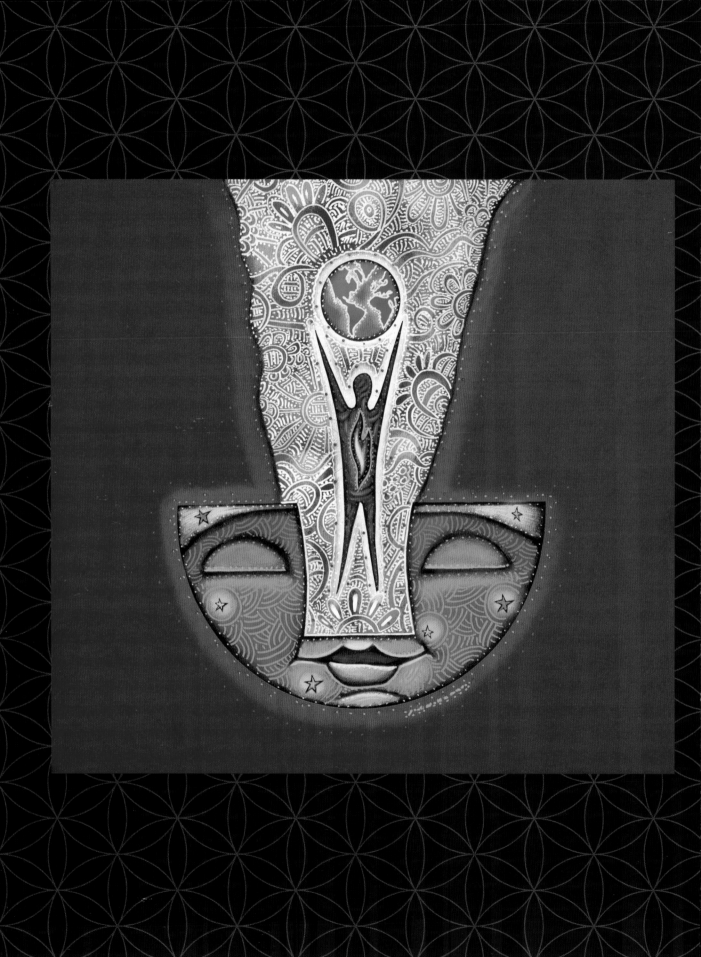

3

The Passageway

The number three brings solution to the conflict of division by presenting a third point of balance. Connecting these three points creates surface—two-dimensional space expressed geometrically as a triangle. Three lines are necessary to form a planar figure and three dimensions are required to form a solid. Three synthesizes one and two and is the universal symbol that relates to the elementary experience of productive human fulfillment: the female and the male and their fruit. The image of this trinity reflects the divine order of many spiritual traditions. For example, the ancient Egyptians expressed divine order as Isis, Osiris and Horus; the Hindus express it as Brahma, Vishnu and Shiva; the Christians have the Trinity of the Father, Son and Holy Spirit; and the Buddhism Tripitaka teaching consists of the Sutra, the Vinaya and the Abhidhamma.

We have seen how unity creates a reflection of itself in duality. This duality is an illusion of separateness. The harmonic product of the action of unity upon duality creates a third possibility—a separate entity that is a unique communication of wholeness and expresses the growth of unity within itself. Carl Jung put it this way: "… every tension of opposites culminates in a release, out of which comes the 'third.'" In the third, the tension is resolved and the lost unity is restored. Pythagoras, the ancient

Figure 3.1
Trinity by Joel Nakamura

Ionian father of mathematics, imparted the same idea when he said three was the number of completion. Three is the offspring of unity and duality (1+2=3) and is the only number out of an infinite body of numbers that is a culmination of all numbers below it. It is a completely different whole created from the prior two.

3.3

3.4

3.2

Figure 3.2
Isis, a goddess in Egyptian mythology. Isis was the mythological wife and sister of Osiris and mother of Horus, and was worshipped as the archetypical wife and mother.

Figures 3.3, 3.4
The Holy Trinity encompassed by the all of God and its Celtic symbolic counterpart of the triad woven into the circle.

Figure 3.5
Illustration of in situ relief of the Buddha flanked by two bodhisattvas. The trinity, the basic hierarchic Buddhist group, may have originated in India. The earliest triad consists of Buddha accompanied by the Brahmanic gods, Indra and Brahma, in a depiction of the Descent from the Tusita Heaven, as found in Gandharan reliefs. This triad with unidentifiable bodhisattvas in place of the gods probably symbolizes the temporal and spiritual powers of the Buddha. Illustration from The Archive for Research in Archetypal Symbolism (ARAS), New York City, New York.

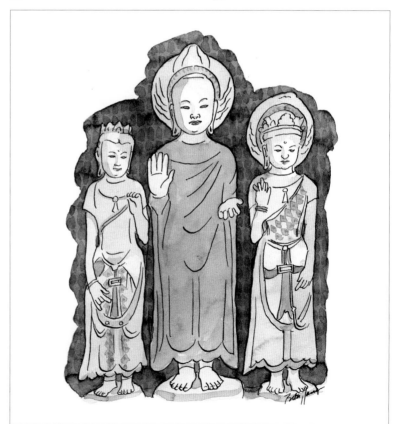

3.5

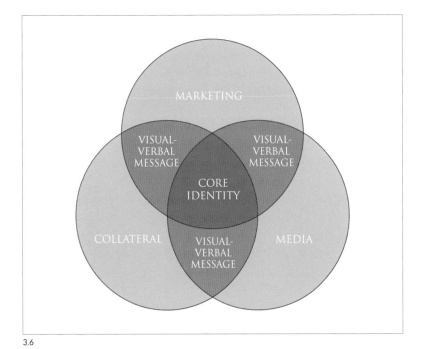

Figure 3.6
A Venn diagram shows all possible logi-
cal relationships between groups. The
identity's core should overlap into every
aspect of the company's efforts of display-
ing and saying who they are.

3.6

COLOR AS THREE, APPLIED IN THE WORLD

Color is based on three. Light wavelengths are broken down into three
components by the cones within the retina of the eye. These visual recep-
tors are responsible for the acuity—or detail—of color and shape. The
human eye interprets color in two ways: as reflected or direct light.
Reflected light is bounced back by a solid object that absorbs light (for
instance, a printed page), whereas direct light retains the intensity of
unobstructed light, such as we see on a computer monitor. As some of the
wavelength energy is lost in reflected light that travels from light source
to object, and then from object to eye, reflected light is less stressful on
the eye. Direct light is far more brilliant as there is almost no interference
between the energy of the wavelength and the eye.

Direct light is a blend of the colors red, green and blue (RGB). These
colors are called additive because when added together they recompose
white light. You can test this with three flashlights, each covered with a
red-, green- or blue-colored filter. Where they overlap on a surface they
will recombine into white.

Figure 3.7
Three as color.

Subtractive colors (found in paints and printers' inks) are pigment colors whose primaries are red (magenta), blue (cyan) and yellow. They are called subtractive because the colors remain after direct light has been absorbed into the surface. Direct light adds towards white and pigment colors subtract towards black: What you see on the surface of objects is what is left after the true color has been absorbed.

A Brief Overview of Color Theory

The principles of color theory appeared as early as the fifteenth century in the writings of Leon Battista Alberti and Leonardo da Vinci, but the traditional view of color theory began with Isaac Newton's theory of color around the beginning of the eighteenth century.

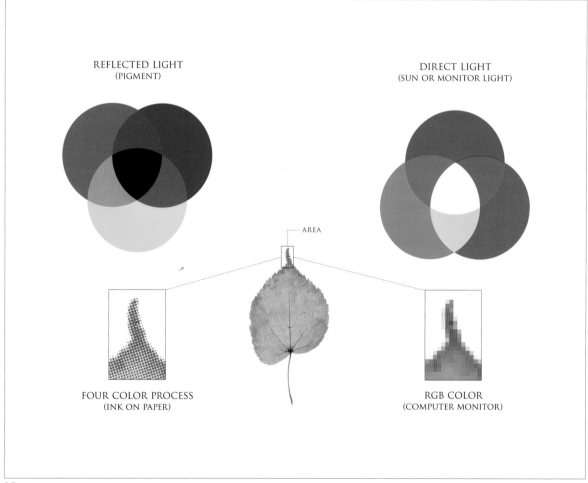

REFLECTED LIGHT
(PIGMENT)

DIRECT LIGHT
(SUN OR MONITOR LIGHT)

AREA

FOUR COLOR PROCESS
(INK ON PAPER)

RGB COLOR
(COMPUTER MONITOR)

3.7

Color theory was originally formulated in terms of three primary colors or pure pigments on the color wheel. These are the subtractive colors mentioned on the previous page: red, yellow and blue. If you add any two of the three primary colors together, you get a secondary color (the union of two beget a third). There are three secondary colors: green (blue+yellow), orange (red+yellow) and purple (red+blue).

From the union of the primary and secondary colors come the six tertiary colors: red+orange=red-orange, red+purple=magenta, blue+green=blue-green, blue+purple=blue-purple, yellow+orange=yellow-orange, and yellow+green=lime green (yellow-green). Each tertiary contains one primary color plus one secondary.

Adding black to any color creates a shade. These create the value, or darkness of a color. Adding white to any color creates a tint. Hue is the pure color from the color wheel without any additives of black or white, and saturation is the intensity of the hue. Neutrals, also called achromatic colors, are created by combining colors opposite each other on the color wheel (complementary colors), or by adding in black or white. Pure neutrals are blends of black and white for a range of grays, and near neutrals incorporate some color that shifts their hue toward a warm or cool tint. Neutrals are often used as backgrounds to augment stronger colors.

3.8

3.9

Figure 3.8
The RYB color wheel showing primary, secondary and tertiary colors

Figure 3.9
The RGB color wheel

Three is everywhere in our world because there is a beginning, middle and end in nearly everything we do. The sum of all human ability is threefold: thought, word and deed. We experience three states of being: spirit, body and soul. We live in the third dimension and in three divisions of time—past, present and future as we move through birth, life and death; the sun has three stages (dawn, noon, dusk); there are three kingdoms of matter (animal, vegetable and mineral); and the world exists through creation, preservation and destruction. There are three lights on a traffic signal; three wishes; three strikes you're out; three primary colors that create all other colors; and we are taught ABCs and 123s.

Three is the number of fit for three-dimensional space, as fundamental structures are braced with triangles, such as the arch or the geodesic dome, or the truss of our pelvis. An arch, as da Vinci put it, is "two

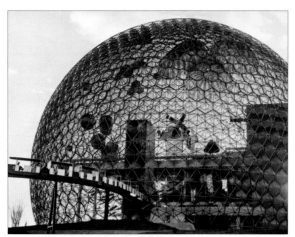

3.10 Courtesy, The Estate of R. Buckminster Fuller

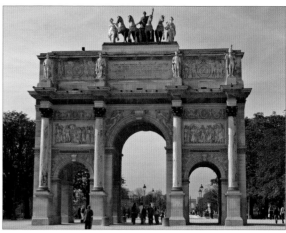

3.11

3.12

Figure 3.10
Montreal Biosphere designed by Buckminster Fuller, 1967

Figure 3.11
The Arc de Triomphe Structural du Carrousel, Paris, an arch demonstrating classical architecture

Figure 3.12
The recycle symbol, perfectly representing the transformative process, is also based on the triad. Life folding into itself is a principle of the effective reuse of three-dimensional space to create newness: Life eats life to live. The triangle resembles the mother circle of the ouroboros in its purpose: Cycles underlie universal process, in different shapes to accommodate different tasks. The triad creates the transitional surface through which matter can manifest.

weaknesses that together make a strength." The joining of two, very different than the intersection of two, creates a third point of balance and provides an opportunity for the next aspect of dimensional space to take place: depth.

Three influences us at subtle levels of consciousness in the aspirations of the recombination of the original one and two into an entirely new form of balance. Three is also the number of aspiration, as so many designs show, from the Masonic pyramid crowned by the eye of God on our dollar bills, to the pyramids of the Egyptian and Mayan cultures. Countless logos use the triangular symbol to represent a focal point of upward aspiration, or three elements to underscore the process of transition to completion.

Some of our superstitions come from the number three. Not walking under a ladder comes from an Egyptian warning not to break a triangle—or as Michael S. Schneider explains in *A Beginner's Guide to Constructing the Universe*—"… don't disturb a complete event." Schneider also points out the scale, our symbol of justice, is the balance of two elements into order and resolution by bringing in a third neutral perspective to restore balance to all: Our legal process is by *tri*-al. The number three epitomizes a whole process. Threeness is the principle of duality being braided back into the greater whole via a third component.

3.13

3.14 Copyright © 1978 by *Playboy*. Illustration by Kinuko Y. Craft.
Reproduced by special permission of *Playboy* magazine.

Figure 3.13
Economy Prevails in Nature
Many fruits and vegetables have tripartite center divisions. Elastic materials, such as soap bubbles, drying mud or concrete, crack when stressed at corners that are joined at 120°—because this angle is the most efficient at breaking space into parts. 120°+120°+120°=360°, the full circle of unity. You can investigate triangular composition by deconstructing images within tripartite objects. Re-illustrated from Michael S. Schneider's *A Beginner's Guide to Constructing the Universe*.

Figure 3.14
The scales of justice

Figure 3.15

Pelvis as truss system and
transformance passageway

Pelvis as Truss System and Transformance Passageway

Indeed, three is intimately connected with our own transition into the world. A woman's reproductive organs form an upside-down triangle: ovaries, womb and birth canal, contained within the triangular truss of our structural system, the pelvis. The inverted triangle is traditionally a symbol for female, while the triangle pointing up traditionally represents male. Both are symbolically obvious. As opposed to the asexual cloning of reflection—essentially a mathematical duplication that is limited to the qualities of the parent alone without any external influence—three introduces a new combination open to circumstance. It has strong parental leanings, but is tempered by chance. You can see this clearly in the shape representations. The point extends to a line, which becomes a plane and opens the opportunity for something entirely different to happen. The stage is being set for the addition of depth, the quality of our next number.

3.15

The Triad in Practical Application

Living in New Mexico, home to Sandia and Los Alamos National Labs, I've had the opportunity to work with lab scientists and engineers whose developments have crossed into the private sector. Dr. Creve Maples developed MuSE, the acronym for Multi-User Synthetic Environment, a shell software program that extrapolates raw data into a visual interpretation for immediate accessibility and makes it understandable to our senses. For example, brainwave patterns can be visually reinterpreted to make a map of the brain, allowing the surgeon to plan his path toward a tumor removal and avoid the most critical areas during surgery. Or, a missile launch begins with a complex path through a maze that a pin must follow precisely to detonate. To assure an unintentional detonation—such as a lightning strike could potentially cause—MuSE can be programmed to run through a series of different maze configurations to test their viability before being permanently encrypted as a launch code.

Figure 3.16
The finished MuSE logo

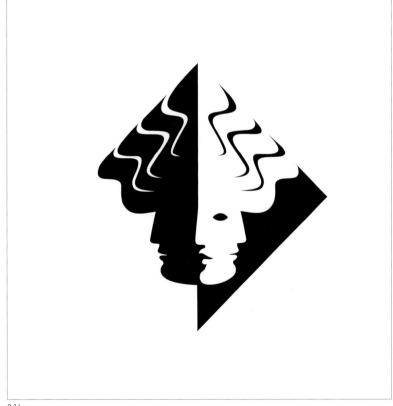

3.16

Figures 3.17, 3.18

Working on a logo design, I often start with a list of components and qualities particular to the client rather than visual material. Words offer an abstract quality that can be useful in culling imagery. Though they may not be literally or even conceptually incorporated into the design, it's a good way to get acquainted with the client's work. I also start with the most obvious of visual associations, such as you see here with the sense/dimensional aspect of the two faces and the cube. Terribly elementary, but since a logo must be simple, an obvious association can jump-start a more intimate connection.

Figures 3.19, 3.20

I wanted to show the interactive qualities of the MuSE program and began with this rather scary depiction of three entities that look more like an evil circular saw. The client never saw this; I knew it wasn't workable as I was doing it. Still, sometimes false starts can lead to the real deal. A second attempt left the brains without many options. Persistence is the key; you can only find out where meanders go by following them, even though they may not have an obvious connection to the final concept.

I've always been interested in the correlations between art and science, and something that struck me on the first trip to the client's office were the freestanding sculptures in the lobby. Individual reproductions of Michelangelo's sculpture *David*—the eye, ear and nose—were used as a decorative tie between the scientific and aesthetically sensual perceptions of three-dimensional space. In Delphian mythology, there were three Muses responsible for the practice of remembering mythology through song. The program's ability to interpret numbers into a two-dimensional rendering of three-dimensional space and the name "MuSE" with its relationship to feminine principles of sensuality provided the visual cues graphically embedded in the logo.

3.17

3.18

3.19

3.20

3.21

3.23

3.22

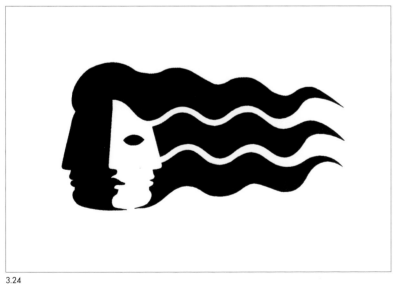

3.24

Figure 3.21

By doodling, I wanted to get to know the muse a little before incorporating a more figurative visual into the design. This is all warm-up. Getting to know your subject by drawing all over and around it is a good start.

Figure 3.22

I move toward a more classical Grecian drawing style and am struggling with how to derive meaning out of the meaningless space between the figures.

Figure 3.23

Though still rough, three-part harmony is beginning to come into play. I discover that I need to turn the faces away from each other to have them truly relate. I knew this was the fit for the logo and only had to resolve the line work into something more substantial.

Figure 3.24

The relationship is finally made by how they connect in the middle—a shadow defines and gives substance to the third muse. I only needed to stylize the hair and add the contrasting triangles to indicate the transitional state of manifestation that comes through our senses.

Case Studies Based on

Designer:
Maggie Macnab

Design Firm:
Macnab Design

Location:
Sandia Park, New Mexico

eyeku

The psychological impact of three strong shapes—seen here as an eye, a line and the word "ku"—makes up a triptych that synthesizes the interaction between the visual and intellectual. "eyeku" is the name I have used to describe the education I do for creative departments and students of design in the visual literacy of symbols. Based on the Japanese word "haiku," a style of existential poetry traditionally written as three short lines, the name suggests the larger concepts that symbols embody.

Designer:
Woody Pirtle

Design Firm:
Pirtle Design

Location:
New Paltz, New York

Brown-Forman

"I was commissioned to update the existing symbol, which was designed in the late sixties by Raymond Lowey. Conceptually, I felt that the symbol was very successful in its reflection of the nature of the company's business, but needed to be simplified and modernized.

"I began by reducing the scale of the "BF" initials, then decided to discard them to allow the stylized glass and bottles to emerge as the central focal point. Next, the icons within the oval were redrawn to

make them bolder and more successfully resolved. Finally, the silhouette of the oval was refined and converted to a solid field, from which the icons could be reversed."

—Woody Pirtle

Visual illusions are engaging because they allow us to see opposite perspectives almost simultaneously. Three-dimensional space requires three objects to imply depth so that all edges are defined and the mind can fill in the missing information. When done successfully, as Woody has done here, it is a compelling symbol.

Elenov Wines

"This Macedonian family wine business was trying to reach new markets. The challenge was to rebrand Elenov and upgrade the rustic Cyrillic logo. To do this I used a simple calligraphic approach, with the letters positioned to create the shape of grapes. My goal was to create a globally understood trademark."

—Jelena Drobac

Designer:
Jelena Drobac

Location:
Serbia

The typeface lends itself to the tiered overlap of cluster growth, simplified into three stages.

Designer:
José Carlos

Design Firm:
Kriando

Location:
São Paulo, Brazil

Australis Wines

"Our goal was to create a logo that would promise sophistication and easily communicate 'wine' for this distributor for Australian wines in Brazil. The 'grapes' establish a wine context—the challenge was to develop a symbol that avoided common representations. When I started to develop the logo, the word 'Australis' was initially handwritten, and out of the curved shapes of the handwritten letters 'au' came the organic shapes to build the symbol. I then realized that the casual logotype and symbol were not communicating the sophistication that I wanted, and replaced the handwritten name 'Australis' with a more formal font. After the logo was developed, other graphics were inspired by vines, using the most organic element of the brand, the vine curl."

—José Carlos

This logo connects in an organic flow and symbolically represents the spherical curve of grapes with undulating lines of varying weights. The triangular shape of the cluster could be read as the altering effects of alcohol that disorient, or transform, normal perception.

Radio Free Europe

"Founded in 1949, Radio Free Europe/Radio Liberty promotes democracy in parts of the world where human rights violations, war and state-controlled media are routine. RFE/RL asked for a new visual brand that would convey the ideal of freedom through a single graphic that could be embraced by all cultures across twenty-eight different languages. The final symbol, a forward-leaning torch whose flames rise to become a bird in flight, embodies the spirit of the organization, and orange was chosen as the most inviting and least globally controversial color."

—Steff Geissbuhler

Designer:
Steff Geissbuhler

Design Firm:
C&G Partners

Location:
New York City, New York

The triangle is the alchemical symbol for fire. Base substance being transformed into gas is a metaphor for transcending earthly form into the spiritual ether—itself a metaphor for transforming destiny into choice, or repression into freedom.

Advanced Surgical

"When I began to work through the process of identifying the most promising solution for this identity, the primary consideration was to conceptually link the identity to the end use of the company's products. In reviewing upper case 'A's, I realized that each stroke of the Futura 'A' is the same weight and that the letter is totally symmetrical. I started

Designer:
Woody Pirtle

Design Firm:
Pirtle Design

Location:
New Paltz, New York

sketching by filling in the counters, resulting in a solid triangle. Then I removed the positive counters and began to move them around, looking for a solution to emerge."

—Woody Pirtle

Designer:
Maggie Macnab

Design Firm:
Macnab Design

Location:
Sandia Park, New Mexico

Insight Out

This symbol was originally designed for an international psychological association, but was not accepted. A friend a few years later needed a symbol to represent her company, Insight Out, a market research firm. The name was a happy coincidence combining the visual of two people interacting around the centered "eye" of insight. The figures represent duality as opposite viewpoints containing a central perception between them.

Mexico City Metro

"Since the forming of Mexico City, the square Zócalo has been the symbolic center. The Metro logo is three lines cut into a square to form an 'M', a reference to the three original Metro lines that are cut into the city. The 'M' is filled with orange, representing the orange Metro cars."

—Lance Wyman

Designer:
Lance Wyman

Design Firm:
Lance Wyman Ltd.

Location:
New York City, New York

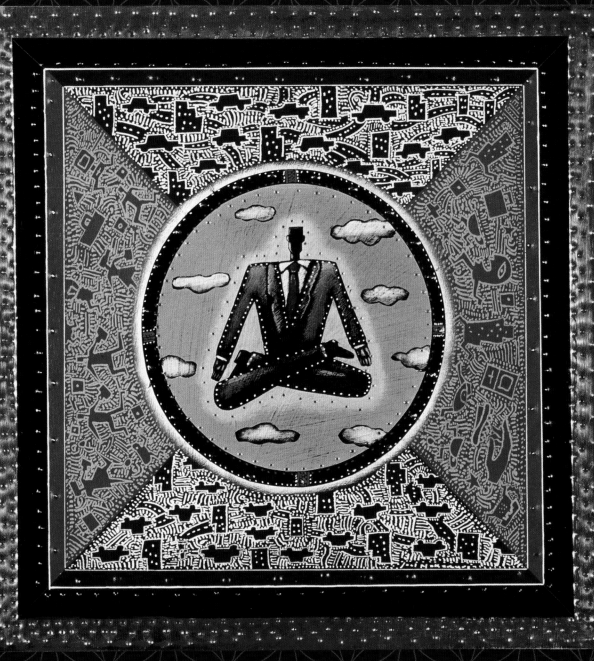

Manifestation

Four is a perfect fit for the world we live in. From the four corners of the earth to the four directions, elements and seasons; from the earthbound quadrupeds to the quadrants of a city; from the quarters we are housed in to the quarters of the hour we live our lives through, four is the numerical and shape principle of the structure of reality. In fact, the stuff of three-dimensional space is composed of exactly four particles: protons, electrons, neutrons and electron neutrinos. Simply by adding one point to the three points of a surface, we step into the entirely new dimension of depth to play out the drama of form in the sensual world.

The first shape for depth is the tetrahedron (Greek: "four faces"), created by adding a fourth point to the three points of a plane. This creates an enclosed pyramid of four sides and is as essential to the basic structure of space as the triangular shape is to the plane. Four spheres happen to stack perfectly within it. It is the strongest and most stable of all solids, and is the only three-dimensional shape in which the corners are spaced evenly from every direction.

Because shapes are most easily created on a two-dimensional surface, we use the symbolic shape of a square to describe four. This is the linear

Figure 4.1
The Business of Dominion by Joel Nakamura

4.2

4.3

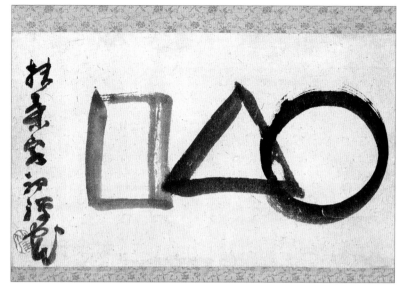

4.4

Figure 4.2
Khafre's pyramid with the Great Sphinx of Giza in the foreground. Though one plane of the pyramid is triangular (a seemingly better fit for Chapter Three, on the surface), it has a total of four sides, putting it in the next dimensional category of depth.

Figure 4.3
Constructing three-dimensional space from a two-dimensional surface

Figure 4.4
Literally translated as "Circle, Triangle, Square," this painting by Zen master Sengai from the nineteenth century means "universe" in Japanese. It is read right to left in Eastern tradition and shows how a symbol moves through dimension by its transformative nature. Born out of the wholeness of one, the symbol passes through the triangular plane of transformation, and then into three-dimensional reality by the addition of a fourth point. In 2-D space it is visualized as a square, and as a tetrahedron in 3-D space.

and literal shape shown as four points connected on one plane. Note that by connecting the opposite corners of the square with a line (see Joel Nakamura's illustration that opens this chapter), four triangles are revealed snugly embedded together. The triangular strength of the truss underlies the building blocks of our world. The crossed X's within a square also refer to cross-pollination and cross-breeding: The diagonals of these triangles as lines intersect over the human reproductive organs on the exact center of a square surrounding the figure. Reproduction, or cross-breeding, is another version of building in the physical world.

From micro to macro scales, quadrature is the universally practical construction of our world seen in the concrete squares of sidewalks, or in the brick, block, sheetrock and windows of buildings, and most of the objects that fill them. Notice that many city plans are based on grids. Squares fit very well into many aspects of three-dimensional space. Four also underlies the human perception of time: we quarter hours (which had more meaning as a circular clock face than digital numbers do now), and the equinoxes and solstices quarter the year in cyclical seasons.

With its right angles, the square doesn't contain movement like other shapes such as the circle, spiral, triangle or hexagon, and is used as a symbolic description of Earth. At one time the world was believed to be flat because that was how our senses perceived it. Of course, we know now

that the Earth is a sphere, even though our personal experience tells us the Earth won't roll out from under us. By its nature of being stationary, the square is also stagnant and is one of the least interesting shapes. It is this quality that relates it to the mundane aspects of reality: familiarity, safety and boredom.

Money, like language, is an evolution of civilization. It supports and creates trade and forces us to interact with others, and ultimately to co-mingle with them. Coins were traditionally made of precious metals and had inherent integrity and value, a basis for the circular shape (as integration is represented by this shape). Paper money, on the other hand, is only a promissory note: It promises value as the paper itself has almost none. The four sides are a functional aspect of milling, printing, trimming and using paper, as well as substantiating support for something that has value in theory, but not necessarily in reality.

Figure 4.5
Just as our genetic DNA twists in crossover form as a double helix, there is an intersection that resides at the center of our developed physical structure in the reproductive organs. "X"-breeding produces the next generation and is the sexual version of building in three-dimensional space. It resides at the center point within a square where the two diagonals intersect and cross … or in the pornographic shorthand of XXX, one crossing not being enough.

Figure 4.6
A new design commemorating the new century—and perhaps the new power gained by corporations in the last quarter of the twentieth century—shows something off-center. And compared to the high level of beautifully engraved design on previous versions of our cash, it's not very aesthetic, either.

4.5

4.6

H&R BLOCK

4.7

Figure 4.7
H&R Block was originally started in the mid-1950s by Henry and Richard Bloch and is now the largest tax preparation company in the world.

DECONSTRUCTION OF THE H&R BLOCK LOGO

There is nothing more tedious than filling out forms—especially tax forms. I remember it as fun in my younger days, an opportunity to see the accumulation of my life in the most basic, linear terms. That shiny newness wore off as life became more complex.

Taxes have gone from boring to painful as the rules become more convoluted and, well, more taxing. Here is the first functional success of this logo: It is so excruciatingly simple that it's boring. This communicates that H&R Block deals with the monotony of tax returns so you don't have to, and implies they have the expertise to simplify the complex. The next workable feature: It's a square. The shape corresponds to the founders' name (Bloch, pronounced *block*) and the worldly reality of paying taxes. Also, it's green. How you interpret this depends on your circumstances, but it's without doubt about money: H+R Block saves it for you, or you pay it to the government.

By no means an aesthetic beauty, this logo is nevertheless effective by appropriately incorporating symbolism that communicates several fundamental qualities about the company simultaneously.

Construct a Square From the Vesica Piscis

As with all basic geometric shapes, the square originates in the circle. This simple exercise refines further detail of out of "everything" by adding a fourth point and creating depth: the third dimension. Four is the same on all sides: This shape eludes to the stable structure necessary for life to exist within it as its container.

1. Draw a vesica piscis.
2. Connect the points of intersection.
3. On the center point of these two intersecting lines, draw a smaller circle within the mandorla.
4. Connect the points of intersection between line and circle and you have created a square on a 90° tilt.

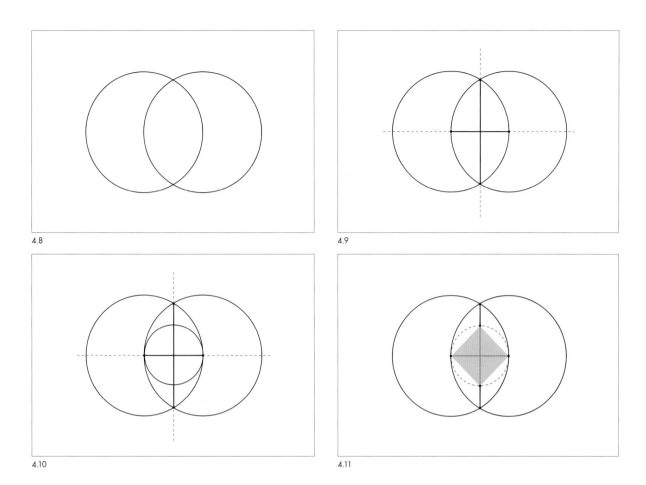

4.8

4.9

4.10

4.11

Figure 4.8, 4.9, 4.10, 4.11
Construction of the square from the vesica piscis.

DECONSTRUCTION OF THE RED CROSS EMBLEM

The original International Committee of the Red Cross and its symbol were created in Geneva, Switzerland, in 1863. This organization was begun as a nonpolitical humanitarian authority to provide relief to victims of armed conflicts, and now also aids in large-scale disasters. Switzerland is politically neutral and has not been involved in a foreign war since 1815. The Red Cross symbol, with its cultural association to the inverted Swiss flag, is a visual message of its apolitical standing. The color inversion of a red to white ground also relates to the white flag of surrender; a symbolic yield to conflict. As a universal symbol, the two intersecting opposites imply the restoration of balance between polarities as discussed in Chapter Two. Intersecting lines in the shape of an equilateral cross are sym-

4.12

Figure 4.12
The Red Cross and the Red Crescent emblems at the museum in Geneva. The Red Crystal emblem will be a part of this group soon.

bolic of bringing two opposites into balance by way of relationship (spirit and material, or energy and form).

Let's look at how this symbol relates universally, beyond the cultural associations mentioned above. All people in all times have seen the horizon in the same way—as a horizontal break between earth and sky. This is most simply noted as a flat line. Our desire to wonder about what lies beyond sensual experience is represented by the vertical line: Up is where we often look when we wonder about things beyond our reach. The "crossing" of these two concepts—tangible form with aspiring thought—is a symbolic expression of the human experience. That's us at the point of intersection: We reside at the point of spirit touching matter. The symbolism can also be interpreted from a mathematical perspective of the four points from which the two lines are drawn. Intersecting lines emphasize relationship, as described by the plus symbol.

Cultural symbolism does not retain the same consistency as universal symbolism. The Red Cross does not have just one logo: It has four different symbols that can be used in combination with the Red Crystal to create a symbol that applies directly to the culture in which it is being used. The cross has been closely associated with Christianity for more than two thousand years, and even though it isn't intended as a religious symbol in this context, it is often perceived as such. During the Russo-Turkish War, the Red Crescent was implemented by the Ottoman Empire to prevent their soldiers from being alienated by the Red Cross emblem as a Christian symbol (recalling historical Muslim/Christian conflicts). The curved symbolism of the crescent is also reminiscent of the curved shape associated with the cross's Eastern equivalent, the yin yang.

Israel's emergency system, the Magen David Adom, which was originally formed in 1930, was denied entrance into the International Red Cross and Red Crescent Movement until 2005 when they replaced the Star of David—unapproved because of its religious association—with the more acceptable Red Crystal. Symbolically, the Red Crystal reinforces the Red Cross by implementing the same symbolism of four points connected peripherally rather than through the center.

The more simplistic the shape, the more general—and neutral—it is. The circle, the solitary line, the triangle and square are all examples

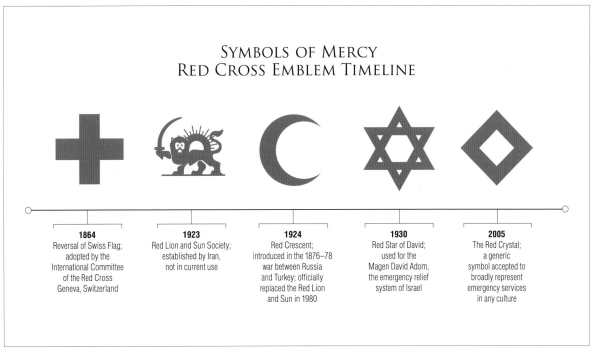

SYMBOLS OF MERCY
RED CROSS EMBLEM TIMELINE

1864
Reversal of Swiss Flag;
adopted by the
International Committee
of the Red Cross
Geneva, Switzerland

1923
Red Lion and Sun Society;
established by Iran,
not in current use

1924
Red Crescent;
introduced in the 1876–78
war between Russia
and Turkey; officially
replaced the Red Lion
and Sun in 1980

1930
Red Star of David;
used for the
Magen David Adom,
the emergency relief
system of Israel

2005
The Red Crystal;
a generic
symbol accepted to
broadly represent
emergency services
in any culture

4.13

of this. The diamond shape is perhaps the most appropriate of the three officially used shapes today because of its ubiquitous nature. The Geneva Conventions allow any of the National Societies belonging to the Red Cross organization to incorporate their recognized emblem inside the Red Crystal; that is, the cross, crescent or six-pointed star can be dropped into the center of the crystal as another way to identify the Red Cross. They are also recognized as stand-alone symbols without the enclosure and can be implemented either way by cultural preference.

Figure 4.13
A timeline showing the divergent symbolism used to represent humanitarian aid, as determined by culture

Four is the economic structure of the physical world and denotes strength, stability, fidelity, predictability and the addition of depth, bringing dimensionality to existence. But physical existence is not aliveness. That is another aspect of symbolism we will explore in the next chapter.

Case Studies Based on

Designer:
John Langdon

Location:
Philadelphia, Pennsylvania

Rehabilitation Hospital Corporation of America

"I like to think of logo designs as crystals—beautiful little gems that represent something much larger and more complex. They take the essence of an organization and synthesize it into a concise visual that communicates a lot of information almost instantly. I worked with creative director Richard Weiss of JRA Marketing Associates and after I created this logo, Richard wrote the company's tag line: 'We rebuild lives, step by step by step.'"

—John Langdon

Designer:
Henry Steiner

Design Firm:
Steiner and Company

Location:
Hong Kong, China

Equion

This Chinese coin incorporates both the circle and square and unconsciously speaks to worldly necessity brought into harmony with the whole of unity, also known as "squaring the circle." Incorporated as the visual messaging symbol for this bank, the coin shape embodies the balance between the paradox of unity and separation.

Heart Hospital of New Mexico

The four directions of the Zia symbol for the state of New Mexico extend as fingers from a heart-shaped palm to create a multi-tasking symbolic communication of care, cardiology and the southwest embedded within the international symbol of the cross.

Designer:
Maggie Macnab

Design Firm:
Macnab Design

Location:
Sandia Park, New Mexico

Designer:
Alex de Janosi
Design Firm:
Lippincott Mercer
Location:
New York City, New York

Bank of New York

This logo references the traditional patterning of currency and financial certificates. The crosshatched lines suggest a comprehensive and integrated array of services, and the square-on-square shape carried into banners and other collateral reinforces the appearance of institutional stability. The movement and color appeal to the hyper-reality of the energetic pace we live today.

Designer:
John Langdon
Location:
Philadelphia, Pennsylvania

EarthAirFireWater

The "earth air fire water" ambigram was created for Dan Brown's novel *Angels & Demons*, accompanying ambigrams of each individual word, the word "Illuminati," and an ambigram of the book's title. The four

elements manifest as letterforms and fit snugly into the square shape of three dimensions; the 45° diagonal creates movement and further emphasizes the concept of depth; and, finally, the aspect of right-reading regardless of the 180° rotation gives a mysterious, multi-dimensional effect on a two-dimensional plane.

Shelter Housing Charity

This London charity focuses on housing conditions for the poor, a social issue most of us have a preconceived opinion about. This design simply gets to the point without bogging down in preaching or fixing; it cuts to the chase and facilitates action. The "pitched roof *h*" is carried into a variety of applications, and "home" becomes the universal focus by association.

Designers:
Michael Johnson, Luke Gifford, Katherina Tudball
Design Firm:
johnson banks
Location:
London, England

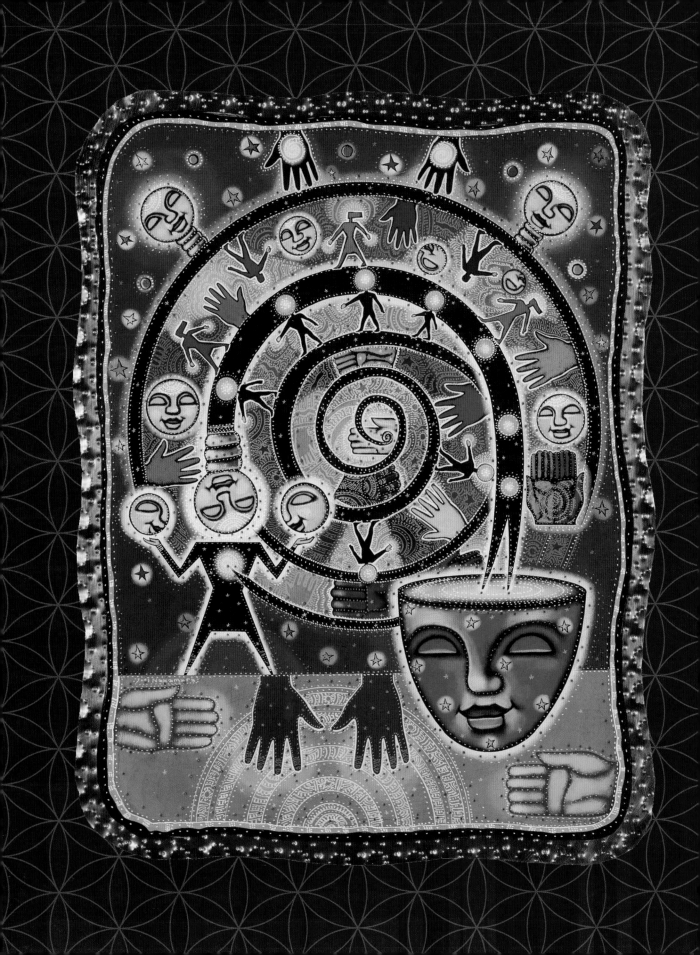

5

Free-Form Life

We have now arrived at the keystone in our exploration of number as quality. The number five is symbolic of man, health, love and the energy of movement acting upon matter—what we also call magic. The ancient Greeks originally recognized four elements—air, fire, water and earth—until Aristotle added a fifth, ether. The Pythagoreans called it nether, the fifth essence, which they said flew upward to creation and out of it the stars were born. Ayurveda, the five-thousand-year-old healing art of India, recognizes that these five elements play a role in creation, regeneration and healing. This fifth element called nether, or ether, is the quintessence—the magical stuff of living, breathing form. It defines an element so rare that it can't be seen or felt but is pervasive in everything created and everything we do. It creates our sense-ability, and yet we can't sense it. Quintessence (literally from the Greek: *quinta essentia*, "fifth element") is behind the principle of regeneration, and as its name implies, it is symbolized by qualities of the number five. We can't really know the mysterious "how" of the aliveness of five, but we can explore the "what" of its nature, which is as beautiful as it is intriguing.

The principle of regeneration is that the whole exists in the parts. Usually organic nature reproduces itself through a seed or an egg, but

Figure 5.1
Sun Head Spiral by Joel Nakamura

5.2

Figure 5.2
Starfish can regenerate not only a new leg, but an entirely new body from the detached leg under the right conditions. This is an Antarctic brittle starfish displaying the life-giving qualities of five as star and spiral.

Figure 5.3
The spiral cochlea labyrinth of a guinea pig showing 4.5 turns. The human ear hears about ten octaves of sound with our 2¾ spiral turned cochlea; dogs (and other mammals) have several more turns to their cochleae, allowing them to hear subtle frequencies we can't.

some plants and animals can regenerate from a part of themselves. Many plants root from cuttings and a starfish can regenerate a lost leg, while the lost leg grows a whole new body. The number five symbolizes the unseen force of regeneration—renewal, rebirth, revival, restoration and all the other words that imply the ability to recreate something old as something new.

Five as symbol can be visualized graphically as a pentagon—a geometric figure that has five sides and five angles. Let's begin our discussion of the symbolic use of five by exploring the most elementary visual form of the pentagon, the star. The Pythagoreans said the fifth element, nether, created the stars. A star is symbolic for that which is superior, excellent and powerful. A child who excels comes home with a star on her homework; we eat at five-star restaurants and stay at five-star hotels when we want the best; we decorate our military soldiers with five-pointed stars; we made a star a lawmaker's badge to exert its influence on taming the wild west; and we admire movie stars and award them handsomely for a "stellar" performance. The image of the five-pointed star is so inherently engaging to humanity that more than sixty nations of conflicting ideologies include it as a design element on their "unique" flag. And of the prior volume shapes, the pentagon comes closest to covering the same area as the shape of the circle, or "everything."

THE LOVE AFFAIR BETWEEN THE SPIRAL AND THE STAR

The more common symmetry of five as pentagon (or star) holds a lovely secret. Though not apparent at first glance, there is a spiral curled in every pentagonal star. The spiral is at the heart of quintessence. The logarithmic spiral (a spiral whose distance between turnings increases in a geometric progression) embedded at the heart of five manifests in both organic and inorganic nature as a beautifully effective shape of growth and balance (see Figure 5.9). Our aesthetic sense of it is instinctual because it is at our core: The double helix that carries our DNA is a three-dimensional Archimedean spiral, or a spiral that grows at a fixed rate.

5.3

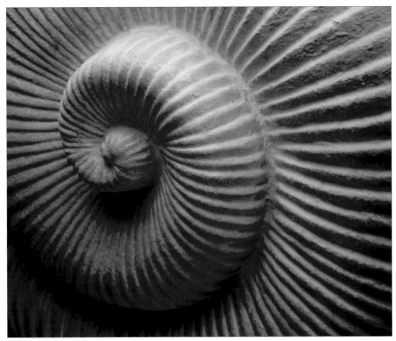

5.4

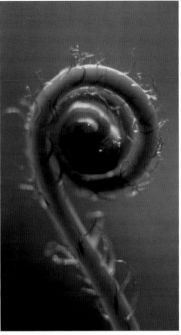

5.5

A star is created by five triangular arms extended from each of the five angles of a pentagon. Each of these is a golden triangle because the longer and shorter sides are in a phi ratio. If you fit the right angles five times into one another, they create the self-similar curl of a golden triangle. Follow the curl with curves at the intersecting points and you have drawn a logarithmic spiral, the expanding signature of regeneration.

Flowers whose petals number five or multiples of five also open as a spiral: the multi-petal rose or the unfurling of the five petals of a peach blossom. Five-petal blooms on a plant indicate edible fruit because they are completely compatible with our system. The spiral is embedded in our sense of sound and whispers sweet nothings of love into the spiraled cochlea inside our ears, filling our hearts with the music of the cosmos. The heart symbol itself is two reflected spirals connected, and at our heart, the core of our being, resides a contractor muscle in the shape of a left spinning spiral vortex. Spiraling quintessence permeates our being, sustaining body and soul.

Figure 5.4
A logarithmic spiral, the most common natural spiral, grows at an expanding rate that widens as it moves away from the center of its source.

Figure 5.5
An Archimedean spiral grows at a fixed rate, with each successive coil remaining the same distance from its core.

5.6

5.7

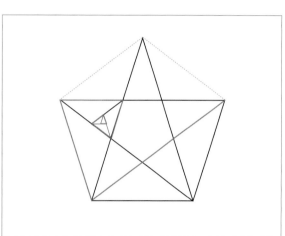
5.8

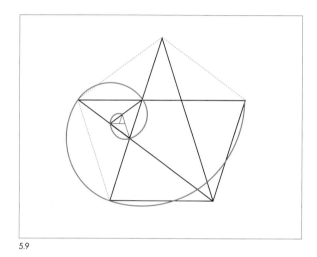
5.9

Figures 5.6, 5.7, 5.8, 5.9
Golden spirals exist inherently within the five-pointed star.

The Sun's-Eye View: The "Golden" Angle

You can see the embrace of spiral and five from the sun's-eye view, or as the sun would look down upon a plant. Many plants have a leaf pattern of groups of five traveling up the stalk in a spiral, and the growth of the embedded spiral with five distinct angles is evident in this cross section of a purple cabbage. This is the "golden" angle. Because the five "star" points of leaves or petals are tiered to get the most advantage of sunlight, they are offset slightly in this spiral configuration to take advantage of the most exposure to the sun.

The apple in cross section—as the sun looks down on it—carries through its propensity for five from the number of petals in its blossom to the number of seeds at its core.

5.10

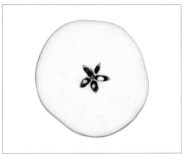

5.11

Figure 5.10
Cross section of purple cabbage displaying its pentad qualities of the spiral and starlike formation.

Figure 5.11
A cross section of apple shows its life-supporting properties of five in its core.

Figure 5.12
The five-point structure of the fingers and thumb serves the same purpose as the leaves on tree: to capture energy and put it to use, whether through absorbing sunlight and converting it to energy, or through hands that generate work. It's no wonder we feel affinity toward the number five and the shapes of its making; it is key to our survival.

Figures 5.13, 5.14
Leaf structure is also often pentagonal, a visual underscore to the pervasive properties of five that underlie life.

The Pentad of Nature

Plant, animal and human forms display pentad geometry in their structure. It is also evident in the proportional aspects of whirling spirals such as atomic oscillation and water spouts. This is intimately connected to the mystery of the infinite through the supreme ability of life to regenerate itself. As the most powerful symbol that indicates the pin-

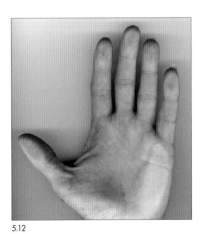

5.12

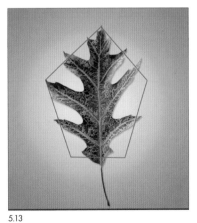

5.13

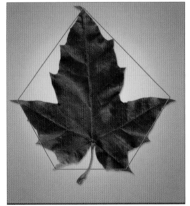

5.14

Figure 5.15
Spirals range from the subatomic to galactic scales, shown here in an artistically enhanced picture of particle tracks in the BEBC, Big European Bubble Chamber. Negatively charged electrons spiral in a counterclockwise direction, while positively charged protons spiral clockwise. Life's movement gathers momentum and dissipates in the spiral shape.

Figure 5.16
A hand x-ray reveals the Fibonacci proportions in the bone structure. When we make a fist, the fingertips curve into a spiral, not a circle. This is because the ratios of finger bones lengths are related in the same way as all naturally occurring logarithmic spirals.

nacle of the best, the pentad doesn't have to be shown literally in star-form. It can be subtly integrated as a spiral, or through pentad and spiral proportions for engaging results.

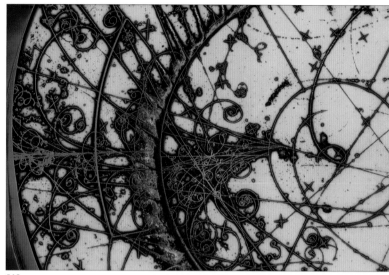

5.15

The Fibonacci Sequence of Beautiful Regeneration

In the early thirteenth century, an Italian nicknamed Fibonacci penned what has come to be known as the Fibonacci sequence. In this very simple continuous set of numbers, each number is simply the sum of the preceding two: 0, 1, 1, 2, 3, 5, 8, 13, 21, 34, 55 and so on. This is a phi relationship (Ø, in uppercase, or as it is more typically displayed in lowercase form to represent the golden ratio: φ). Because each number comes from within the series and never adds anything outside itself, it can be said that the series is self-generating. This is the beauty and mystery of regeneration: It begins with nothing—symbolized by the initial zero—and becomes everything. The series goes on indefinitely, never arriving at the infinite.

This sequence recurs with regularity in everything from the lengths of the finger bones (which curl into a spiral just like a nautilus), to the correlation of the distance between planets and their moons when they have more than one moon, to the proportionate division of human facial and bodily structure, to the spirals in the head of a pinecone. This sequence is indicative of the reproductive process of most life forms: It

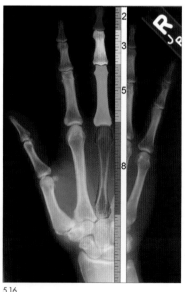

5.16

produces proportionate patterns that are appealing in our eyes because it speaks to the continuity of our experience. This pattern is precisely about the regeneration of us.

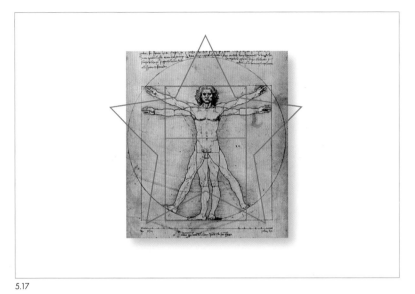

5.17

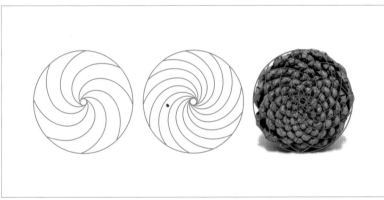

5.18

5.19

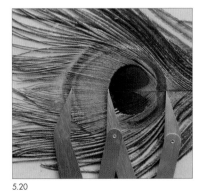

5.20

Figure 5.17
Human form is compatible with the first five numbers: one (we are whole organisms); two (the mirrored aspect of our physical structure as if we were split down the middle by a line); three (the triangular pelvic truss of our bodies that supports our structure and regenerative organs); four (the solid tangibility of our physical nature); and five (embedded in our form from the inside out in proportion and number). The average height of the navel of a man is .618 of his total body height: a phi proportion. The human body, including the head, has five appendages attached to the torso, and the hands and feet each have five fingers and toes with which we manipulate space and maneuver through it. As with the square, our reproductive organs lie at the intersection of the golden rectangle's diagonals, attesting to the principles of regenerative growth being entwined with both principles.

Figure 5.18
Each seed in the pinecone belongs to both sets of spirals, eight clockwise and thirteen counterclockwise. The ratio of 8:13 is 1:1.625, almost the golden proportion of 1:1.618. Approximation is essential to diversity. Absolutes suppress diversity and ultimately collapse as a system. Therefore, nature contains a wide range that falls within approximate guidelines. Some mutations within that range take hold and evolve into new forms, while others die out. Redrawn from *Geometry of Design* by Kimberly Elam.

Figures 5.19, 5.20
These are the golden mean calipers that expand and collapse proportionately to measure the phi ratio found in a variety of living forms—even in life-signatures such as the human heartbeat.

SEED MEDIA GROUP, SAGMEISTER INC., NEW YORK, NEW YORK, USA

Stefan Sagmeister says, "Seed Media Group is a scientific publisher of magazines, books and films. As we worked on the identity it became clear that the end result should contribute a visualization of science and media. Science is culture, it surrounds us, it is part of everything we do. We were looking for something open ended and flexible, a vessel we could fill with new meanings as they developed.

5.21

5.22

"Formally, the identity is based on phyllotaxis, a form found everywhere from seashells to Greek architecture, from pineapples to the Sydney Opera House, from horns of gazelles to the optimum curve for a highway turn. It plays a role in biology, zoology, botany, medicine, physics, geometry and math. It's in the golden ratio and golden curve.

"Looking at the world through this scientific lens of the phyllotaxis, we developed an identity like a chameleon; it always takes on the form of the medium it is put on."

This identity, in both conceptual and realized terms, demonstrates how a pattern can be used effectively as a symbol. Science and media are very different disciplines complementing each other as a fused service by this client. The visual evokes the dynamic grace of the spiral, the beauty of resolved balance between opposing forces out of which something new is born.

From the Fibonacci series mathematicians have concluded that the ideal number phi—rounded to 1.618—exists, but cannot be realized. This is the number of the infinite. Numbers never arrive at the infinite, but beautifully describe it as a sequence of regenerative life that moves unceasingly toward that goal. Life emerges from and returns to the infinity of nothing. Out of this mystery comes the ideal that it approaches, known by one of its names as the golden ratio.

Philosophers and mathematicians throughout time have recognized this ratio (also called the golden proportion, the divine proportion and the golden cut, among others). From our center outward, this relationship is demonstrated in the bone lengths in our hand, the subtle shape and balance of our facial characteristics, the number of fingers per hand that allow us to manipulate space and the number of toes on our feet that move us through it, and the number of senses we use to experience living in three-dimensional space. We *are* the embodiment of the five-part harmony that we are drawn to in the world. Used for centuries by artists and architects, this proportion is also seen in the self-organized growth patterns of many plants, from seed head whorls to the spiral configurations of leaf growth along a stem shoot, to the unfurling of an embryo in the womb. Pentagonal symmetry is the signature of living, breathing form. It's only natural that it would be beautiful to us.

Figure 5.23
In architecture: Vatican Museum spiral staircase (to heaven), Rome, Italy

Figure 5.24
In nature: Clockwise and counterclockwise phyllotaxis spirals of a sunflower seed head

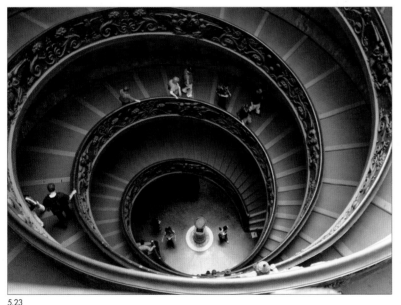

5.23

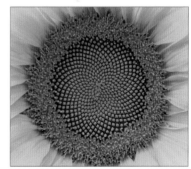

5.24

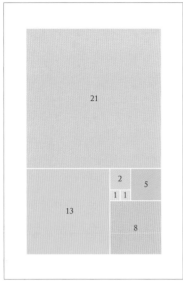

5.25

Figure 5.25

Constructing a golden rectangle

Construct a Golden Rectangle

A simple method to construct a golden rectangle following the Fibonacci numbers series:

1. Draw a square (yellow No. 1), duplicate it and slide it a full step to the left of the original square.
2. On top of these two squares, draw a square of size 2 (=1+1).
3. Draw another square touching the original No. 1 square and No. 2 square. The new square is made of a total of five units, following the Fibonacci sequence of 1+1=2+1=3+2=5+3=8, etc. We can continue adding rotated squares around the original one, with each new square having a side whose length equals the sum of the last two. The resulting dimensions approximate the ratio 1:ø, or 1:1.618, the golden ratio. When the interior squares are removed, the remaining rectangle has the same "golden" proportions.

The original parent squares begin with the same cloning procedure as the circle to create the vesica piscis in Chapter Two. Note the necessity for a square to complete the task of measuring the golden proportion. A fourth point factors in depth, the essential quality by which time and space can be measured (and therefore exist).

Construct a Golden Spiral From the Golden Rectangle

The square (being the shape of depth) supports the complexity of the life force seen in these exercises as it evolves into a spiraled regeneration of self. The circle clone is an elemental duplication of itself limited to a linear scale of the same (vesica piscis) or half (yin yang) size, and relates to simple division and multiplication: a linear separation for a linear result. Depth, however, creates the opportunity for exponential and unexpected growth.

1. Beginning with the top center point between the two originating squares, extend your compass from its center point outward to the far edges of the original squares.

 As with the original distinction of polarity in the circular form of the vesica piscis, the parent squares to begin the golden rect-

Decoding Design

angle are duplications of each other. Exactly one-quarter of a circle is necessary to complete the continuity of the spiral. This quarter turn relates directly back to the square and fills a linear translation of space with the fluid movement of life force.

2. In this same sequence, continue from the center point of the next larger square and draw quarter circles for that square, with each progressively larger quarter circle connected to the preceding smaller quarter circle. You will always place your center point in the furthermost inner corner of the square as it relates to the golden rectangle.

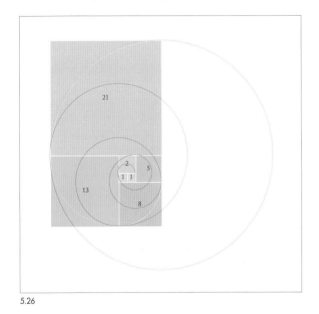

5.26

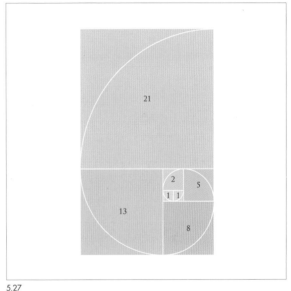

5.27

The golden spiral is made up of circle fragments, and as such is not a true mathematical spiral. This is the approximating spiral found in nature; its sole purpose is to link rather than to perfect. This spiral allows the slight variation necessary for mutation and evolution.

The intimate relationship between the continuity of the spiral and the linear breaks of the square is seen in the golden proportion, and perhaps it is this ability to simultaneously display what we tend to see as opposites that we find so attractive. Opposites are really complementary interaction—the essential distinction necessary for existence—rather than our tendency to see them as conflicted.

Figure 5.28
Constucting a pentagon, steps one
through eight

Figure 5.29
Constructing a pentagon, step nine

The points on the spiral are 1.618 times as far from the center
after each quarter turn. In a whole turn the points on a radius out from
the center are 1.618⁴—6.854 times farther out than when the curve
last crossed the same radial line.

Construct a Pentagon (After Euclid)

How to construct a regular pentagon from a circle and line:

1. Draw a circle in which to inscribe the pentagon beginning at the
 center of the mother circle (the red circle in Figure 5.28).
2. Draw a line through the center of the circle (intersecting the cen-
 ter point) to serve as one vertex of the pentagon (Point A).
3. Draw a perpendicular line through line A passing through the
 center at 90°. Mark its intersection with the right side of the circle
 as Point B.
4. Construct the Point C as the midpoint between the original center
 point and Point B.
5. Draw a circle with center Point C extending out to Point A. Mark
 its intersection with the line (inside the original circle) as Point D.
6. Draw a circle centered at A through the Point D. Mark its inter-
 sections with the original circle as points E and F.
7. Draw a circle centered at Point E through Point A. Mark its other
 intersection with the original circle as Point G.

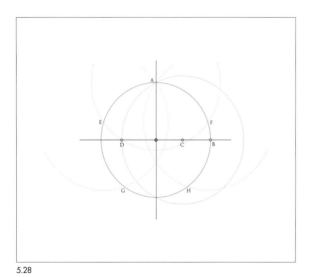

5.28

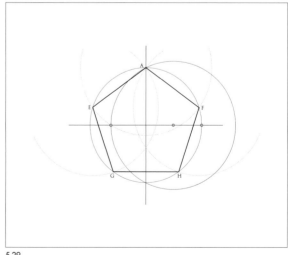

5.29

8. Draw a circle centered at Point F through Point A. Mark its other intersection with the original circle as Point H.

9. Connect the lines at the vertices to create a regular pentagon.

Construct a Pentagram From a Pentagon

Join the diagonals of a pentagon to create a pentagram, with a smaller regular pentagon in the center. Or you can extend the sides until they meet to create a larger pentagram. This demonstrates the infinitesimal nature of five to replicate itself, as seen in Figure 5.34.

Figures 5.30, 5.31
Constructing a pentagram from the pentagon

Figures 5.32, 5.33, 5.34
The fractal nature of the pentad moves toward infinity with self-similar regeneration, and is the essential quality of the number five.

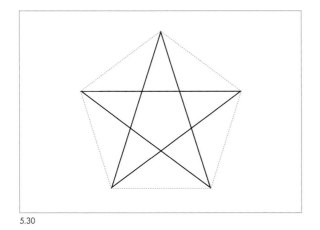

5.30

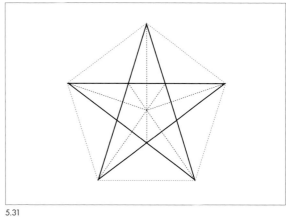

5.31

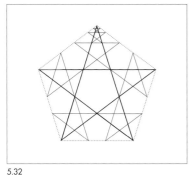

5.32

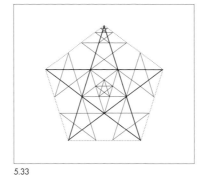

5.33

5.34

DECONSTRUCTION OF THE WALGREENS LOGO

Designers need to recognize that, though their goal is to influence consumers, the effect upon individuals and society must be considered. They

Figure 5.35
The Walgreens logo today

must decide whether to use their creative energies and the power of symbol to present something that benefits society or to use it in a way that is false but personally advantageous.

Today the pharmaceutical industry is a multibillion dollar business driven by the consumer's misplaced fear, ignorance, desire and hope. Take the example of antidepressants being administered to teens to treat behavior problems rooted in patterns that could be changed instead with structure, discipline, motivation and diet. Pharmaceutical drugs can certainly be a useful and effective treatment, but the industry sometimes creates a false need for the sake of profit.

Symbolic framing is the manipulation of symbolism in corporate communications to influence an emotive response. Five symbolizes health, regeneration and love, along with excellence, power and authority—all positive traits. What happens if the symbolic power of five is used to morph the reality of the product?

5.35

The Walgreens logo is a pharmacist's mortar and pestle, with twenty stars (fifteen inside and five outside, reinforcing the "human" factor of five). Here stars are associated with drugs, the powerfully mysterious forces that are both medicinal and poisonous depending on proportion, and the visuals can be read to subliminally symbolize magical transformation. The mortar and pestle conjure a cauldron and mixing stick to create magic.

The visual message implies that drugs can fix anything in the same way magic transforms reality.

If you view the design as the stars flying *into* the mortar, there is another message: The pestle will grind the stars to dust. Since stars can also be read as symbolic of the human condition, this perspective is subliminally far more threatening. The design intimates that pulverization could be the result of a challenge to the system's demand.

The symbolism of this logo evokes an emotive response that effectively manipulates consumers by enticing them with seduction and securing them with an embedded threat.

The Infinite Nature of Beauty

Today we interpret the word "symmetry" to mean a mirror image, but the literal translation from the Greek word *symmetria* translates as "alike measure," or having similar qualities at different scales. Rather than the implied precision of a mirror image such as the vesica piscis we explored in Chapter Two, living and growing forms correspond to the number five of the pentagon and the approximate ratios contained within a spiral.

Five symbolizes regenerative growth from the inside out. This is nature's way of producing endless variety using an elegantly simple self-reproducing scheme that can be altered by external conditions or inherent genetic quirks. Nature allows for eccentricity; things that don't work become obsolete and things that do become an inherited trait. Genetic physicists are just beginning to understand that we contain many inactive genes that are "switched off," waiting for opportunity to present itself.

An asexual cloned duplicate, on the other hand, is a feedback loop that consumes and collapses in on itself. An exact replica of the previous parent is unsustainable as an evolving form because no new genetic material is added for synergistic change to occur. This is highly dangerous for species that relies on being able to accommodate change for survival—we have no idea how genetic modification will affect the food chain in the future. It is clear that stagnation is unworkable in a universe based on movement. The same holds true for template-generated design. There is

nothing at all wrong with using a template, but it is key to the success of the design that creativity is integrated to prevent its collapse into the black hole of white noise.

All is contained within the parts. This is the magic and mystery of life. Any of the shapes—the parts of the whole—you find in this book can be integrated very effectively to communicate with universal appeal at an intimate level. Part-as-whole is also central to chaos theory and fractal mathematics, an important new area of study in theoretical physics.

The Modern Shamans

The further science delves into outer space, the more elusive and intangible space seems. Physicists now find themselves in the role of shaman in our modern world. They are rediscovering the mysteries of the universe that have been explored by our ancestors with other technologies and other perspectives countless times before. Some things remain unchanged: We all want to understand mysteries, and we do so with theories that are beautiful and simple—elegant ideas indicate we are on the right track. Still, much remains mysterious. Quantum physicists have come up with elusive theories embellished with playful language to describe their explorations into the mysterious subatomic world. The most accepted interpretation during the last four centuries of what the universe is composed of, atoms, have been even further broken down into quarks which come in "flavors" that are "charmed," "strange," "up" or "down." These modern day physicist-shamans say that it is possible to alter an object with our mind, and not only that, we can also alter time and space by directing our consciousness to do so. It takes discipline to achieve, but this is the possibility that shamans, gurus and metaphysical practitioners from cultures all over the world have consistently stated. Perhaps this is the "magical ether": the intangible but indispensable element of inspiration in everything human worth doing, including good design.

How Computer Technology Visualizes Symbolic Regeneration

In the 1970s Benoît Mandelbrot, an engineer with IBM, discovered the Mandelbrot set, an extremely simple equation that is iterated, or folded

back into itself, multiple times over to produce dazzling images of mathematical infinity. This is called a fractal. A fractal is the representation of matter (something) as it relates to mass (non-thing): The outside area of the fractal is empty, while the "all" of the equation is on the inside. The interest is along the boundary between the two. All the action resides in their direct relationship. This edge is analogous to a symbol. It is the visualized tension between thought and form. The self-similar worlds that you can explore in a fractal give firsthand experience of regeneration and its nature of cascading into other dimensions.

Images similar to this can be created on Macs or PCs with an open source shareware called Xaos. It's an incredibly small program and downloadable on the web. I recommend visual exercises such as this to let go of the linear segments of our daily experience. This relaxes the mind and prepares it for nonlinear thinking, an essential ingredient to inspired design.

Fractals

Examples of fractals which show the wide differences the initial set of conditions generates in the final form are all generated from a simple equation—not unlike a basic string of DNA with minor divergences

Figure 5.36
This computer-generated fractal is based on a formula by Isaac Newton, magnified 10^9.

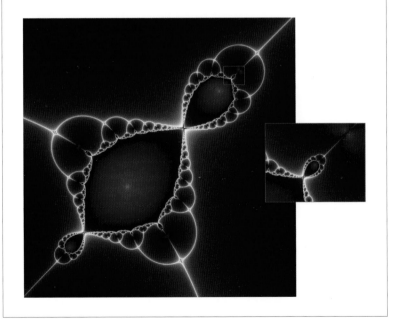

5.36

Figure 5.37
Another Newtonian fractal is based on an equation using the number 5, magnified 10^4.

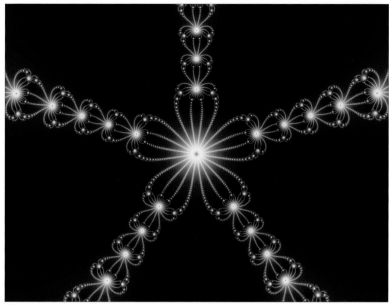

5.37

in starting points that generate a vast body of diverse life forms. These metaphoric principles can be embedded into a logo for effective results that will integrate into multiple applications and media.

Fractals demonstrate regenerated self-similarity with diversity that revolves around unchanging principles—just as a tree branch pattern mimics the visual of the overall tree. But a fractal doesn't describe a literal translation of the universe any more than a fingerprint can describe a face. Rather, they are symbolic models with which to grasp a concept and unfold our thought process. This helps us connect with the unfathomable concept of infinity. It is a metaphorical stepping-stone that, once simplified enough, the mind can make sense of. The simple equation of a fractal mirrors the symbolic principle of regeneration in the qualities of the spiral, which is a prevalent pattern in fractal imagery. Like a symbol, the fractal is simple at its essence but regenerates itself toward infinity.

Another way to think of a fractal is that it shows visible traces of phenomena in space. Natural examples of fractals include the path water cuts through a canyon, or the trail of destruction a tornado leaves behind in its wake. The shapes of coastlines and meandering rivers, the structure of blood vessels, tree branches and the clustering of galaxies are also examples of natural fractals. Man-made fractals include stock market

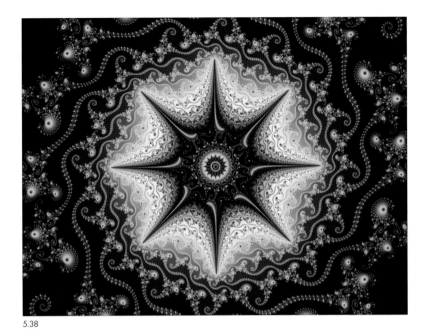

5.38

prices, written music and artful computer-generated fractals such as those displayed in this chapter.

As a Mandelbrot set visually demonstrates, a simple point of origination is the base of a consistent, but complex, universe of form. This endlessly generative nature of a fractal is called self-similarity, or the ability to repeat similar patterns that scale from micro to macro worlds.

Taking the time to explore these images relieves the mind from linear thinking. This can be used to enhance intuitive imagination—so important to synergistic creativity. Connecting with what we can't explain in words translates well as emotive connection and far better than words ever could.

Like the fractal, a symbolically sound logo can germinate an entire identity and branding campaign by regenerating various expressions of itself in scale or application to any relevant material. This method holds interest and extends its reach because a logo that embodies symbolic components provides immense potential for flexibility, however it is implemented. The endless potential of a symbol also creates opportunities in branding that evolve as the company grows. This is particularly important to start-ups that rarely know how future growth will affect their overall image (see the deconstruction of the MasterCard logo, page

Figure 5.39

Drawn in a few minutes, the association was evident once I made the connection. Making the unseen relationship visible is the job of a symbolic designer. It really comes down to trusting your gut and taking its lead.

Figure 5.40

Oriental Medicine Consultants logo

60). Being able to relate universal qualities between the client and the communication supports long-term evolution in tandem with the client's business. It also effectively identifies the client over a long period of time.

The Spiral Principle in Practical Application

Spirals signal growth and transformation through resistance. They result from the interplay of opposites. When opposites interact, one either overwhelms the other or the pair resolves into a dynamic spiral balance.

Oriental Medicine Consultants was a partnership of two Western nurses who fused their traditional training with Eastern methodologies to become doctors of Oriental medicine. I used the symbolism of the double helix as a way to describe the interplay of contrasts in their medical training. This symbolism works very well to describe the balancing of "qi," or energy, which is the core approach to health in Eastern medicine. From a Western point of view, the entwined serpents have traditionally represented the medical profession as a caduceus. This symbol was a perfect fit to address all of the core aspects of their business.

The dynamic balance of the double helix, coupled with fusing relevant information about the client in a visually integrated way, were keys to creating a symbolically intuitive logo. The caduceus was my template.

5.39

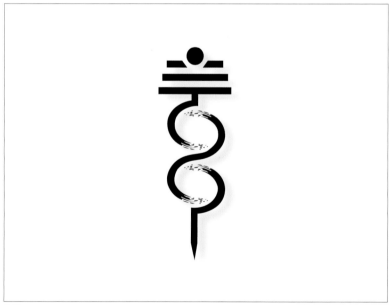

5.40

I dissolved the entwined serpent shape into bits indicating energy. The design is crowned with the *I Ching* hexagram, Tui, or "the Lake" that represents the positive attributes of joy, pleasure, encouragement and progress. The center staff is a balance reference and acts as a sublimated needle, creating a visual connection to the client's work. An honest logo supports trust: Understanding appropriate symbolic references supports ethical application and effective communication.

Needles bother many Westerners, but as the primary tools in acupuncture, it simply wouldn't be right to imply they don't exist. Acupuncture produces equilibrium through the opening of meridian points, the energetic concourses that run throughout our body. The long-established image of the entwined serpents suggests venom and medicine are one and the same, and the result of ingesting them is distinguished by proportionate use. Honesty builds trust even when it's an inconvenient truth. You don't have to drive it through your audience like a truck; subtly place the symbols to provide immediate, intuitive information.

This logo was created in the late 1990s, before alternative medicine had become the mainstream option it is now, and I was conscious to not make the intimidating needle front and center. The emphasis on this logo is the visual balance that fuses several key aspects of what they do into one comprehensive, but simple, symbol.

5.41

Figure 5.41
The essential double helix structure as the blueprint of genetic design—the spiral of regenerative growth—is at our essence. From the esoteric to the practical and embedded at ever-deeper levels of association, one should never underestimate the power of a simple symbol.

Case Studies Based on

Designers:
Dominick Ricci and Carla Miller

Design Firm:
Carbone Smolan

Location:
New York City, New York

Brooklyn Botanic Garden

"Strategizing with the client led to several key words: modern, growth and plant life. The final logo is spare yet formal and the mark intertwines the three major focuses of the garden: research and education, people and events, and plant life. A vital part of the design is one of the spirals in the logo is based on the Fibonacci series. The blade is used as a container for imagery and text on the garden's website and across all of its materials."

—Dominick Ricci and Carla Miller

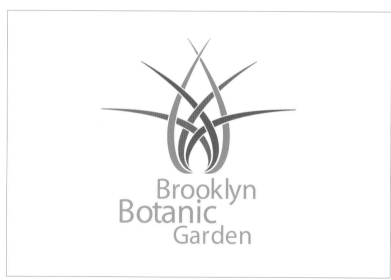

Designer:
Si Scott

Location:
Manchester, England

BMB Perfect Love

"An animated logotype for the BMB (Beattie McGuinness Bungay Advertising) 'Discuss Excellence' website. The site's purpose was to discuss anything that can be construed as being excellent in the contemporary world. People are asked (by invitation only) to talk about what they deem to be held worthy of being excellent."

—Si Scott

Embodying the expressive and expansive nature of regeneration, Si created a logotype that gives the sense of undulating the viewer in waves of moving, organic form.

"Life must be composed by ear."

Using the visual properties of the F-clef shape, I took advantage of this musical notation resembling an ear and added sound waves. I integrated the text later for a product line. The spiral shape of the clef/ear combined with the text describes the unfolding nature of experience: the principle of generative growth. The word "clef" is from the French for "key": The key to happiness in life is how we synthesize our experience of it.

Designer:
Maggie Macnab

Design Firm:
Macnab Design

Location:
Sandia Park, New Mexico

Life must be composed by ear.

Designer:
István Orosz

Location:
Budakeszi, Hungary

Hagyomany ("Tradition")

"This illustration was originally designed for an art exhibition whose purpose was to show the continuity and influence of ancient ages on contemporary arts," says István Orosz. This image was later used for a poster exhibition of the designer's work, shown here. The spiraling Escheresque hand conveys the continuity of connection through time and the "hands-on" nature of art.

Office Angels

"Office Angels is a professional matchmaker, linking small businesses that need support services with an at-home workforce. Both words in the name Office Angels conjure an array of images and icons from halos to pens, clouds to computers. None of these icons or symbols is original or memorable on their own, so it was crucial to find a unique union between the two. Many options were explored, but a trip to an office supply store led to one of those 'Aha' moments, when the right solution became apparent. The paper clip appropriately symbolizes order and organization, and a winged figure gives the impression that Office Angels is always there to help you with your small business needs."

—Brian Boyd

Designer:
Brian Boyd

Design Firm:
RMBB

Location:
Dallas, Texas

Ghostwork Marketing

Designer:
Raja Sandhu

Design Firm:
Raja Sandhu Media Corporation

Location:
Toronto, Ontario, Canada

The spiral's organizing nature of balance holds the chaos of movement together from electrons to galaxies. This principle is embedded across all scales—including within the seemingly insignificant paperclip—by managing a paper trail. Integrating the balance-principle of the spiral, the visual association of an object to represent the paper-driven work of marketing, and the letterform "G" for the client's name, Raja designed a beautifully simple, balanced and powerful logo.

Heart Institute of New Mexico

This design morphs the ideas of "care" and "heart" into one simple symbol. What could be more human than hearts and hands to support the idea of health care?

Designer:
Maggie Macnab

Design Firm:
Macnab Design

Location:
Sandia Park, New Mexico

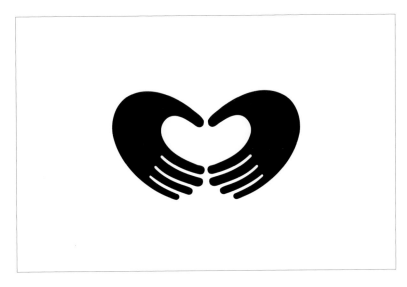

Designer:
Henry Steiner

Design Firm:
Steiner and Company

Location:
Hong Kong, China

Dah Sing Bank

Steiner originated the conceptual work on this design beginning with a counting tool. The abacus dates back to Asia almost three thousand years ago. The beads that move up and down on the center rods have been bifurcated into a human shape. "Dah" means "big," and the human-shaped figure is also the Chinese character for this word.

Time Warner

We've all seen this logo, and it belongs to the principle of five. Warner was primarily concerned with entertainment, Time with journalism. So their common denominator needed to be much broader—looking and listening, reading and hearing, receiving and sending. The new logo was a pictograph combining eye and ear, the essence of communication.

Designer:
Steff Geissbuhler

Design Firm:
CG Partners

Location:
New York City, New York

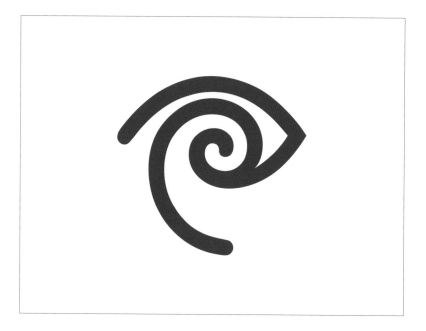

"The time has come to bring back more symbolic marks whenever possible and appropriate because we've been over-saturated with abstractions … the best communication is something recognizable that people can relate to."

—Steff Geissbuhler

Serbian Refugee Council

This logo is a very simple fusion of two elements that represent a very big concept. People in need give the opportunity to change the world: A hand extended in compassion brings connection, connection brings understanding and understanding brings peace.

Designer:
Denis Radenkovic

Design Firm:
38One

Location:
Serbia/Madison, Wisconsin

Serbian Refugee Council

Designer:
Lance Wyman

Design Firm:
Lance Wyman Ltd.

Location:
New York City, New York

#1

"The No. 1 was done as part of an exhibit in New York and Mexico City. The exhibit was the work of thirty-one invited designers and artists, each having a day of a month. The idea of the No. 1 was to suggest getting the show off the ground."

—Lance Wyman

Though on first glance this logo seems to logically fit in Chapter One, I chose the spirals—in sets of five off to either side of "one"—as having

the stronger emphasis. The purpose of the show was art, and in combination with the lift of quintessence, distinguishes "five" as the most important quality of this identity.

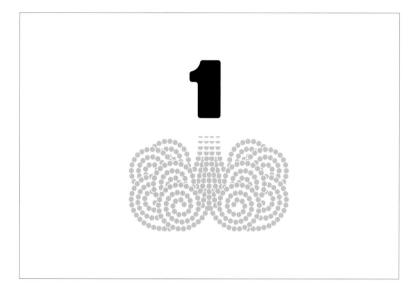

Structure as Form

The principle of six is purposeful structure and order, as seen in the organized efficiency of the bee and the hexagonal honeycomb it builds. While pentagonal structure underlies organic form exclusively, the hexagon appears in both organic and inorganic form, and these two structures combine to create the spherical form upon which both exist as the manifested energy of matter. Six contains the properties of efficiency that fit perfectly within space, and drives the sequential properties of power and time with clockwork precision. Six expresses the cooperation of time, form and energy. The hexagon is the third and final two-dimensional shape that packs matter into space without any waste, after the triangle and square. It is considered the first perfect number as both product and sum of the first three numbers (1+2+3=6 or 1x2x3=6).

Figure 6.1
Bee Guy by Joel Nakamura

THE VERSATILITY OF ABSOLUTE STRUCTURE

Six-sided carbon atoms, occurring in all organic life and with an atomic number six, have the ability to bond with millions of compounds, thousands of which are vital to organic life processes. Carbon bonds also

Figure 6.2
Scanning electron microscopy (SEM) image of buckyballs self-organized from branched DNA-polystyrene hybrid molecules. The diameter of a buckyball is about 0.5 millimeters. This shape fits well into organic life and is used to deliver drugs at the molecular level. It fits so well, in fact, there are concerns about mutation and damage to DNA during the bonding process because it can alter the physical structure of DNA.

cover a wide range of extremes, from the hard and abrasive translucence of the diamond, to the soft, lubricating and opaque nature of graphite. The bonds link as hexagons and pentagons, which in turn assemble into spherical shapes resembling the geodesic domes designed by the architect-engineer Buckminster Fuller (see Chapter Three, page 86). These two shapes together comprise the structure of many viruses and man-made elements because of their ability in combination to fit perfectly around a spherical surface. Used in nanotechnology for drug delivery, fullerenes (another name for buckyballs) can alter the structure of the double helix or create mutation by latching in chain-like fashion onto one of the helix twists and shifting its balance. This edits life at the genetic level.

6.2 By permission of Prof. Dan Luo's research group at Cornell University. Authors: Soonho Um, Sang Kwon and Dan Luo.

In shape form, six appears as the perfect hexagonal patterns of nature seen in snowflakes, honeycombs, reef corals and the crystalline structure of diamonds. Many man-made objects that require maximum stability and strength, such as six-sided faucet handles, utilize the shape as well. Six symbolizes precision, and as such is found in music (the six strings of a guitar create the basis for harmony) and targeting accuracy (six bullet chambers rotate around a center pin).

6.3

6.4

Figures 6.3, 6.4
In soccer balls or domes, the hexagon tessellates around a pentagonal shape to create spherical forms.

Figures 6.5, 6.6
On a flat surface or in stacking mode, such as sidewalk pavers or bolts readied for shipment, hexagons are the most efficient shape for packing matter into space. Note the addition of the spiral threads in the center of the bolt: The organizational quality of the spiral complements the ultra tight fit of the hexagon to secure structures to the world.

Figure 6.7
Six-sided human objects employ this principle, as shown here on a faucet handle. Six sides maximize efficiency by leveraging perfect symmetry.

This shape implies high functionality with nearly limitless build-out potential. At the molecular scale, six vertices provide the structural opportunity for the stable branching of dendrites with endless expansion. Used with design, this shape implies high functionality, structural strength and flexibility.

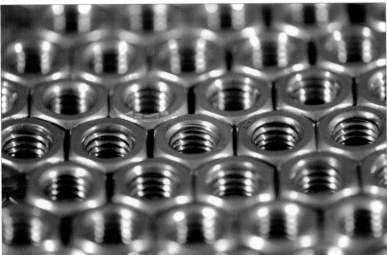

6.5

6.6

6.7

Multiples of six, particularly twelve and sixty, are frameworks for measuring everyday things: time (sixty minutes in an hour; twelve months in a year); measurement (twelve points to a pica; twelve inches to a foot); and geometry (360° in a circle). And when it comes to restructuring the negative patterns of addictive behaviors, twelve-step programs are found to be effective.

Six Degrees of Separation

Human social networks also use six as a number of efficient structuring through connectivity. The idea that any two people could be connected through no more than five others was originally conceived in 1929 by Hungarian author Frigyes Karinthy in the short story "Láncszemek" ("Chains"). The theory of six degrees of separation was verified in 2001 by an Internet experiment conducted by Duncan Watts of Columbia University in which an e-mail was circulated between 48,000 senders and nineteen targets around the world. Surprisingly, the average number of intermediaries was six. This transference method, called lateral diffusion—or the spreading from one node (or person) to another—is also how gossip, jokes, rumors, diseases, corporate communications and computer circuitry move through space with very fast, two-dimensional speed. We intuitively recognize this shape's principle of highly efficient connectivity—whether implemented in three-dimensional space as a building component or in the two-dimensional world of facilitating transmissions.

HOW SWEET IT IS

We love honey and for good reason: It has been used as a high-energy food and effective topical and internal medicine throughout human history. Mead, one of the oldest fermented drinks (made for eight thousand years or more), is made from honey, and the term "honeymoon" derives from the bride's dowry consisting of enough mead to celebrate the marriage for one month, ensuring at least one menstrual cycle and the likelihood of conception. Honey's health benefits come primarily from

its antibiotic properties. Most bacteria and other microorganisms cannot grow or reproduce in honey, so it is the only natural food that will not spoil. Honey also contains concentrations of vitamins, minerals, amino acids and antioxidants. In the process of collecting flower nectar to make this delicious stuff, bees are a primary source of supporting the reproductive cycle of plants by collecting and distributing pollen.

Bees are admired for the masterful engineering of the near perfect home (as noted by Buckminster Fuller in using hexagonal buckyballs to build geodesic domes), as well as their teamwork in

Figures 6.8, 6.9, 6.10
All true insects have six legs, including butterflies, beetles and bumblebees. Bees have a predominately six-sided nature to every part of their being, from building six-sided wax chambers for a nursery and home to the microscopic structure of their antennae and epidermis. Many cultures have considered the hive the ultimate symbol of organized structure and have based their society on it.

Even the molecular structure of the glucose in honey is six-sided. The hexagon is the intrinsic blueprint of hyper-efficiency for connecting organic life in a moving, living universe.

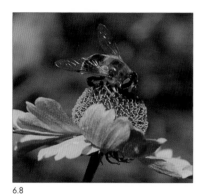

6.8

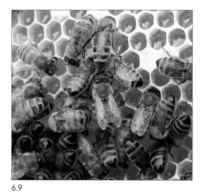

6.9

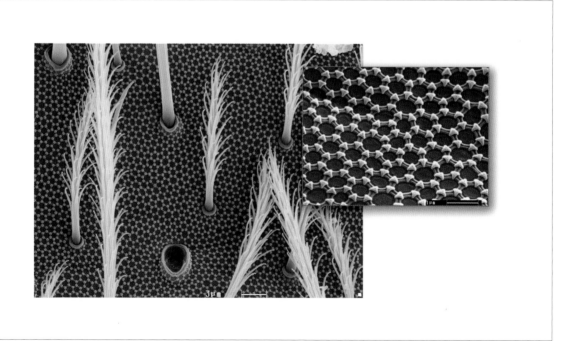

6.10

maintaining the hive. The hexagonal honeycomb chambers are the most efficient shape for holding honey: They use significantly less wax (18%) than triangular tubes, and slightly less (7%) than square tubes. Glucose, with a chemical structure based on the hexagon, is one of honey's two primary sugars (the other being fructose with a pentagonal molecular structure). Glucose is a simple sugar that is metabolized very quickly, and is used as the primary energy source for most organisms at the cellular level, from bacteria to humans. Six is the shape of extreme efficiency and dependability for structuring life, and is therefore a useful visual principle to incorporate into logos that denote high efficiency, reliability and several parts working seamlessly together as a whole.

Draw a Hexagon

Six is born of three half-stepped (overlapped) circles, combining the unity of one and balance of three. Six circles fit perfectly around a seventh. Points of intersection in either diagram are connected to enclose the hexagon: one of the three perfectly fitting structures of space (triangles and squares being the other two).

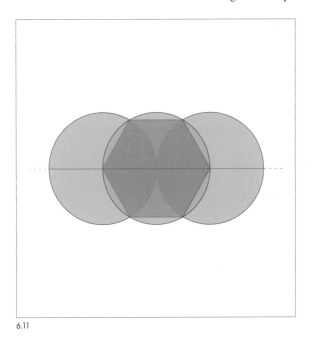

6.11

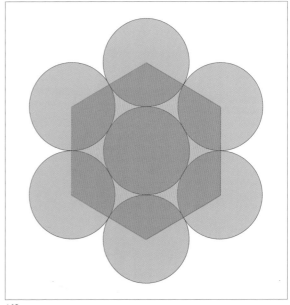

6.12

Simply connect the center points with lines, or if working in a computer drawing program, draw a line between two of the touching points of intersection, and rotate and copy that line 60° five times. The rotational degrees are determined by dividing the 360° of a circle by the number of angles you wish to create, in this case six.

DECONSTRUCTION OF THE HSBC LOGO

This is a more literal approach to logo design with its hard-edged angles of economy. It is most appropriately used to convey highly structured dependability, efficiency, consistency and reliability, and shapes of this nature are often used for clients who are engaged in hard-fact professions such as finances or the research sciences.

Let's look at the practical implications of using six as symbol using the international HSBC bank as an example. HSBC is one of the world's largest banking and financial services. It's more than 140 years old and has branches in more than seventy-nine countries and territories including Europe, the Asia-Pacific region, North and South America, the Middle East and Africa. Looking at these facts alone, we can deduce that their logo

Figure 6.13
An emerging giant in 1983, the Hongkong and Shanghai Banking Corporation (HSBC) was an ungainly name for a bank developing international subsidiary brands in banking, finance, brokerage and insurance. Henry Steiner of Steiner and Company/Hong Kong shortened the brand name to HongkongBank. He was inspired by the bank's original St. Andrew's cross flag. Suggesting connections and points of the compass, this mark fuels HSBC's dramatic expansion in worldwide directions.

6.13

design needs to be extremely efficient, structurally dependable, denote high efficiency, suggest reliability and incorporate many parts into a seamless whole. These are the company's core business principles and values:

- Effective and efficient operations
- Strong capital and liquidity
- Strict expense discipline
- Customer service

This company is a perfect candidate for using the principle of six in their logo design. The logo is a straightforward, red, six-sided shape inset with two white facing triangles, so the six is essentially repeated twice in their design in case you didn't get it the first time. Recall the bank's core values above; recall the message of a hexagon—three separate qualities of effective structure, function and order coming together to form a whole of seamless economy. This is exactly what this extremely uncomplicated (but not simplistic) logo is about. In a tiny space with the simplest of shapes, the logo can communicate across seventy-nine countries without offending anyone and at the same time speak to the company's core values.

The logo's simplicity and clean-cut shapes also denote a company that isn't hiding anything: It is multi-faceted, yet straightforward. This implies transparency. In the world of finance, HSBC is indeed unique. They have a social, moral and financial courage and commitment that few financial institutions appear to have. This is summed up by their response to the question, "What are you doing to share the success of your enormous profits with others?" (Notice how often the words they use relate to the nature of the number six. Italics added for emphasis.)

"HSBC's *duty* to its customers is to look after their financial affairs with *expertise, fairness* and *transparency* ... At the same time, HSBC believes in sharing its success with the less fortunate members of society because economic success and social deprivation are incompatible in the long term, because the public increasingly expects major companies to support the community, and because, simply, HSBC has always believed it is *the right thing to do* ... balancing these different responsibilities is sometimes challenging ... We have identified education for

6.14

6.15

Figures 6.14, 6.15
International HSBC signage applications

the underprivileged and *environmental sustainability* as the two main
planks of our philanthropic policies."

HSBC is committed to "capitalism with a conscience." When compa-
nies think in a global way that is backed up with sustainable initiatives,
their business practices follow the structure-function-order underlying the
number six. Why? Because these practices contribute to the whole and if
you consider any whole thing you'll recognize that it has structure, inher-
ent power and duration in time. Structure-function-order are really one
concept. Each must incorporate the other to exist. If the structure of a
company is sound, order follows, and the company will likely withstand
the duration of time. This is a benchmark of efficiently working within a
space by supporting that space. The HSBC logo integrates the reciprocal
interlinking that is inherent in their business philosophy.

As a designer, before you put the first mark on paper, these are the
sorts of facts you want to research about the client. By doing this you will
begin to get a sense of how shapes, numbers and symbols start to tell
your client's story. In the practice of connecting our clients to the values
they represent, we also connect the client to their audience while connect-
ing us all to our world.

Case Studies Based on

Designer:
Pepe Meléndez

Location:
La Habana, Cuba

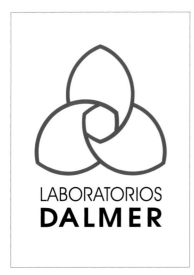

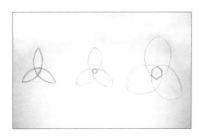

Designer:
Emanuela Frigerio

Design Firm:
C&G Partners

Location:
New York City, New York

Dalmer Pharmaceutical Company

"As a designer at the National Bureau for Industrial Design, I was commissioned to develop the trademark and identity manual of this Cuban company whose purpose is to market pharmaceuticals made from natural sources. They are exclusive, highly effective products, and due to their natural origin, have almost no negative side effects. The target was to create a competitive image with regard to the international standard in this type of company, but with an emphasis on the natural origin of the products. I don't usually have sudden intuitions, but from the beginning of this project I had the idea of using a geometrized flower to explain both the pharmaceutical science component and the virtue of the natural origin of Dalmer products. The solution was a three-petal flower born from a hexagonal center, entwining science with nature."

—Pepe Meléndez

The structural dimensionality of six is a natural expansion from the plane of three. Plants that flower with six or nine petals often have medicinal properties (or are poisonous in high doses), relating the visual to the client in a deeply semiotic manner. Though the designer may not have been aware of this consciously, it worked its way into the design as a structural element that coherently translates to our most basic sensibilities.

Index Corporation

With sparse simplicity, this identity employs a hexagon that grows out of the Index wordmark to communicate both the strength of the brand and its diversity. The hexagon suggests tradition, and is a traditional Japanese symbol for the family. The hexagon also suggests organic, stable growth, where each piece supports the others uniformly and harmoniously. The

identity system expresses Index's aspirations as a growth-oriented company with the inherent strength of a hexagonal shape.

M33

"M33 is a small, but bright nearby galaxy marked in the night sky by its three brightest stars of the constellation Triangulum. In this case the three stars represent the client's strongest assets: its people, technology and network. The shape in this mark represents the repeated hexagonal mirror arrangement used in the most advanced deep space telescope optics technology."

—Brains on Fire

Design Firm:
Brains on Fire

Location:
Greenville, South Carolina

Designer:
Mark Spanton

Design Firm:
Pollenation Internet Ltd.

Location:
Leeds, Yorkshire, England

Designer:
Scott Kim

Location:
San Francisco, California

Pollenation Internet Ltd.

Pollenation is founded on the premise that a small team of experienced consultants will be more productive, produce better quality work and ultimately be more cost effective than any large team of junior staff. The structural shape of the logo combined with the idea of a single cell from a hive support this theory.

Silicon Graphics

The stability of this design is just what an emerging technology needs. Originally designed in 1982 by Kim and used until recently, it addresses both the fluidity and structural integrity of silicon-based graphics. This was Kim's process:

"First I tried working with the words 'Silicon Graphics,' and incorporating an image from computer chips. That led nowhere, so I asked myself a series of questions.

- What is the core of Silicon Graphics' identity? *3-D graphics*
- What is the archetypal image of 3-D graphics? *The cube*
- What is an interesting way to draw a cube? *In one continuous line, as shown in the final logo*
- What is the most graphically interesting way to render this shape, so it will reproduce well even under difficult printing conditions?

"I answered the first three questions within a few minutes. Answering the last question took a couple weeks of painstaking experimentation. I wrote a program in JaM (the precursor to PostScript) with parameters for line thickness and spacing between lines, and systematically generated many variations. I considered whether round or sharp corners looked better. Finally graphic design colleague Suzanne West helped me

choose the best variation (with generous space between lines, and small segments of the bar seen between other bars), and chose the color (a light desaturated purple, as an alternative to the overused color blue).

"The result is a logo that looks like a flower on the first few viewings, then surprises the viewer by popping into 3-D. Many people have told me of their delight on realizing that the flower was a cube."

—Scott Kim

Kim's painstaking effort to work through the process to find the best solution is clear in his sketch developments. In particular, the last exploration shows the vast range of difference minor adjustments to line weight and spacing can make in how we perceive 2-D space as a 3-D representation.

Jerusalem Botanical Gardens

The three Hebrew letters J, B, and G create menorah-like monogram that doubles as a branch and leaf.

Designer:
Dan Reisinger

Location:
Givataim, Israel

The Virgin Number

Since antiquity the number seven has been regarded as holy and has been worshipped in ancient mystery cults. It is connected to the four different quarters of the moon (first, new, third and full), each measuring seven days. The Gregorian calendar we use today is based on the four moon quarters plus the monthly two or three moonless nights, totaling the approximate thirty-day month. In the book of Genesis all life was created in six days; the seventh day became a day of rest to complete the cycle of creation. Long before Christianity, the cycles of the moon were related to fertility and goddess worship. Symbolically, seven refers to the perfect order of a set of parts that facilitate the completion of a stage.

Because seven is indivisible by any other number with a whole remainder (other than by "wholeness," or one), it is known as the "virgin" number. Nothing can separate it. The heptagon (or septagon) can be approximated with a geometer's tools, but not constructed with complete accuracy like the other nine shapes. The Pythagoreans regarded the number seven as perfect because it is made up of three plus four, representing the triangle and the square. A classic combination used in Greek architecture, the triangle placed upon the square is metaphoric for transcending the mundane nature of literal reality with an inspirational pointer to

Figure 7.1
Mermaids by Joel Nakamura

Figure 7.2

The illustrated shapes representing
1–10 show the imprecise nature of
seven. (Redrawn from Michael Sch-
neider's *A Beginner's Guide to
Constructing the Universe*.)

the lofty heavens. This number is about rising beyond fact and into truth, or transforming the obvious into the sublime by acknowledging the absolute. Seven is the untouchable, mystical process. It is associated with superstition and the luck of the draw ("lucky seven"), and has a feminine orientation: invisible, mysterious and linked to the unknowable.

The Infinite Nature of Seven

Among all shapes, seven is the only one that cannot be precisely constructed out of the mother circle. Its "virginal" status is derived from the fact that it is never actually "born" as other shapes are. Of all the basic numbers, none are evenly divisible by seven: The result is always an infinitely repeating decimal. Seven is indivisible, and does not form whole relationships with other numbers, another reason for its virginal status. Nature has no use of the physical structure of seven as it cannot fit into space precisely, but it does describe the process essential to the workings of physical space.

Because it is ethereal and indefinable, this is a number of mystery. Just as we are drawn to games of chance, we experiment with throwing potentialities together to see what happens. Seven weaves chance into fate with results that we call either lucky or unlucky.

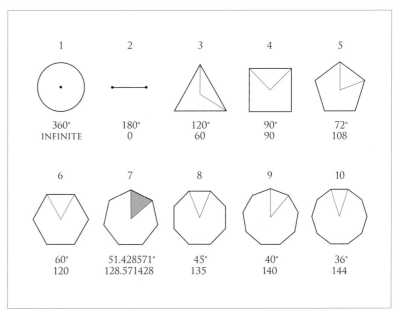

7.2

The symbol of the virgin has evolved over time from meaning "a maiden or an unwedded girl" to "someone without sexual experience." A thesaurus also lists the synonyms fresh, brand-new, natural, pure and undisturbed. We use "virgin" to describe a forest, olive oil or snow. As a designer you will want to explore all distinctions such as these, because doing so gives you the advantage of using symbols in their most powerful way.

The seven colors of the rainbow emulate a set of stages that move toward the whole. They are separated, but inextricably connected through their dependence on one another to create the wholeness of their total: pure white. The original seven planets, metals and days of the week are all woven into the pattern of seven: Moon/silver/Monday; Mars/iron/Tuesday; Mercury/quicksilver/Wednesday; Jupiter/tin/Thursday; Venus/copper/Friday; Saturn/lead/Saturday; and Sun/gold/Sunday. There are Seven Wonders of the Ancient World—a collection of the most magnificent architectural structures and works of art. There are seven continents: Asia, Africa, Europe, North America, South America, Antarctica and Australia; seven seas; and seven worlds to travel to achieve spiritual transformation. In Judaism the sacred candelabrum called the menorah has seven branches representing the creation and planets as well

Figure 7.3
René Descartes (1596–1650 C.E.) refined a Persian astronomer's explanation of the rainbow phenomena by experimenting with rays of light passed through a large glass sphere filled with water, as a typical raindrop is spherical. By measuring their emerging angles, he concluded that the bow was caused by a single internal reflection inside the raindrop. We don't see a full circle because the earth gets in the way. The lower the sun is to the horizon, the more of the circle we see. At sunset we would see a full semicircle of the rainbow. The higher the sun is in the sky, the smaller is the arch of the rainbow above the horizon. Isaac Newton later showed that white light was comprised of the full spectrum of the rainbow and would separate when refracted through a prism (or a drop of water) and coalesce back into white when refracted through a second prism.

Figure 7.4
We love the interplay of opposites, seen in this photo of rain in the desert. Dry, red earth contrasting with the deep blue gray of a cloud-heavy sky tells us that life is brewing in the recombination of opposites into complements.

7.4

7.3

Figure 7.5
Minerva, Protectress of Warriors and Goddess of Wisdom and Weaving by Elihu Vedder. An 1896 preparatory study for the mosaic *Minerva*, which is in the Library of Congress, Jefferson Building, Washington, D.C.

Figure 7.6
The Virginal Madonna with Child, also known as *Our Mother of Seven Sorrows*, Christian.

as seven heavens. The Buddhist, too, believes in seven heavens, and Native Americans associate seven with the Dream of Life. The Chinese see the seven stars of the Great Bear Constellation in connection with seven openings of the human heart. Over and over again we see the transcendent and holy symbolism of the number seven.

VIRGINS OF DESTRUCTION AND CREATION

The virginal goddesses Neith (Egyptian), Athena (Greek) and Minerva (Roman) were all goddesses of war, weaving and wisdom (destruction, creation and the wisdom to know which was appropriate when), and all had virginal births. Their temples were based on the number seven, and Minerva's temple resided on Aventine Hill, one of the seven hills on which Rome was built. The Virgin Mary had seven sorrows piercing her heart to express her compassion for humanity.

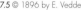

7.5 © 1896 by E. Vedder

7.6

7.7

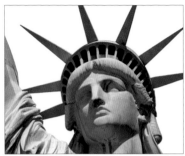

7.8

Figure 7.7
Muddy Waters live and electrified.
"Hoochie Coochie Man," lyrics
by Willie Dixon

> On the seventh hour
> Of the seventh day
> Of the seventh month
> The seven doctors say,
> "He were born for good luck
> That you'll see"
> I got seven hundred dollars
> Don't you mess with me
> I'm the hoochie coochie man

"Hoochie Coochie Man" written by Willie Dixon, ©
1957, 1985 (renewed). HOOCHIE COOCHIE MAN
(BMI) Administered by BUG. All Rights Reserved.
Used by permission.

Figure 7.8
The seven rays of the Statue of Liberty's
crown represent the seven seas and conti-
nents of the world.

In Masonic terms, seven members are required to make a perfect lodge:
three principal officers, two fellows of the craft, and two apprentices, whose
initiation is symbolic of entrance into the spiritual plane. There are the
seven liberal arts and sciences: grammar, rhetoric, logic, arithmetic, geom-
etry, music and astronomy, the study of which polish the mind for clear
and enlightened thinking. The diatonic musical scale has seven tones—do,
re, mi, fa, so, la, ti—the white keys that surround the five black keys on the
piano. Music has long harmonized humanity with the universe by describ-
ing the structure of its order in tone. We all have the experience of tran-
scending intellect through music: Listening to music emulates the motion
of the spheres, and uplifts us from the mundanity of wordly concerns.

The predominance of seven in religious, mystical and mythological
symbolism reveals its role as stages of refinement to an inherent universal
order, and it manifests in many ways. Seven crystal systems make up the
intense beauty of gemstones that we value for their levels of purity, and
the seven endocrine glands represent stages of our spiritual journey by
chakras, or "wheels," that revolve our energies up seven levels from sur-
vival to enlightenment. Seven is a transcendent metaphor for our earthly
experience. Always available but forever evading capture, mystery sur-
rounds and envelops us, with the occasional gift of its glimpse. It takes a
structured procedure to achieve the highest order, and seven's secrets have

Figure 7.9
The Pleiades star cluster is also known as "the small dipper."

Figure 7.10
Subaru logo

been kept mysterious and difficult to access to prevent the uninitiated from having powers they were not ready to receive. This number's principle should be used in only the most particular circumstances and with the highest intentions for visual communication.

Seventh Heaven: The Pleiades and Subaru

In Greek mythology, the Pleiades were the seven daughters of Atlas, a Titan who held up the sky as punishment for leading the war against the gods, and the Oceanid Nymph Pleione, protector of sailors. After relentless pursuit by the hunter Orion for seven years, Pleione and her daughters' prayers of escape were answered by Zeus when he transformed them into doves, later transforming them into stars to comfort their father so he could hold them in his arms. The constellation Orion still pursues them across the night sky.

Only six stars are distinctly visible to the naked eye, as one of them became invisible out of shame because she married the mortal Sisyphus, who was condemned to eternally push a boulder up a hill. There are many myths about this star cluster that follow along these lines, including Native American, Hindu, Celtic, Nordic, Chinese and others.

Designers can use the symbolic influence of this number to suggest companies that create products that are brand-new, inspiring or have uncorrupted values. Fuji Heavy Industries, Ltd. (FHI) was founded in 1953 by the merger of five Japanese private aircraft manufacturers that

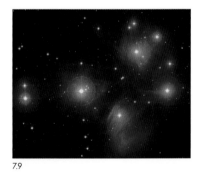
7.9

7.10

Decoding Design

integrated into one large new company (the largest star in the logo). Kenji Kita, the first president of FHI, was enthusiastic about branching out to automotive transportation, and searched for a suitable Japanese name for the company's first passenger car, the P-1. While most Japanese car companies are named for the founder, Kita chose to call the company Subaru, the Japanese name for the Pleiades star cluster in the Taurus constellation. Subaru means "to gather together." Since ancient times the Japanese have considered Subaru the most beloved cluster of stars.

Subaru uses the Pleiades cluster to describe the "gathering" of its companies. The logo shows the six clearly visible stars while the seventh remains invisible to the naked eye, suggesting the invisible synergy of compatible mergers. They also use the symbolism of the number seven in developing concepts and products for Subaru, such as the seven categories of automobiles and seven Japanese Minicars.

DECONSTRUCTION OF THE STARBUCKS LOGO

Starbucks, the outrageously successful coffee merchandiser, has also implemented principles of seven but in a much different way. What visual components reside in the logo to tell us more about who they are as a company?

The original Starbucks logo contains a twin-tailed, bare-breasted siren with a sensual pose and a smile: all symbols of access and seduction. She is related to the virgin in the semantics of the symbol: The top half is woman, but the bottom half is fish—without the ability to copulate. Mermaids are the sweetened descendents of the siren, having lost most of the siren's original power and seduction. It's important not to confuse the two. Mythological sirens have the head and torso of a woman, but the body of a snake, bird or fish, depending on time and place. They are known for their beautiful singing that seduces wayfaring sailors to falling prey to the depths of the sea. This myth harkens back to Homer's *Odyssey* and persists into the present day.

According to *The Herder Dictionary of Symbols*, sirens can be understood as psychological symbols of compulsive self-destructive tendencies; they represent mortal *or* moral danger. And according to *A Dictionary of Symbols* by J.E. Cirlot, translated from the Spanish by Jack Sage, the siren

7.11

7.12

7.13

Figure 7.11
Original Starbucks logo, 1971–1987

Figure 7.12
Secondary Starbucks logo, 1987–1992

Figure 7.13
Current Starbucks logo, 1992–present

is " … symbolic … of the torment of desire leading to self-destruction, for their abnormal bodies cannot satisfy the passions that are aroused by their enchanting music … symbols of the 'temptations' scattered along the path of life … impeding the evolution of the spirit by bewitchment, beguiling … causing its premature death."

Howard Schultz, in his book *Pour Your Heart Into It: How Starbucks Built a Company One Cup at a Time*, explains the use of the image on his company's logo, " … That early siren, bare-breasted and Rubenesque, was supposed to be as seductive as coffee itself." But as Starbucks grew, the logo was cleaned up for a broader audience that might find the siren's sexual presentation offensive. In the second version, her breasts were covered by flowing hair, with the navel was still visible, and the fish tails were cropped. In the current version, her navel and breasts are completely covered, and only traces of the spread fish tails remain. The corporate position states that the revisions to the logo were changes resulting from the merger of Starbucks with Il Giornarle in the late 1980s. Selling a

substance with addictive potential is a delicate process: Presenting it in a wholesome way is the best strategy for the bottom line.

To understand this logo's message we need to look at the properties of coffee. As with any substance, coffee can have either a negative or positive influence on health depending on how it is consumed. Drinking one or two cups a day can act as a mild stimulant and painkiller, and people in our culture have traditionally used it to kick us into gear in the morning. It increases heart rate, blood flow to the muscles and blood pressure, and it decreases blood flow to the skin and inner organs while increasing the levels of dopamine in the brain (one of the reasons caffeine is an ingredient in headache medications). For most people a couple cups of coffee a day are fine. But what happens when a six-ounce cup becomes a twelve-, sixteen- or even twenty-ounce cup—the marketed sizes of Starbucks coffee? A beneficial drug in small quantities can quickly become an addictive drug with detrimental effects. What began as a pleasant feeling of alertness and well-being can transform into agitation and escalate into anger or fear, because the same adrenaline that tells your body to fight or flee in a stressful situation is triggered by caffeine, as well. If you drink two or three twenty-ounce "cups" of coffee a day, your heart will race, your blood pressure will soar, and the increase of blood flow to the muscles will exceed the safety zone. The larger the quantity of coffee you drink, the more coffee you will need to get the same buzz you got previously, as goes the cycle of addiction. If you analyze Starbucks' marketing, you will find that over the years they have steadily increased the cup sizes.

Those who fall under the spell of Starbucks marketing will be seduced—as their logo promises—by a jolt of energy and a temporary state of euphoria. But it comes with a price. The original concept of this particular identity image was intuited with a hint of the darker side of coffee—capitalizing on desire can quickly become exploitation. Being able to comprehend embedded symbolism and how it is used is an important tool for designers and consumers alike. In this case, the "siren" can also be read as a loud and clear warning about the danger of becoming bewitched by the quick fix.

Case Studies Based on

Designer:
Lars Borngraber

Design Firm:
Rosendahl Grafikdesign

Location:
Berlin, Germany

Homann Color Management

The rainbow of unruly lines in this design falls into order as the lines approach "color management." A simple but elegant representation displaying the principle of bringing chaos into line, and stepping into a coherent order.

Medeia

Theater poster illustration for the production of Medeia by Sophocles. The labyrinth has always been a metaphor for the human quest. It is this knowledge that all religions, esoteric disciplines and psychologies aspire to provide. There are two versions of this symbolic journey: unicursal, or the single path taking the traveler to the center and out again on seven circuits that never traverse the same ground twice; and

Designer:
István Orosz
Location:
Budakeszi, Hungary

the maze requiring many excursions of trial and error to escape (such as Theseus and the Minotaur), a metaphor for transcending pattern to achieve release.

Junia

Designer:
Luba Lukova

Design Firm:
Luba Lukova Studio

Location:
Long Island City, New York

Luba created this silkscreen print of Junia—potentially the only recorded female apostle—for the print portfolio *Women of the Bible* (Liturgy Training Publications, Chicago). As most women were written out of the Bible millennia ago, the illustration shows Junia trapped inside a man's head and translated through the dominant male perspective of modern-day Christianity.

Department of Canadian Heritage

A universal principle can also be incorporated in a completely different way than as a numerical quality or as a shape. Particularly, as the com-

plexity of the numerical value and shape increases, its functionality as a visual symbol decreases. But that doesn't mean the principle can't be somehow integrated. In this example, David had a design challenge that he met with an unusual solution. His leap of thought put him into the mystical and mythical quality of Chapter Seven.

Designer:
David Berman

Design Firm:
David Berman Communications

Location:
Ottawa, Ontario, Canada

ABCDEFGHIJKLMNOPQRSTUVWXYZ
abcdefghijklmnopqrstuvwxyz
1234567890

"In developing this identity, we decided we'd prefer to use a Canadian-designed typeface, and yet could not find one we found suitable ... so we designed a custom typeface for the project.

"The Culture.ca typeface reflects the sophisticated, modern direction of the website while being reminiscent of the typographic forms used only in Canada for writing Inuktitut, the language of the Inuit people. This honors Canadian aboriginal culture by featuring one of only two alphabets in use in the world today that was intentionally designed, as opposed to evolving naturally. The letterforms used in Inuktitut were created in the mid-nineteenth century by James Evans, a Wesleyan missionary. The other intentionally designed alphabet is Hangul, the native alphabet of the Korean language, from about 600 C.E.

"The client was so enthused with the font, that they contracted us to develop the complete alphabet, including all symbols required for standard international use."

—David Berman

Infinity Captured

As we move into the higher numbers, we explore higher levels of conceptual integration. While seven addresses the individual stages of a process, eight brings us full circle to completion of a process. Mathematically, eight is the first cubic number following one ($1 \times 1 \times 1 = 1$, $2 \times 2 \times 2 = 8$), and in reverse, can be halved all the way to its original source of one ($8/4/2/1$), showing its direct lineage to wholeness and completion. The digit 8, shown on its side, is also the symbol for infinity. The two connected circles of the Möbius strip symbol make sense for the quality of wholeness, with an added twist at its center to represent the dimensional change that occurs when energy transforms. Infinity expresses all, including the reality that energy and matter are interdependent: Two sides of one coin (or the slender, dimensionless edge that separates content from everything else).

Completion is about a cycle coming full circle to the beginning to make the whole. In music, this principle is described as an octave: It's the same tone that the "do" of "do, re, mi, fa, so, la, ti, do" finishes on, but at a different pitch. The eighth note completes a scale of seven pitches that begin and end on the same tone. The sun's pattern of travel through its year's cycle is also based on the figure eight visible in time-

Figure 8.1
Moon Lotus by Joel Nakamura

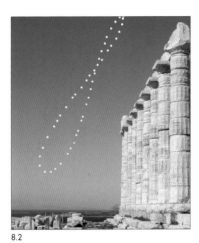

8.2

Figure 8.2
Temple of Poseidon at Sounio, Greece.
The analemma is the figure-eight loop that
results when observing the position of the
sun at the same time during the day over
the course of a year. One full yearly cycle
of the sun is a symbolic pattern of infinity.

Figure 8.3
The moon cycles through eight phases
every 29.5 days. They are:

- New Moon: The lighted side of the
 moon faces away from the Earth.
- Waxing Crescent: A small part
 of the moon appears lighted and
 grows larger on successive days.
- First Quarter: The right half of the
 moon appears lighted, with the
 lighted part growing larger on
 successive days.
- Waxing Gibbous: More than half
 of the moon appears lighted, with
 more becoming illuminated on
 successive days.
- Full Moon: The lighted side of the
 moon faces toward Earth.
- Waning Gibbous: More than half of
 the moon appears lighted, with illumi-
 nation receding on successive days.
- Third Quarter: The left half of the
 moon is illuminated, and recedes on
 successive days.
- Waning Crescent: A small part
 of the lighted moon is visible and
 recedes on successive days.

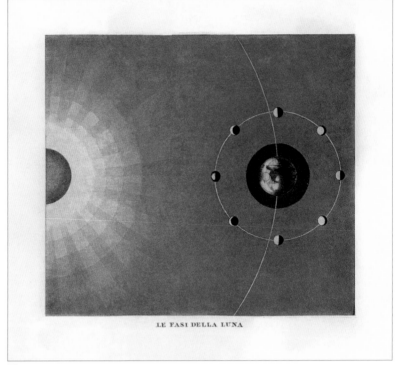

LE FASI DELLA LUNA

8.3

lapse photography taken over a full year at regular daily intervals. And
the moon travels her monthly cycle in eight distinct phases. Our pat-
tern of time is a loop rather than a line—infinity rather than forever, as
Joseph Campbell said.

Higher numbers incorporate the qualities of the numbers that came
before them, just as children have traits passed to them from their par-
ents. All numbers have their own specific "personalities" observed in their
shape and quality, but they also contain composite qualities and shapes
from their predecessors. The tertiary aspect of the number eight ($2^3=8$,
or the three 2s that make up 8) provides the quality of three, or the tran-
sitional plane through which life is transported to manifest (see Chapter
Three). Eight's geometric shape is related to transition in its "squared"
breakdown of four as well: Eight is composed of two overlapped squares,
one rotated 45° whose points can be connected to create an octagon.
In this sense, eight could be seen as crossing the substance of earth, air,
water and fire with the qualities of cold, dry, wet and warm. Both are
intrinsic to the support of life, and one doesn't go far without the other.

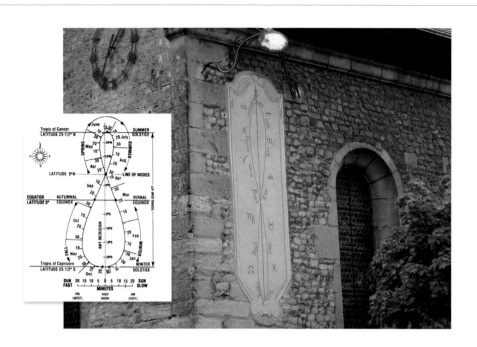

8.4

There are also eight vertices, or corners, to a cube—the square's transla-
tion with depth factored in. Life needs more than just a playing field
upon which to exist, it also needs the breath of oxygen, which contains
eight each of protons, electrons and neutrons, and consequently carries
the atomic number of 8. And the atom, now known to be composed
of those neurons, electrons and protons, is encircled by eight electrons
around its outer shell, two of which are empty for the hook-up capability
of creating compounds.

Contrary to the origin of the word "atom" (from the Greek *átomos*,
meaning "indivisible"), quantum physics has determined that the atom
is indeed divisible. Perception is continually altered by our access to
knowledge. Just as shape-complexity increases alongside its correspond-
ing numerical value, perception expands by the number of viewpoints we
can hold simultaneously. They re-present themselves by showing up from
another viewpoint. Symbols transcend by connecting to multiple ways of
expressing one thing.

Figure 8.4
An analemma diagram inset on a photo
of an engraved sign in Avenches, Swit-
zerland, shows the declination of the
sun throughout the year with its equation
of time. It may be shown on a plane or
curved surface, such as on an analemmat-
ic sundial, but is most commonly shown
near the equator on a terrestrial globe.

8.5

Figure 8.5
Squaring the square makes eight.

Figure 8.6
An oxygen atom has eight electrons. There are two empty electron spaces in oxygen's outer shell allowing it to bond with other electrons and create compounds.

Figure 8.7
Durga is depicted as a warrior goddess riding a lion or a tiger with multiple hands carrying weapons. This form of the goddess is the embodiment of feminine energy, also known as Shakti. She is often shown with eight arms (sometimes more or sometimes less).

OXYGEN ATOM

ELECTRON

ELECTRON

EMPTY

8.6

Fall Down Seven Times, Get Up Eight

The Buddhist saying that opens this section focuses on a key aspect of Eastern spirituality. Eight, as a number of completed stages, is prevalent in Eastern religions. Vishnu, the Hindu god who maintains the universe, is often depicted with eight arms, as is his female counterpart Durga, the supreme warrior mother goddess.

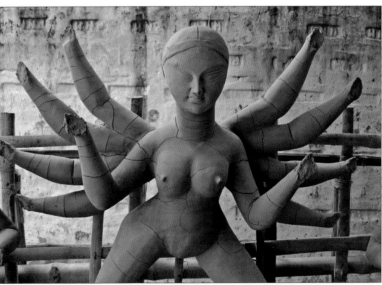

8.7

There are eight spokes in the Buddhist Dharma Wheel symbol—both in the Wheel of Life and the Wheel of Doctrine. To the Buddhist, the Dharma wheel's eight spokes represent the Noble Eightfold Path (see next page). A universally transcendent symbol, the wheel is symbolic of the Self and the Self's relationship to all (see Chapter One). The hub, or center of the primal Self, is the nucleus of the personality, and can also be interpreted as the core connection with one or "god." The rim represents actualized potential of self, or where the rubber meets the road of life—our conscious interaction with reality. The spokes are representative of the unrestricted flow between consciousness and intuition, or the in and out of conscious breath. The wheel's rim orbits like an electron around its nucleus of the core—analogous with the eight outer electrons that orbit an atom.

The Noble Eightfold Path in Buddhism teaches reconditioning of thought and behavior as a release from human suffering. These eight paths lead to spiritual perfection through personal insights during the practice of meditation. Through this process one distinguishes between need and desire, or what His Holiness the Dalai Lama calls "happiness over pleasure." Through the experiential process of being one with all, choices can be made that are more appropriate to the individual. Direct experience is more beneficial than doing or believ-

Figure 8.8
Dharma Wheel in the Sun Temple in Konark, Orissa State, India
The Dharma wheel represents the Noble Eightfold Path and refers to humankind's coherence with the underlying order of nature. The eight spokes symbolize Buddha's supreme enlightenment and subsequent teachings, and set what Buddhists call the Wheel of Law in motion. Each spoke corresponds to one element of the Noble Eightfold Path.

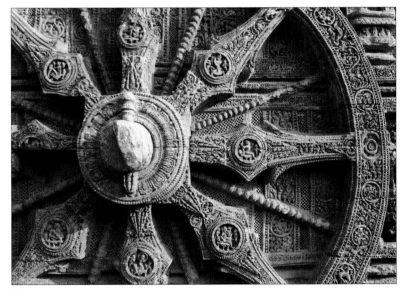

8.8

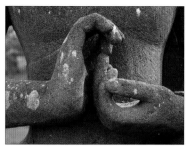

8.9

Figure 8.9
Mudras are symbolic hand gestures used in Buddhism, meditation and yoga with specific associations. This is the gesture of teaching that sets the wheel of Dharma, or natural law, in motion. In this mudra, the thumb and index finger of both hands touch at their tips to form a circle. This circle represents the Wheel of Dharma, or the union of method and wisdom. Each hand touches at the fingertips creating the symbolic "flow" of the endless nature of imparting and receiving knowledge.

ing something because of what others think, say or do, because it directly accesses our essence. Direct experience is far more powerful than any second-hand description. Carl Jung once commented that religion is a defense against the religious experience. What Jung meant by this is that human concepts in the form of organized religion are merely vehicles to aid in understanding universal principles, nature or god, and not in fact "truth." When an ideology is literally construed as reality it becomes a block to that truth, rather than its intended purpose as an access to it. Buddhism teachings are considered the "raft" that is only of use in "crossing the river." After being crossed, the raft should be discarded.

THE NOBLE EIGHTFOLD PATH

1. Right Understanding: comprehending the law of cause and effect
2. Right Thought: a mind free from greed, anger and ignorance
3. Right Speech: speech free from deceit, malice and idle chatter
4. Right Action: no killing, stealing or adultery
5. Right Livelihood: no occupation that causes harm
6. Right Diligence: sincerely striving to do one's best
7. Right Mindfulness: maintaining constant awareness
8. Right Meditation: calming the mind to help see the truth

In the West, cognitive psychologists have applied Buddhist practices to resolve conflicting thoughts that arise when beliefs are out of alignment with actions. In her essay "Buddhism Meets Western Science," psycho-therapist Gay Watson writes, "Research has shown that repeated action, learning and memory can actually change the nervous system physically, altering both synaptic strength and connections. Such changes may be brought about by cultivated change in emotion and action; they will, in turn, change subsequent experience." By changing the energetic patterns of thought, what we call reality is also transformed via the mutable nature of altered perception. This is an important concept (again, just a

raft) for designers to understand, because we are interpreting the "truth" of a client. We are creating the reality that revolves around the nucleus of their truth. When synchronized with the client, symbolic visual communication gives powerful reinforcement by conveying experiential qualities that we all can relate to.

Eight stages of thought-altering discipline are used to shift reality perception, and in so doing alter it in fact. In all sports, but perhaps most particularly in the martial arts, physical ability is directly related to mental acuity, and the willingness to take personal risk. The disciplinary training of martial arts involves eight sequential stages of mental conditioning that lead to abandoning both hope and fear, the final stage of spiritual bravery. In situations requiring quick mental and physical response, this frees energy for clean, immediate and results-oriented action. It is interesting to note that the martial arts were originally entwined with Eastern religion's roots; warrior-monks were the keepers of martial arts, spiritual knowledge and wisdom.

Incorporating the principles of eight into visual communication is a powerful but calming element and best associated with high intention and integrity. The processes involved in meditation, therapy or physical discipline are much like that of creating inspired, integrated design, and why immersion in the research of a project before jumping into its design is so important. Spending time consulting with a client in-depth and researching their business on your own can provide angles that are impossible to access from a superficial standpoint. Exploring connections opens up possibilities that don't exist prior to being searched out. And once the unseen connection is brought to light, it is often far more obvious than obscure, which is one of the most unexpected and delightful qualities about it.

Turning over stones in the pursuit of information can provide surprising connections that can be simply described using symbolism when you understand the principles they represent. Symbols contain deep, timeless knowledge that is re-experienced by whole consciousness, at every level instantaneously. Brain crunching on the other hand involves figuring out, processing, categorizing and storing information in the maze-like depository of the mind. Knowledge is embedded in our

Figure 8.10
Cross spider awaiting prey

Figure 8.11
Peruvian land drawings on the Nasca Plain include the Nazcan spider. Measuring about 150 feet in length, it is formed by one continuous line corresponding with Grandmother Spider's continuous spiraling web. These precise animal land constructions are best appreciated by air because of their size. They were discovered in the 1930s when airplanes were surveying for water.

being and the whole is accessible from infinite angles. Information, on the other hand, is processed in a linear way because much of it is tied to conscious memory.

THE WEB OF LIFE

In many creation stories, the universe is made of polarities woven together to create the fabric of matter, just as it is described by the literal and symbolic shape of the double helix (see Chapter 0). Grandmother Spider, the eight-legged arachnid of the Native American creation myth, weaves outward from the center of the universe along the path of a spiral, embedding the secrets of infinity into her pattern. Her webs are the road maps of creation on which the wheel of life rides, the cosmological order (from the Greek word *kosmos*, meaning "embroidery") of the universe that form must follow.

We human beings are conscious nodes of energy woven into existence by our individual knotted links to the whole. We are *all* designers because design is at our core. A visual designer works as Grandmother Spider by beginning at the core of a concept and linking it outward into a visual pattern of communication. The process of

8.10

8.11

design weaves visual form into concept, and then manifests it as communication. It takes a thoughtful approach to accurately interpret and employ the intuitive symbols found within the core of effective communication. Powerful design rests on the ability to integrate symbolism that communicates at an experiential level and connects us to our inherent knowledge of the world.

The Infinity Principle in Practical Application

Samba asked me to help develop their brand in late 1998, during the height of the dot-com boom. Capitalizing as many did on business applications of technology on the web, Samba was involved in collecting data and information for insurance and other purposes.

The most obvious staring point was the name itself, a Brazilian dance. Movement was called for—the fluid movement of digitized information. I decided that the vast amount of information—and the feedback loop needed to employ it effectively—seemed a good fit for the infinity shape that was ultimately used in this identity.

Figure 8.12
Finalized Samba logo

Figure 8.13
Dance was the most obvious point of departure, beginning with a rough concept. The dancers become a tightened sketch of trapeze artists, a metaphor for the acrobatic skill of juggling vast amounts of information.

Figure 8.14
Using a more abstracted graphic and wrapping the dancers on a Möbius strip became the solution to describe motion, vastness and the capture of elusive digitized data.

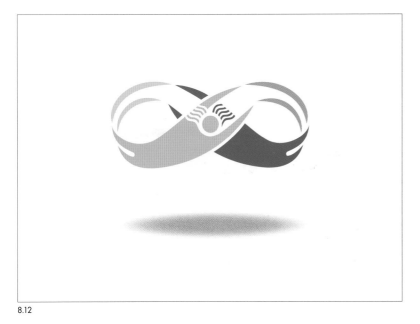

8.12

8.13

8.14

Case Studies Based on

Designers:
Dwayne Flinchum and Lori Ende

Assistant Designer:
June Park

Design Firm:
Iridium Group

Location:
New York City, New York

Rockefeller Brothers Fund

"The RBF was founded in 1940 and supports the arts and the promotion of culture that creates beauty, invites discovery, reflection and generates self-knowledge. They also support numerous programs that are designed to help and sustain worldwide efforts to make the world a better place to live and thrive—programs that enhance lives, promote the well-being of individuals and that conserve ecosystems. Their programs support social change geared toward protecting democratic values by supporting efforts that encourage democratic governments to be inclusive, accountable and transparent in order to empower and promote citizens to participate in their democratic government. The Rockefeller Brothers Fund supports a Peace and Security program that includes, among other strategies, finding ways to create greater respect and understanding between Muslim and Western societies."

—The Rockefeller Brothers Fund website

"The infinity symbol is an excellent icon to represent a sustainable, enduring mission, which is the focus of this particular organization. Through visually representing unity and inclusiveness—along with respect for individuality—we intended to convey the concept of many global cultures meshing together to promote knowledge, enrichment and enlightenment. Fresh, revitalizing colors were chosen to reinforce organic beauty and the ideal of a world that embraces harmonious values over conflict and divisiveness."

—Dwayne Flinchum

This design speaks simply and directly to the interdependence of conflict. Instead of a fluid, continuous figure-eight, the designer made a link between independent loops, metaphorically summarizing the importance of continuity, even when division is clear.

Karen Taylor, Acupuncturist

"The client uses her hands to encourage healing. She also utilizes herbs, hence the plant-like form in the negative spaces. The red circular form reinforces the Asian origins of acupuncture and wholeness—a healthy 'oneness.' The rose was a delightful surprise but not my intention. Roses are a symbol of love and care."

—Jeff Kahn

Designer:
Jeff Kahn

Design Firm:
Kahn Design

Location:
Encinitas, California

Sometimes symbolism has a way of magically integrating itself into a design. Something completely unexpected and perfect appears at the completion of an idea or when shifting perspective. Jeff began with the circle and hand as separate entities and fused them through the rose symbolizing love, healing and growth.

Designer:
Woody Pirtle

Design Firm:
Pirtle Design

Location:
New Paltz, New York

LifeMark

"LifeMark is focused on the ongoing care and well-being of terminally ill patients. The company's symbol is particularly effective by merging two universally understood icons—the infinity symbol and the heart.

"When I was commissioned to develop this identity, I immediately began to think about the associations connecting the heart with the notion of love and caring. Simultaneously, I wondered how I could connect those associations with the idea that those feelings are never ending, as suggested when linked to the infinity symbol.

"After trying a number of stylistic treatments of the two icons combined, I settled on this linear treatment that allowed for the intertwining of the two. The resulting symbol suggests that the combined meanings of the two symbols are inextricably connected."

—Woody Pirtle

Infinity Publishing

"Starting from the obvious point of the infinity symbol, I initially thought of screening it behind the text but in playing with the infinity sizing, I realized that it would fit nicely within the design as a substitute "n." Wanting to stylize the infinity symbol, I broke one of the center lines, which better describes the letterform while still maintaining the integrity of the symbol. To balance the bold, rounded symbol, I utilized a simple Helvetica block font to typeset the rest of the company's name."

—Chris Master

Designer:
Chris Master
Location:
West Conshohocken, Pennsylvania

Hexagraph Fly Rod Company

"I'm an avid fisherman myself, and after speaking with the owner, the logo concept was immediately apparent. I could envision the visual solution as a singular idea ... no real exploration was required. I pulled off the road and looked for any piece of paper and pen I could find to sketch out the initial thumbnail."

—John Swieter

Designer:
John Swieter
Design Firm:
Range U.S.
Location:
Dallas, Texas

It would seem the name dictates a hexagonal solution, but the design comes from the fluid motion of the casting technique. The rod derives its name from its hexagonal shape that makes it a flexible, strong structure—a perfect combination for the lightness and agility needed for casting and the strength required for reeling in the catch. This is a good demonstration of the most obvious solution not necessarily being the most appropriate one. As fishing is more about relaxation and enjoyment than survival today, a visual that speaks to a fluid interaction with nature rather than the absolutes of hard-edged survival suits this design better.

Designer:
Maggie Macnab
Design Firm:
Macnab Design
Location:
Sandia Park, New Mexico

One Spirit

The intent of this design was to show the interrelatedness of humans and animals. Support of one supports the other.

Designer:
Stanislov Topolsky
Location:
Kiev, Ukraine

Watch & Clock Shop

This is a visually apparent design that embeds the image of time and infinity with a lettermark. Until I saw Topolsky's logo, I hadn't made the conscious connection that the hourglass is in the shape of infinity, and that infinity is two triangles pointed toward one another. In order for time to transform from the present to the past, it must squeeze from one dimensional plane to another. The more you work with symbolism, the more transparent and intuitively accessible nature becomes.

SKAP (The Swedish Society of Popular Music Composers)

"This logo and poster were designed for SKAP's 75-year anniversary. We wanted an elegant design with a little 'party' in it."

—Fredrik Lewander

Designer:
Fredrik Lewander

Design Firm:
Redmanwalking

Location:
Stockholm, Sweden

FÖRENINGEN
SVENSKA KOMPOSITÖRER
AV POPULÄRMUSIK
FYLLER 75 ÅR

SKAP 75 ÅR

Connecting to the effervescence of champagne, celebration and music, this poster describes the completion of a mile marker anniversary with the metaphorical association of a musical octave.

The Peak Experience

Nine has the greatest numerical value of all the single digits and holds its own special properties. The most apparent is its position at the top of the single digit tier. Each digit manifests with specific qualities in the world, and nine represents the ultimate limit of manifestation in three-dimensional space. It is also the first odd square number ($3^2=9$), indicating its deep connection to three. As three's square, nine is an exponential enhancement of three's structural stability.

The use of nine in language tells us how it is regarded. For example, we dress to the nines when every detail is attended to, cats have nine lives and not one more (nine's enough, isn't it?), the whole nine yards leaves nothing out, and cloud nine is a most ecstatic place to be—all of these expressions give clues to the nature of nine. Nine is figuratively and literally the highest, the ultimate, the last, the nth degree.

Construct an Enneagon

Figure 9.2: Use one of the constructions of the hexagon from Chapter Six. I've chosen the simpler diagram (Figure 6.11).

Figure 9.1
All Together Now by Joel Nakamura

Figures 9.2, 9.3, 9.4, 9.5
One of the first visual observations of the nine-sided enneagon, also called a nonagon, is the mathematical principle of three squared. In Figure 9.3, two right-angle triangles are overlapped in a six-sided star, illustrating the principle of 3x3, and the deep connection between three, six and nine, each intrinsic to the structure and functionality of three-dimensional space.

Figure 9.3: Rotate the hexagon 30° so one of the vertices (corners) is upended. Connect the three corners of the top and bottom vertices to create two overlapped triangles.

Figure 9.4: Run a centerline through each vertex of the triangles on the diagonal.

Figure 9.5: Using either a compass (if drawing) or the circle tool (if drafting on a computer), place your center point on cross point 3 and scribe or expand out to cross Point A. Do this two additional times from cross points 2 to C and 1 to B.

Figure 9.6: These intersections connected with existing cross intersections will create a nearly equal nine-sided enneagon.

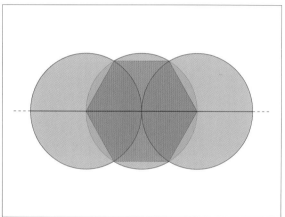

9.2

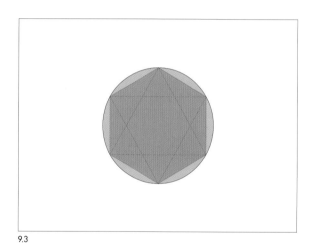

9.3

9.4

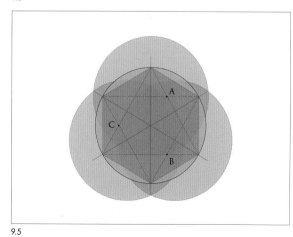

9.5

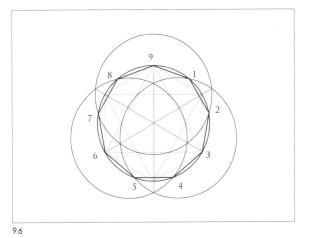

9.6

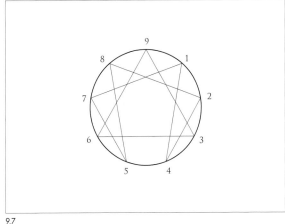

9.7

There are two things I learned when first constructing this polygon. One: Be sure to draw the new circles and not duplicate the mother circle. They are slightly different sizes. Mistakes cascade, and one little deviation will turn a beautiful piece of geometry into a grossly lopsided mess. Two: If you are using a computer, you can always use the polygon tool and set it to nine sides. However—and this is a big however—I recommend doing it by hand the first time just for the learning experience. Physical action gives a more tangible understanding that helps set the pattern of a process. In other words, the more times you venture out not knowing and have success, the more likely you are to take a risk again. Our species has excelled in the thing we do the best: invent. Don't rely on a tool. Rely on common sense. Then use tools to enhance common sense. Or invent a new tool. In its moment of conception you are experiencing the evolution of our species.

Figure 9.6
The nine-sided enneagon is constructed here from the mother circle.

Figure 9.7
This is an enneagram model.

ENNEAGRAM PERSONALITY TYPING

The popular Enneagram (the Greek *ennea* means "nine" and *gammos* means "drawn") is used as a template for understanding human personality. The Enneagram describes the various forms the human ego can take, and reveals hidden, negative or destructive tendencies that prevent us from liberating our greater potential. At its most basic structure, it is composed of three groups of sub-types, generally characterized as heart, mind and physical orientation toward lived experience.

Figures 9.8, 9.9
Ecumenical Church, designed by
my father, Alexander (Sandy) Jesse
Macnab II, in the early 1960s.

Graphically, the Enneagram is presented as nine points arranged in a circular diagram. Essentially, it connects the points of the enneagon you just constructed. Each point represents a personality type and the lines drawn connecting the points reveal the nature of the relationship between personality and lived experience. This system was introduced to the Western world by G.I. Gurdjieff in the 1920s. He claimed to have learned the wisdom of the Enneagram from a Sufi (Sufism is the mystical arm of Islam) who had learned the system in China. As with many symbols, there is no historical evidence as to the origin of the Enneagram. They simply have always been.

Nine in Practice: An Ecumenical Church

To use a real-world example, let's take a look at a building my father designed in 1961. This architectural design supports the intent of the structure. The nine legs hold theistic and atheistic symbols at equal heights: The human belief experience is suggested as mutually equivalent, regardless of theology, and exists alongside and within wholeness, represented by the circular building.

Separation is illusion made transparent by allowing the whole to move through the man-made experience. The supports are open and double as

9.8 © 1961 Alexander (Sandy) J. Macnab II

9.9 © 1961 Alexander (Sandy) J. Macnab II

door arches that allow light, sound, smell and wind to travel through, a metaphor for receiving wholeness through our senses. The center support is a transparent grid that leans into the summer solstice, giving movement and life to the design. The head-like shape crowning the structure alludes to intelligence. (The scale figure is of me at about six years old.)

My father had the following comments about this work. He called the work *An Interfaith Chapel for a Desert Crossroads*.

> "Caretaker (a holy man, if one can be found) functions as nature agent with duty to restore deprecations."

> "Flat stones with incised comments turned facedown and placed as occasional pavers in the sand outside where the tacks of lizards, birds and doglike animals mingle with the traces of man."

> "Concrete surface covered out and in with clear thecal mutual interior surface receives only the incised symbols of the seven major religions plus a symbol for the religious atheists, a circle; plus a blank area for the agnostics."

> "Geodesic egg in center made with metal mountains and clear glass triangles is open to sky above and earth below and contains a spontaneity of indigenous vegetation."

> "The whole condition is of life not in repose but in yearning, in this case southward at the angle of the summer solstice. Also from here you can see the moonrise and anyone can confirm it: The astonishingly commonplace sources of all religious experience."

> "Can the intellect abolish the soul with indifference?"

THE MAGIC SQUARE

A magic square is a square numerical configuration in which every row, column and diagonal total a constant, or magic, sum. It is at least four thousand years old and has been used by several cultures. The smallest is on the order of three, shown in Figure 9.10. Five is at the center of nine

Figure 9.10

The magic square is based on
threefold symmetry.

in numerical sequence—visualized in a square configuration it holds the center. Because it is of the order of three, it is bordered by three numbers on each side. Consequently, you get the number fifteen (or 5x3), the number of regeneration multiplied by the number of transformance, regardless of the direction from which the sum is derived. The digital root of fifteen is six (the distillation of numbers by adding them together until they reach a single digit, or, in this case 1+5=6). Six is one of the three perfect-fit numbers translated as shape (three and four are the other two) because it tiles on a plane with no overlaps or gaps. The square is regarded to have mystical properties, though many of those have been lost or hidden over time. Incorporating this number into visual communication imparts a sense of highest order in physical space and is the final step before the new cycle of double-digit numbers. It is implemented by a variety of identity systems, with varying levels of success.

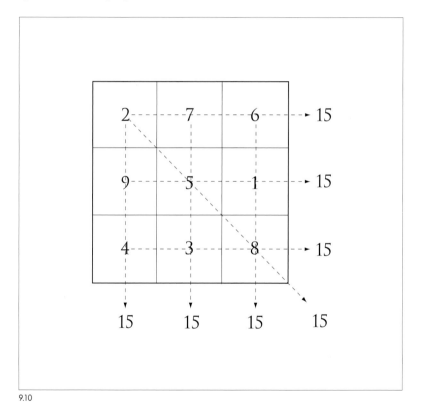

9.10

Incorporating Complexity Into Symbolic Visual Communication

The principles of nine's superiority are apparent, but the complexity of its geometric shape and quantity can preclude its use in small-scale visual applications. However, large-scale design applications can take advantage of the luxury of space for the complexities contained by nine. A good example is architectural design, whose purpose goes well beyond its humble beginnings as shelter.

Most political and religious buildings are not only elaborate; they are huge (in fact, they are what is left standing after everything else disintegrates). This is not necessarily for practical reasons, but for another reason just as important: They are institutions of persuasion and rule. My father, an architect for nearly sixty years, always told me that architecture's purpose is to "puff up the institution." An omnipotent presence that is visible long before direct contact is made has impact long after it is out of sight. Physical presence indicates power. Think of how we regard anything that is significantly larger than us. Its looming presence can be threatening—especially considering that most of our short history has been spent dodging larger predators. Architecture, just on

9.11

Figure 9.11
The Bahá'í faith symbol is the nine-pointed star. *Ecumenism* is derived from the Greek word *oikoumenikos*, meaning "the inhabited world" or "I inhabit," from the time of Alexander the Great. It now refers to the religious influence of worldwide cooperation, of which the Bahá'í faith and Unitarian Univeralism are examples. The nine-pointed star represents inclusion of all.

Figure 9.12
Chichén Itzá, Mexico

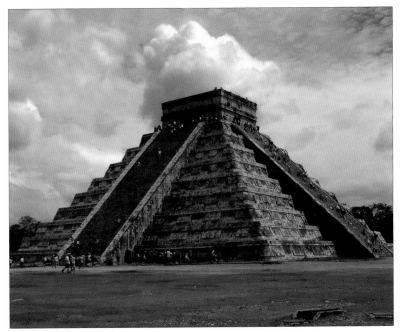

9.12

scale alone, is a good example of how we intuitively interpret qualities prevalent in our experience. Size commands attention. Elaborate decoration enhances importance. When these principles are embedded with the ultimate quality of nine, the power of this message is multiplied. As with all symbolically expressed universal principles, it is common to all cultures throughout time, and is repeated in cultures that have no connection to one another.

9.13

9.14

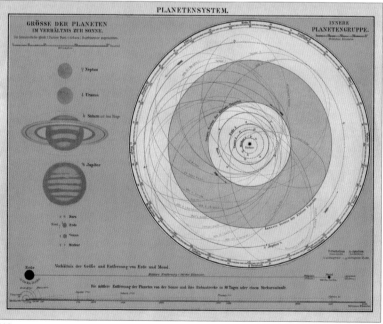

9.15

A classical implementation of the "supreme" quality of nine is shown in Mayan temples that are built on nine stepped stories. A tiered building is symbolic of the cosmic mountain made manifest in the sacred center of the world. According to ancient Mayan beliefs, the Cosmos is made up of Nine Underworlds. This idea was structurally expressed at its most fundamental level—from the bottom up in their most important pyramids, the Pyramid of the Plumed Serpent in Chichén Itzá, the Pyramid of the Jaguar in Tikal and the Temple of the Inscriptions in Palenque.

Cilia and flagella are physical projections from the cell that are made up of microtubules. They are designed to move the cell itself or to move substances over or around the cell. Both cilia and flagella have the same internal structure when you look at a cross section. They each consist of an array of nine microtubules, surrounding a set of microtubules (called a 9+2 structure). This is also the tail structure of a sperm that propels itself to the final destination of burrowing into an egg. The egg, in turn, is moved down the Fallopian tubes by undulating waves of cilia to start the process of new life that takes nine months of gestation. And our bodies contain nine openings or orifices through which the outside

Figures 9.16, 9.17
Sperm tail cross-sections of living creatures (the first are from marine snail testis and the second a mouse sperm flagellum) display 9+2 arrays within the flagellum that propel the movement of single cells in a wave-like, swimming motion. This is produced from the binding and releasing of proteins within the cell. Cilia (another flagellum) are found on the surface of many cells, and also have a 9+2 array that drives life ever forward.

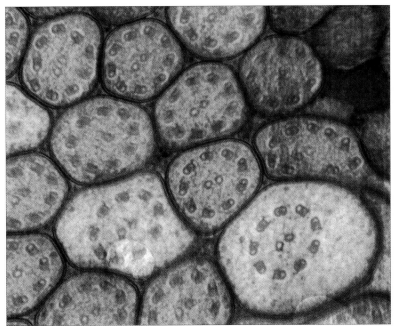

9.16

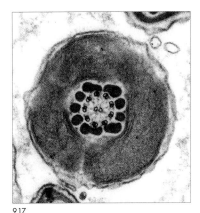

9.17

world passes. There is a connection between the beginning steps and smallest movements of life being grounded in the ultimate manifesting principle of nine.

DECONSTRUCTING THREE CORPORATE LOGOS

Nine Network of Australia

Nine Network of Australia is the oldest and one of three major Australian television networks.

This logo was in use from 1963–1976 and again from 1988 until the end of 2006. The Nine Network logo capitalizes on the magic square, a simple but strong statement of dot arrangement, reinforced by color and typographic treatment. Television was fairly new in 1960. In this logo, spheres (or two-dimensional circles) emerge from nothing-ness in a beautiful and systematic order, suggesting the intelligence of a superior tool. It is magic until it becomes a set modality, or pattern we are all familiar with.

9.18

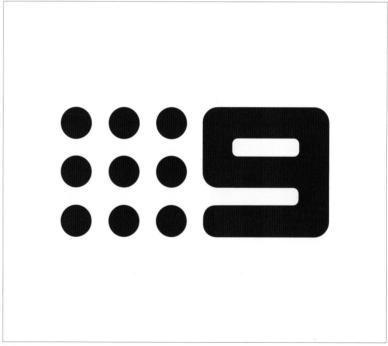

9.19

The Nielsen Company

The VNU Group, a global information and media company based in the Netherlands, changed its name to The Nielsen Company and rolled out a new identity designed by Landor and Associates that incorporates nine dots in a line. With no real connection to the identity's name or purpose, the dots become a line of floating ellipses. The typographical serifs slimmed to the point of disappearance weaken the visual impact of this design, but effectively describe the effects of global information bombardment in which the media industry plays a major role. Mass population coupled with fast technology creates too much too fast—illustrated by this design. The nine dots allude to the maximum possible, while the dissolving typography indicates the strain on dwindling resources, patience and time.

9.20

Figure 9.20
The Nielsen Company logo

Eveready Battery Company

You can also connect a colloquialism to a visual, like that of a cat having nine lives. This expression comes from our understanding of cats as fearless explorers and acrobats—their speed and flexibility allow them to survive adventures that would kill a less skilled animal. They have an intuitive knowledge of physics that allow them to retain balance when falling through the air, and can fall from tall buildings with up to a 90 percent survival rate. In a 1987 study from the *Journal of the American Veterinary Medical Association* of 132 cases of cats that had fallen out of high-rise windows, on average 5.5 stories, 90 percent survived (though many suffered serious injuries). When the vets analyzed the data they found—as expected—the number of injuries increased with the number of stories the cat had fallen, up to seven stories. But above seven stories the number of injuries per cat sharply declined. In other words, the farther the cat fell, the better its chances of escaping serious injury. This is explained because after falling five +/– stories, the cats reached a terminal velocity—that is, maximum downward speed—of 60 miles per hour. It's hypothesized that cats relax and spread themselves out like flying squirrels after several seconds to prepare for landing.

According to the Eveready Battery website, "Artists like the late Frances Tipton Hunter, who produced covers for the *Saturday Evening Post*, captured Americana's essence. One Hunter classic features a little girl

Figure 9.21
The Eveready Battery Company logo

watching over a litter of kittens—with the aid of an Eveready flashlight. This print proved so popular that reproductions suitable for framing were offered to readers for ten cents. Readers responded by sending in seventy thousand dimes—in the midst of the Depression. The poster has additional history, as well—the nine kittens were the genesis of the Eveready 'Cat With Nine Lives' symbol."

Tying the symbolism to a folktale based in truth is a metaphor that doubly supports the visual quality of this logo. Using it as a parallel for a battery with the flexibility and power to continue for multiple lives is very appropriate, if not a little quaint: a long-lived company that manufactures a long-lived battery.

9.21

9.22

Figure 9.22
Fox's pencil sketch shows a high level of geometric drafting.

Figure 9.23
This tight sketch was delivered to the client.

Figure 9.24
Here is the final two-color logo redesign.

Figure 9.25
An icon for Eveready since the late 1940s, it is epitomized in this plastic bit of nostalgia from 1981.

9.23

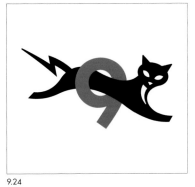

9.24

9.25

Nine is the last and highest of the single digits, which prepares us for a new cycle: the exponential recycling of single digits into infinite recombinations.

Case Studies Based on

Designers:
Mike Savitski, Joe Petrina, Vicki Crowley

Design Director:
Rick Landesberg

Design Firm:
Landesberg Design Associates

Location:
Pittsburgh, Pennsylvania

Red Square Systems

"This growing technology company came to us for a new name and identity. After a number of increasingly rowdy brainstorming sessions, the name Red Square emerged. All agreed that it was strong, memorable and intriguing in its implication of revolution and change. Red Square Systems proposed to bring a 'revolutionary' attitude to technology service, and to free clients from all tech-related problems and concerns. Visually, a square implies strength, solidity, reliability, safety."

—Rick Landesberg

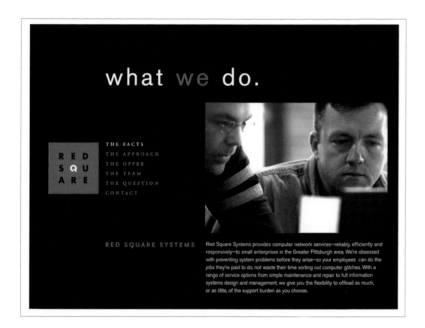

a

Using the square to replace a letterform (a) provides a bright accent within the unusual logotype, a slightly unusual twist within the implied simplicity and reliability.

Stacking the letters to mimic the square (b) forms a nice visual unit; this concept was the forerunner of the final symbol.

b

Quotation marks (c) humanize the geometric shape, and invite the viewer to think and/or say, "Red Square."

Using a green circle in this logo exploration (d) emphasizes the name by moving in the opposite direction from the obvious connotation.

c

d

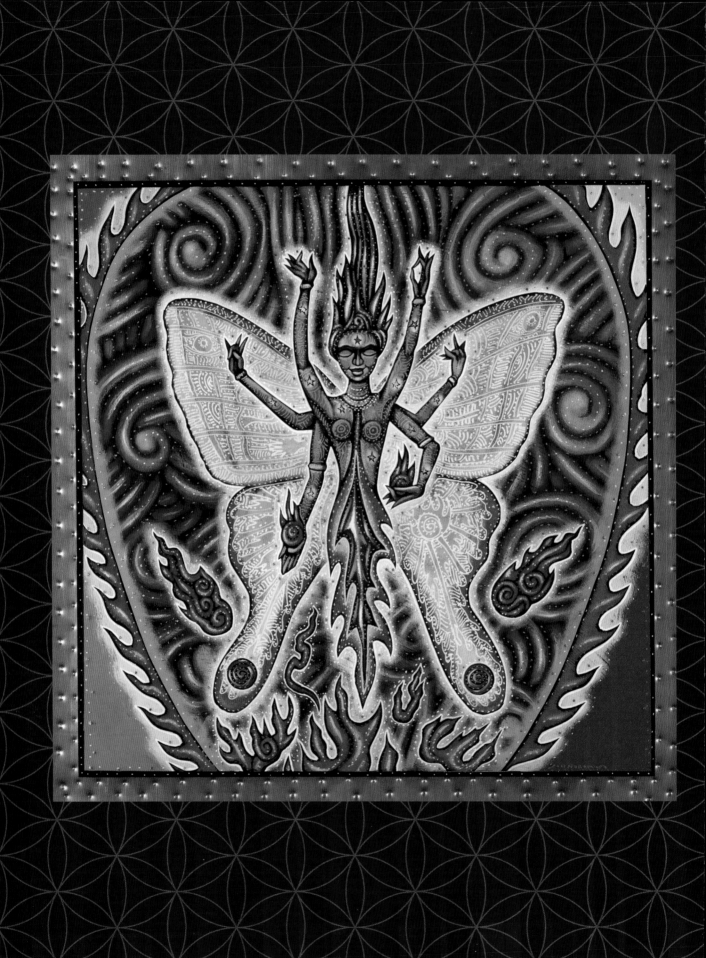

To the Tenth Power

We have moved through and past all the single digit numbers to be brought full circle to 0 and 1 in their mirrored image of ten. The physical world has a symbiotic relationship with numbers through quantity, quality and shape. In the process of considering numbers as more than simplistic digits, we have seen how they grow and develop, just as the organic processes they describe. Zero precedes one as all single digits precede ten, coming full circle to follow one on the opposite side of singleness. The opposition and relationship between zero and one is a dichotomy that can continue to expand itself at exponential powers.

Ten is the sum of the first four numbers: 1+2+3+4=10. These numbers and their associated shapes represent the dimensions zero through three that comprise the physical world. Ten includes the whole of nature within its number and form, giving it the inherent power to make the next leap forward. Its divine affinity is apparent in its triangular structure of the tetraktys. Recall from Chapter Three that the triangle is the symbol of inspiration through the transcendence of a mundane base. The divisive line at the bottom of the triangle returns to its divine origins, the point of infinity and wholeness. But ten is more than just a triangle alone: Ten also contains a center point. Like

Figure 10.1
Transformation by Joel Nakamura

10.2

Figure 10.2
One point is zero dimension; two points are a line, or one dimension; three points connect to enclose a plane, or two dimensions; and a fourth point brings us to depth, or the manifestation of form in three dimensions. The first four numbers add up to ten, eluding to its exponential ability to shift from single to double digits and evolve into an entirely new version of "one."

Figure 10.3
This image by István Orosz of Budakeszi, Hungary, is called *Labyrinth*. Our mind achieves quantum leaps by seeing its ability to connect, integrate and transform.

Figure 10.4
Eight fingers and two opposable thumbs make ten digits of transformation. Our ability to symbolize, combined with our digital dexterity, has evolved human technology very quickly ... and positions us uncomfortably close to the edge of not being able to manage what we invent.

10.3

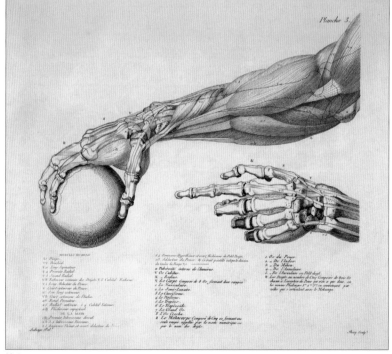

10.4

the circle of infinity that expands from its central point of zero, ten is a symbol of wholeness containing a surface and substance. This makes it the archetype of the double digits, just as 0/1 are the archetypes of the single digits.

10.5 From *Science* Vol. 211, no. 4483, 13 February 1981.
Model: Dr. Robert Langridge. Reprinted with permission from AAAS.

Figure 10.5
The DNA cross section is based on the doubling of phi. At the genetic level, a double helix has five linking bases between the two entwined strands of the helices. This makes ten steps to each turn of the helix, appearing as a ten-sided rosette in cross section.

The number ten contains the comprehensive synergy of all the numbers below it, reinterpreted as a more complex world of double digits that lead to infinity. Our inherent life-essence is based in the principles of the number five, or quintessence. Two hands of five fingers each double to ten, an obviously accessible basis of many counting systems throughout human history and the dominant system today. The word ten, in fact, is derived from the Indo-European word *dekm* meaning "two hands." From a philosophical perspective, it follows that we have been able to manipulate space with our ten fingers, resulting in an exponentially altered reality in a very short time. Ten pushes the sum of our parts forward at a rapid clip.

Connections in Ten

Charles and Ray Eames were a husband and wife team who made hundreds of contributions in the fields of architecture, art, science and education from the early 1940s until the late 1970s. Their philosophy of combining process with product created mainstays of practical and aesthetic design. Charles Eames noted, "Eventually, everything connects." Among their many areas of design were the classic Ottoman chair and industrial furniture created out of molded plywood and plastic, splints and stretchers for the U.S. Navy, and their popular short film, *Powers of Ten* (1977), which describes the universe through the relative distance of scale. One of the most popular shorts ever produced, the film opens at a one meter square view of a picnic and scales out into space by factors of ten every ten seconds, ultimately reversing and returning to the picnic and scaling into a subatomic view of the human body. Ten takes us into the potential of nonlinear thinking—itself the state of ecstasy (Greek for "being outside one's self"). We have always sought the state of divine rapture—as necessary to our soul as food is for our bodies.

Experiencing relationship of scale reveals intimate relationships between things that couldn't seem farther apart. A higher level of processing can be used as a design tool to transcend the mundane by expanding the experience of the viewer. I used this principle for a project that had to express a transformational shift in order to give an effective description.

LANDMARK EDUCATION CORPORATION

Landmark Education Corporation does worldwide transformational training for individuals and organizations. They wanted a clean, professional design for their curriculum brochure that didn't use touchy-feely, new age visuals. I agreed, but I also knew that personal transformation is an intimate process, and the personal nature of it somehow had to be acknowledged. My clue was the cover quote from Irish writer Frank O'Connor paraphrased in a speech by John F. Kennedy, describing the

process of self-realization as "tossing their hats over the wall with no choice but to follow them."

"Throwing your hat over the wall" is a metaphor for transformation through action. By putting intention on a collision course with possibility, new solutions are discovered. Out of this simple quote came the following sequence of illustrations that walk the viewer through the process of personal transformation.

Opportunities to communicate in powerful and engaging ways are all around us. In the case of conceptual design, we discover solutions that tell the story by revealing invisible connections. Oftentimes, our clients provide these cues. Connections provide value by creating relevant meaning, and relevant meaning creates energized communications that are remembered through relationship.

Figure 10.6
The finished Landmark Education brochure; cover and interior spreads. Concept and design by Maggie Macnab, illustrations by Brad Goodell.

10.6

Figure 10.7
Landmark Education's work is about shifting perspective. Responding to the client's request for minimal graphics, I had to figure out how to deliver complex information in the most economical way: The illustrations had to have a logical progression as readers flipped through the pages. The cover quote is about coming to an obstacle. Rather than surrendering to it, it becomes the inspiration to find a new way around it: "tossing their hats over the wall with no choice but to follow them."

Figure 10.8
This led me to the idea of an expanding perspective in a series of illustrations that appear in each spread of the brochure. Like viewing a satellite map, we are pulling out from our initial subject to discover the unseen connections.

Figure 10.9
Now we have projected far enough into space to begin to see the curve of the Earth and the San Francisco Bay. The buildings are obviously not to scale. After all, this is a visual myth about transformation: Exaggeration is not only allowed, it is required to enhance the message.

Figure 10.10
Pulling back farther yet, the entire Earth is now seen suspended in a sea of space.

Figure 10.11
In the next illustration, the earth is floating in something besides space ... but what?

Figure 10.12
The earth is in the hat, or rather in the intention of the hat's action, to illustrate a simple truth: Our world resides in the choices we make and the perspectives we view those choices from.

Brad Goodell's rough pencil sketches were so beautiful and evocative of the transitory nature of personal transformation that we used them as finals.

10.7

10.8

10.9

10.10

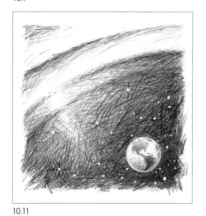
10.11

10.12

Understanding the qualities of number and how they are perfectly aligned to quantity and shape gives access to elegant and meaningful visuals. This is a fundamental quality of design. "More" doesn't equate to better visual communication, but insightful interpretation of the quality of a number can. These principles cross all scale and form in our universe. This is no coincidence; nor is it a secret. It is simply hidden in plain view. This knowing resides at the center of our being and moves us into the infinity beyond our eyes. When you look beyond, you are looking within. When you connect the two, you have designed with creative intelligence.

Case Studies Based on 10

Designer:
Tim Girvin

Design Firm:
Girvin

Location:
Seattle, Washington

The Matrix

"When the Wachowski brothers talked to me about the idea of a scrolling background field—the numbered veil of shifting reality—the exploration began with conventional coding interpretations of the numbers one and zero. But as it advanced, it became another thing. We extended the

thinking into a grouping of monograms and new alphabets to advance the idea of a new digital language of reality. It shifts between what is seen and known, and what is invisible and unknown. So it's really not ones and zeros—it's more. It's a composite of zero and one. The nature of the Matrix shapeshifting is about shifting between worlds. The green field was about trying to develop another world, another reality—a monitor screen background upon which to scroll layered multi-verses of characters, each creating their own universe. The coloration effects evolved with the stories: *The Matrix, The Matrix Reloaded*, and finally, *The Matrix Revolutions*."

—Tim Girvin

Sun Microsystems

On first appearance, the Sun Microsystems logo seems like a better fit for Chapter Four. But look closer; the reason you are drawn into this design is that it contains a vortex of self-similarity, like endless reflections in a mirror. Combined with a 45° rotation, the spinning effect is irresistible. This has held steady as Sun's identity since 1982 because the symbol embodies the essence of moving, living timelessness. It is a 2-D representation of higher dimensions, a perfect symbolic association for evolving technology. It also appropriately expresses the exponential leap from single to double digits.

Designer:
Vaughan Pratt

Location:
Palo Alto, California

a

b

c

It was designed more than a generation ago by Vaughan Pratt, a mathematician from Stanford University, who began as a mathematician should, from a straightforward square. "Who said seeing is believing?" Vaughan says. "When I look around I see that the Earth is flat, nature abhors a vacuum, and time abhors the improbable. Yet I am persuaded that the Earth is round, the universe largely vacuum, and life the improbable product of time. Persuading is believing." Vaughan designed a logo still convincing everyone more than a generation later.

Vaughan's first sketch (a) at the DNA stage: simple, direct and a precursor to its final form.

In another rough development (b), Vaughan worked with physical pieces he cut from board. This allowed him to move them in 3-D space and arrive at the configuration of transformation (c).

His final rendition (d), perfect and perfectly static before energetic movement was added later by a "professional" designer. The quotes are not intended in any way as derogatory. Rather, the point is that regardless of your individual experience, human beings are creative by nature, and all it takes is a little understanding of that nature to re-form it by design. We are all designers by nature.

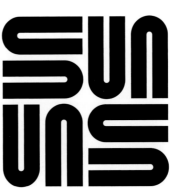

d

Casio

The illustrator Si Scott says, "The idea behind this design was of something mechanical becoming fluid and organic"—a lovely visual metaphor about lower mechanistic states evolving into higher complexity.

Designer:
Si Scott

Location:
Manchester, England

Body Wisdom

To accurately represent the client, the concept was tied to the intelligence of taking care of one's well-being. Gaining wisdom through our senses is another aspect of this design, or transcending the end product of life through process.

Designer:
Maggie Macnab

Design Firm:
Macnab Design

Location:
Sandia Park, New Mexico

Designer:
David Hillman

Design Firm:
Pentagram

Location:
London, England

Royal College of Nursing

Hands are a natural symbol for everything that supports us. Originally, to minister was to "lay hands on," symbolizing the regeneration of health with physical, emotional or spiritual support from one human to another. This logo also incorporates the shape of the letter "N" through connection.

VOX Sacra

This simple typographical logo designed by Tim Girvin is expanded exponentially into a variety of collateral with varying degrees of complexity. Part of the success of the letterform as symbol in this design has to do with the letters within the logotype itself. "VOX" inherently expresses three of the four original shapes. An excellent example of achieving beauty and connection through expansion.

Designer:
Tim Girvin

Design Firm:
Girvin

Location:
Seattle, Washington

Root Idea

Intention combined with understanding grows complex and beautiful fruit. Design is an exploration of learning that improves our clients, ourselves and our world.

Designer:
Ken Lee

Design Firm:
Root Idea

Location:
Hong Kong, China

Acknowledgments

I am awed by and extremely grateful for the generosity of the numerous people and organizations that contributed in so many ways to this book:

The creative people—both individuals and associates of museums, universities and institutions from around the world—who generously contributed design, photography and other visuals, and who also shared their experience, knowledge, wisdom and very good nature;

Particularly, Stan Marlan, Ph.D., Andrzej Stasiak, Eddy Levin and Ron McGee, for going the extra mile in explaining complex theories and sourcing hard-to-find images;

My editors, Amy Schell and Jeff Suess, who gave me room to move while keeping everything in line; and the acquisitions editor, Megan Patrick, who found me and got me in the door;

Linda O'Hair, who researched without falter, made writing suggestions, and supported the process at all times and in all ways;

Joel Nakamura for his generous contribution of the beautiful illustrations that introduce each chapter;

Woody Pirtle and John Langdon, brilliant designers both, who gave their time and experience as support curators of the logo inclusions, and helped put me in touch with international designers;

DK Holland for introducing my writing on critical thinking in design more than ten years ago in *Communication Arts* magazine, and for her comments and foreword to this book;

Tim Girvin, Betsy James and Zac Van Note for calligraphy and illustration contributions;

Cottonwood Printing-Albuquerque, and Vince Thome for image scans and technical support;

My muses Mel Wegner, Lisa Graff, Betsy James, Marie Mound, Jet Zarkadas, Sylvia Webb and Bailey Cunningham for their inspiration, encouragement and friendship;

The other matriarchs: Jane MacNab Christian, my aunt, for her worldwide knowledge and experience in anthropology; and Borbala Szepesi Sanchez, my stepmother, for her love of the Great Mother, Jung and myth; and to both for their boundless love and support;

For Mark Coble, who keeps my feet on the ground and my heart opened wide to the sky;

Finally, my deep appreciation to those who defy the status quo and put natural order first. This work is only possible because of their courage.

Resources

Alchemy and Mysticism, Alexander Roob, Taschen, 2001

The Alphabet vs. the Goddess: the Conflict between Word and Image, Leonard Shlain, Penguin, 1999

A Beginner's Guide to Constructing the Universe, Michael S. Schneider, Harper Perennial, 1994

All of Joseph Campbell, particularly: *The Mythic Image*, Joseph Campbell, Princeton University Press, 1974

The Clock of the Long Now: Time and Responsibility, Stewart Brand, Basic Books, 2000

The Cosmic Serpent: DNA and the Origins of Knowledge, Jeremy Narby, Tarcher-Putnam, 1998

The Curves of Life, Theodore Andrea Cook, Dover Publications, 1979

A Dictionary of Symbols, J.E. Cirlot, Philosophical Library, 1962

Dictionary of Symbols, Carl G. Liungman, Norton, 1994

Envisioning Information, Edward R. Tufte, Graphics Press, 1990

Escher on Escher: Exploring the Infinite, Harry N. Abrams Inc., 1986

Fractals: the Patterns of Chaos, John Briggs, Touchstone, 1992

Geometry of Design, Kimberly Elam, Princeton Architectural Press, 2001

The Herder Dictionary of Symbols, Boris Matthews, Chiron Publications, 1986

An Illustrated Encyclopaedia of Traditional Symbols, J.C. Cooper, Thames and Hudson, 1978

Li: Dynamic Form In Nature, David Wade, Walker & Company, 2003

A Little Book of Coincidence, John Martineau, Walker & Company, 2001

The Magic Mirror of M.C. Escher, Bruno Ernst, Taschen America Inc, 1994

Man and His Symbols, Carl G. Jung, et al, Doubleday, 1968

Mandala, Journey to the Center, Bailey Cunningham, DK Publishing, 2003

On Growth and Form, D'Arcy Thompson, Cambridge University Press, Canto Edition, 1992

Photographing the Patterns of Nature, Gary Braasch, Amphoto Books, 1999

Platonic & Archimedean Solids: The Geometry of Space, Daud Sutton, Walker & Company, 2002

Q.E.D.: Beauty in Mathematical Proof, Bukard Polster, Walker & Company, 2004

Ariadne's Clue: A Guide to the Symbols of Humankind, Anthony Stevens, Princeton University Press, 2001

Sacred Geometry: Philosophy and Practice, Robert Lawlor, Thames and Hudson, 1989

Sacred Geometry, Miranda Lundy, Walker and Company, 2002

Sacred Number: The Secret Qualities of Quantities, Miranda Lundy, Walker & Company, 2005

The Search for Solutions, Horace Freeland Judson, Holt, Rinehart and Winston, 1980

The Shamans of Prehistory: Trance and Magic in the Painted Caves, Jean Clottes and David Lewis-Williams, Harry N. Abrams, 1996

Signs of Life: The Five Universal Shapes and How to Use Them, Angeles Arrien, Arcus Publishing, 1992

Symmetry: The Ordering Principle, David Wade, Walker & Company, 2006

The Tao of Physics, Fritjof Capra, Shambhala, 2000

The Tao of Symbols, James N. Powell, William Morrow & Co., 1982

The Visual Display of Quantitative Information, Edward R. Tufte, Graphics Press, 2001

Visual Explanations: Images and Quantities, Evidence and Narrative, Edward R. Tufte, Graphics Press, 1997

Weaving: Methods, Patterns and Traditions of The Oldest Art, Christina Martin, Walker & Company, 2005

Contributors

3nity
3-3 Block E-2 Dataran Prima
Jalan PJU 1/42A
Petaling Jaya
Selangor Darul Ehsan
Malaysia 47301
www.3nitydesign.com

38one
745 E. Gorham Street
Madison, WI 53703
www.38one.com

**David Berman
Communications**
283 Ferndale Avenue
Ottawa, Ontario
Canada K1Z 6P9
www.davidberman.com

BlackDog
855 Folsom Street, No. 931
San Francisco, CA 94107
www.blackdog.com

Brains on Fire
148 River Street, Suite 100
Greenville, SC 29601
www.brainsonfire.com

Carbone Smolan Agency
22 West 19th Street, 10th Floor
New York, NY 10011
www.carbonesmolan.com

C&G Partners
116 East 16th Street
New York, NY 10003
www.cgpartnersllc.com

**Chermayeff & Geismar
Studio LLC**
137 East 25th Street, 7th Floor
New York, NY 10010
www.cgstudionyc.com

d-idea shop
9 Siva Stena Street
11000 Belgrade
Serbia
www.d-ideashop.com

Girvin
1601 Second Avenue
The Fifth Floor
Seattle, WA 98101
www.girvin.com

Iridium Group, Inc.
72 Madison Avenue
New York, NY 10016
www.iridiumgroup.com

johnson banks
Crescent Works
Crescent Lane
Clapham
London SW4 9RW
www.johnsonbanks.co.uk

Kahn Design
307 Trailview Road
Encinitas, CA 92024
www.kahn-design.com

Scott Kim
www.scottkim.com
www.shufflebrain.com
scott@shufflebrain.com

Kriando Design
Rua da Consolação 2697 – 7°
Jardins CEP 01416-020
São Paulo
Brasil
www.kriando.com.br

David Lancashire Design
60 Amess Street, Carlton North
Victoria 3054 Australia
www.lancashire.com.au

Lance Wyman Ltd.
118 West 80th Street
New York, NY 10024
www.lancewyman.com

Landesberg Design
1219 Bingham Street
Pittsburgh, PA 15203
www.landesbergdesign.com

John Langdon
1926 Brandywine Street
Philadelphia, PA 19130
www.johnlangdon.net

Lippincott Mercer
499 Park Avenue
New York, NY 10022
www.lippincottmercer.com

Liquisoft
6600 Warner Avenue, #209
Huntington Beach, CA 92647
www.liquisoft.com

Luba Lukova Studio
31-05 Crescent Street #A
Long Island City, NY 11106
www.lukova.net

Macnab Design
P.O. Box 59
Sandia Park, NM 87047
www.macnabdesign.com

Jose A. (Pepe) Meléndez
22 360, entre 23 y 27, Velado
La Habana, Cuba
pepeylaura@cubarte.cult.cu

Istvan Orosz
Reviczky utca 20
Budakeszi
Hungary 2092
www.utisz.net

Pentagram Design UK
11 Needham Road
London W11 2RP
www.pentagram.co.uk

Pentagram Design US
204 Fifth Avenue
New York, NY 10010
www.pentagram.com

Pirtle Design
89 Church Hill Road
New Paltz, NY 12561
www.pirtledesign.com

Pollenation Internet Ltd.
Technology House
237 Lidgett Lane
Leeds, Yorkshire LS17 6QR
www.pollenation.net

RBMM
7007 Twin Hills, Suite 200
Dallas, TX 75231
www.rbmm.com

Raja Sandhu Media Corp.
23 Cluster Oak Place
Brampton, Ontario
Canada L6R 1T8
www.rajasandhu.com

Range US
105 Turtle Creek Boulevard
Dallas, TX 75207
www.rangeus.com

Redmanwalking
Rottnerosbacken 33
123 48 Farsta
Stockholm, Sweden
www.redmanwalking.com

Root Idea
CATIC Bldg, Room 208
44 Tsun Yoip Street
Kwun Tong, KLN 852
Hong Kong
www.rootidea.com

Rosendahl Grafikdesign
Kastanienallee 71
10435 Berlin
Germany
www.rosendahlgrafik.de

Sagmeister Inc.
222 West 14th Street
New York, NY 10011
www.sagmeister.com

Si Scott
Temple Works
Brett Passage
Hackney
London E8 1JR
www.siscottdesign.com

Social UK
35 Britannia Row
Islington, London
N1 8QH
www.socialuk.com

Steiner&Co.
28c Conduit Road
Hong Kong
China SAR
www.steiner.com.hk

Stanislav Topolsky
12 Melnikova Street
Kiev
Ukraine 04050
www.topolsky.net

Permissions

0.31 "Fly Eye" image courtesy Goran Drazic, Dept. of Nanostructured Materials, Jozef Stefan Institute, Ljubljana, Slovenia

0.32 "Honeycomb" photo reprinted with permission, © 2000 Gary Braasch, www.braaschphotography.com

0.33 Snowflake image © Dr. Kenneth Libbrecht (Caltech), www.snowcrystals.com

0.34 Chase logo design © 1961 Tom Geismar, Chermayoff & Geismar

0.35, 0.36, 0.37 Photos reprinted by permission: Scanning electron micrograph of dandelion seed, Valerie Knowlton, Center for Electron Microscopy, North Carolina State University, Raleigh; Dandelion seed and head, © Peter Wienerroither, http://homepage. univie.ac.at/~pw/

0.38, 0.39 Photos reprinted by permission: Universe in Eye, © Peter Wienerroither, http://homepage.univie. ac.at/~pw; Earth in space, credit: NASA, http://visibleearth.nasa.gov

1.1 *Breathing Light Into the Universe* by Joel Nakamura

1.2 Ouroborus, Early Renaissance/ Alchemical manuscript, courtesy of the Archive for Research in Archetypal Symbolism (ARAS), New York

1.3, 1.4 Torus and Klein Bottle by permission © 2006 Davide P. Cervone, Dept. of Mathematics, Union College, Schenectady, New York

1.5 Moundville Rattlesnake Disk, c. 1300 C.E., by permission of the University of Alabama Museums, Tuscaloosa, Alabama

1.6 *Taos Round Dance*, by Chiu-Tah, c. 1938, current location unknown

1.7 Sufi Whirling Dervishes, © Serdar Yagci, Shutterstock Stock Photography

1.8 Stonehenge, © Alex Melnick, Shutterstock Photography

1.9 Aztec Calendar Wheel, © Tomasz Otap, Shutterstock Photography

1.10 Dharmacakra on Jokhang Temple, Lhasa, Tibet. Creative Commons Attribution ShareAlike License, by permission of www.onwardtibet.org/index.html

1.11 Lotus blossom carving from the Jain Temples, Palitana, Gujarat state, India, © Shutterstock Photography

1.12 Dome of St. Peter's Basilica, Vatican, © Polartern, Shutterstock Photography

1.13 Dome of a shopping center, Paris, © Polartern, Shutterstock Photography

1.14 Rings of Saturn, image credit: NASA/JPL/Space Science Institute

1.15, 1.16, 1.17, 1.18 Illustrations by Maggie Macnab

1.19 Buddha with many hands, © Foong Kok Leong, Shutterstock Photography

1.20, 1.21 Shaffer Hotel, Mountainair, New Mexico, © 2007 Maggie Macnab

1.22 The Four L's postcard, c. 1907, collection of the author

1.23 New Mexico A&M Swastika yearbook, c. 1936, collection of the author

1.24 Islamic abstract and vegetal artwork, © Manuel Velasco, Shutterstock Photography

1.25 Manhole cover © 2004 Philip Greenspun, used by permission, http:// philip.greenspun.net

1.26 Sunwheel illustration © 2007 Betsy James

1.27 Target logo, mid-1960s

1.28 © Target Corporation

1.29 *Tawa Sun Kachina* ©2007 Alfred (Bo) Lomahquahu, by permission of McGee's Indian Art Gallery, www.ancientnations. com. Photo: Chester Lewis

1.30 I Ching calligraphy courtesy Tim Girvin © 2007

1.31 Androcles and the Lion mechanical wind-up toy, c. 1950s, collection of the author

1.32 Pawprint/bandaid logo © 1983 Maggie Macnab

1.33, 1.34, 1.35 Sketches © 1983 Maggie Macnab

Page 46 © Fashion Center District Management Association, Inc.

Page 47 Chronotime logo property of Chronotime Int'l., designed by Simon Frison

Page 47 © Collaborative Conservation Network. Designed by Ryan Ford, Liquisoft.com

Page 48 © Mark Fox, BlackDog

Page 49 © GoFlex

Page 50 logo © Dallas Opera Company, sketches © Woody Pirtle

Page 51 © The Gardens Shop

2.1 *Juxtaposed Vibrations* by Joel Nakamura

2.2 "Sea Urchin Embryo" image courtesy of the University of California, Lawrence Livermore National Laboratory Archives and Research Center, photo by George Watchmaker

2.3 *Yin Yang Jung* © 2006 Maggie Macnab

2.4 Drawing by Evan Jesse Smith, collection of the author

2.5 Illustration by Maggie Macnab

2.6 current MasterCard logo © MasterCard

2.7 Interbank logo, c. 1966

2.8 current MasterCard Worldwide logo © MasterCard

2.9 "Rostov Kremlin, Russia" © Maxim Bolotnikov, Shutterstock Photography

2.10 *Yin Yang Symbol* © Rickard Blomkvist, Shutterstock Photography

2.11 "Celtic Cross, Scottish Highlands" © Bill McKelvie, Shutterstock Photography

2.12 "Christ in Majesty" Photo © Q. Cazes

2.13 Illustration by Maggie Macnab

2.14 Public domain

2.15, 2.16, 2.17, 2.18 Illustrations by Maggie Macnab

2.19 *Lovers (Mithuna)*, India, Madhya Pradesh, Khajuraho style, 11th century. Red sandstone; H. 74 cm. © The Cleveland Museum of Art, Leonard C. Hanna Jr. Fund 1982.64

2.20 *Arabian Horse Logo* designed by Maggie Macnab, © 1985 BLM and Maggie Macnab

2.21, 2.22, 2.23, 2.24 Drawings by Maggie Macnab

2.25 Maddoux Wey stationery design © 1985 Maggie Macnab

Page 70 © Fredrik Lewander, www.redmanwalking.com

Page 71 © Social UK

Page 73 © Luba Lukova

Pages 74, 75 © John Langdon

Page 75 © 2007 Scott Kim, www.scottkim.com

Page 76 Crossroads logo © Crossroads Films, Inc.

Page 76 © 2002 Maggie Macnab

Page 77 © Citic Pacific

Page 78 © David Lancashire Design

Page 79 © Kriando

3.1 *Trinity* by Joel Nakamura

3.2 "Temple of Isis on Philae Island, Egypt" © Vova Pomortzeff, Shutterstock Photography

3.3 *Shield of the Trinity* diagram of traditional Western Christian symbolism, illustration by Maggie Macnab

3.4 *Celtic Knot Trinity* illustration by Maggie Macnab

3.5 Buddhist trinity © 2007 Betsy James

3.6 Venn diagram illustration by Maggie Macnab

3.7 Illustration by Maggie Macnab

3.8, 3.9 Illustrations by Maggie Macnab

3.10 Courtesy, The Estate of R. Buckminster Fuller

3.11 *Arc de Triomphe du Carrousel* CC Creative Commons Attribution ShareAlike License 2005, by Didier B, Wikipedia Commons

3.12 Photograph © William Owen Smith, www.mayang.com/textures

3.13 "Giant Luna Moth" © Michael G Smith, Shutterstock Photography; "Great Sphinx of Giza" © 'Sue' Shutterstock Photography; "Cucumber" © Anette Linnea Rasmussen, Shutterstock Photography; "Cantalope" © Lee Reitz, Shutterstock Photography; "Orchid" © Mypokcik, Shutterstock Photography; "Sidewalk Cracks" © Amy Walters, Shutterstock Photography

3.14 Copyright © 1978 by Playboy. Illustration by Kinuko Y. Craft. Reproduced by Special Permission of *Playboy* Magazine

3.15 *Art of Anatomy: 1513–1879*, Vol. VIII, Visual Language Library, www.visuallanguage.com

3.16 *MuSE* logo design © 1996 Maggie Macnab

3.17, 3.18, 3.19, 3.20, 3.21, 3.22, 3.23, 3.24 Sketches by Maggie Macnab

Page 92 eyeku™ © 2002 Maggie Macnab

Page 92, 93 © Brown-Forman Corporation

Page 93 © Jelena Drobac

Page 94 © Kriando Design

Page 95 Design by Steff Geissbuhler

Page 95, 96 © Advanced Surgical Corporation and Woody Pirtle

Page 96 © 2000 Maggie Macnab

Page 97 © Lance Wyman

4.1 *The Business of Dominion* by Joel Nakamura

4.2 "Giza Sphinx and Pyramid" © Randall Stewart, Shutterstock Photography

4.3 Illustration by Maggie Macnab

4.4 *Circle, Triangle, Square* by Sengai Gibon (1750–1837), c. 1820, by permission of the Idemitsu Museum of Art, Tokyo, Japan

4.5 "Sampler: Classic Graphics," Planet Art Stock CD

4.6 "Money" © Robynrg, Shutterstock Photography

4.7 H&R Block logo®

4.8, 4.9, 4.10, 4.11 Illustrations by Maggie Macnab

4.12 Photo reprinted with permission from Julius Kusuma

4.13 Emblems © International Committee of the Red Cross; timeline by Maggie Macnab

Page 106 © John Langdon

Page 107 © Steiner&Co.

Page 107 © 1999 Maggie Macnab

Page 107 Exterior building photo by Matt Oetzel for Heart Hospital of New Mexico. Used by permission

Page 108 Design by Alex de Janosi, Lippencott Mercer / © The Bank of New York

Page 108 © John Langdon

Page 109 © Shelter, designed by johnson banks

5.1 *Sun Head Spiral* by Joel Nakamura

5.2 "Astrotoma Agassizii" © Paul Cziko

5.3 © Jean-Marie Aran, INSERM, Bordeaux, France

5.4 "Spiral Shell Fossil" © Linda Webb, Shutterstock Photography

5.5 "Deer Fern Fiddlehead" © 2000 Gary Braasch, www.braaschphotography.com

5.6, 5.7, 5.8, 5.9 Illustrations by Maggie Macnab

5.10 "Red Cabbage" © Myrthe Krook, Shutterstock Photography

5.11 "Apple Cross Section" © Rafal Ulicki, Shutterstock Photography

5.12 Photo by Maggie Macnab

5.13, 5.14 "Pentagonal Structure in Leaves" Illustration by Maggie Macnab, photos courtesy Shutterstock Photography

5.15 Particle tracks in the Big European Bubble Chamber © CERN, Geneva, Switzerland

5.16 "Digital X-ray" © Charles Eaton M.D., www.e-hand.com

5.17 "Sampler: Classic Graphics," Planet Art Stock CD

5.18 "Pinecone" © Randy McKown, Shutterstock Photography; spiral illustration © 2007 Zac Van Note, www.creativefuel.org

5.19 Golden Mean Gauge measuring heartbeat © 1980 Eddy Levin, www.goldenmeangauge.co.uk

5.20 Golden Mean Gauge measuring peacock feather © 1980 Eddy Levin, www.goldenmeangauge.co.uk

5.21, 5.22 Seed Media Group, design by Stefan Sagmeister

5.23 "Vatican Spiral Staircase" © Morozova Oksana, Shutterstock Photography

5.24 "Sunflower Phyllotaxis" © Vladimir Mucibabic, Shutterstock Photography

5.25, 5.26, 5.27, 5.28, 5.29, 5.30, 5.31, 5.32, 5.33, 5.34, Illustrations by Maggie Macnab

5.35 © Walgreens

5.36, 5.37, 5.38 Fractals © Jonathan Wolfe, Ph.D., www.fractalfoundation.org

5.39 Sketch by Maggie Macnab

5.40 *Oriental Medicine Consultants* © 1999 Maggie Macnab

5.41 "DNA Double Helix" © Jenny Horne, Shutterstock Photography

Page 132 © Carbone Smolan Agency

Page 133 © Si Scott

Page 133 © 2002 Maggie Macnab

Page 134 © István Orosz

Page 135 © RBMM

Page 135 © 2007 Raja Sandhu

Page 136 © 1985 Maggie Macnab

Page 137 © Steiner & Co.

Page 137 Design: Steff Geissbuhler

Page 138 © 38one

Page 139 © Lance Wyman

6.1 *Bee Guy* by Joel Nakamura

6.2 By permission of Prof. Dan Luo's research group at Cornell University. Authors: Soonho Um, Sang Kwon and Dan Luo

6.3 "Geodesic Dome Ceiling" © Shutterstock Photography

6.4 "Soccerball" © Hisom Silviu, Shutterstock Photography

6.5 "Bolts" © Martina Hedtmann, Shutterstock Photography

6.6 "Hexagonal Paving Stones" © Roger Asbury, Shutterstock Photography

6.7 "Weathered Faucet" © Anita Patterson Peppers, Shutterstock Photography

6.8 "Bee on Flower" © vnlit, Shutterstock Photography

6.9 "New Honey Cells and Workers" © Dainis Derics, Shutterstock Photography

6.10 *Collembola Antenna* © 2001 Stephan Borensztajn, Universite Pierre and Marie Currie, Paris

6.11, 6.12 Illustrations by Maggie Macnab

6.13, 6.14, 6.15 © Steiner&Co.

Page 150 © Pepe Meléndez

Index